EMPEROR
THE PERFECT PENGUIN

**Take it all in all, I do not believe anybody on earth
has a worse time than an Emperor penguin**

Apsley Cherry-Garrard
from *The Worst Journey in the World*

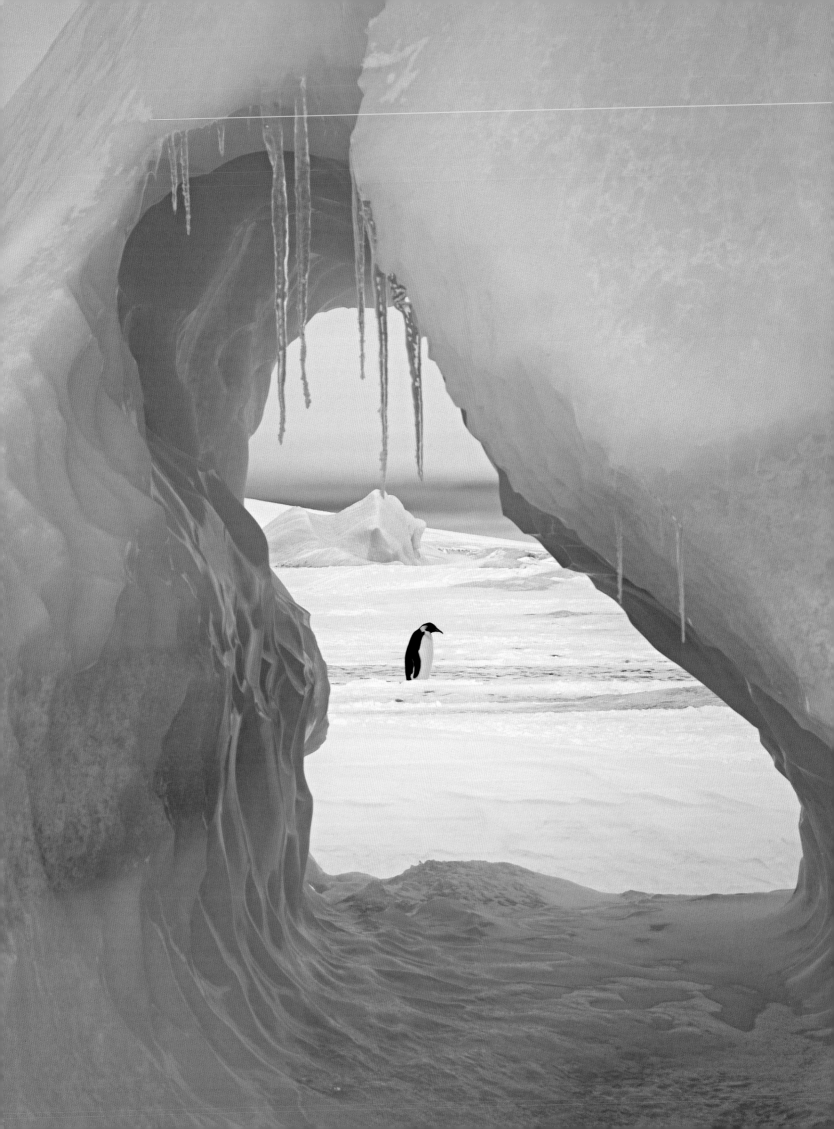

EMPEROR
THE PERFECT PENGUIN

SUE FLOOD

ACC ART BOOKS

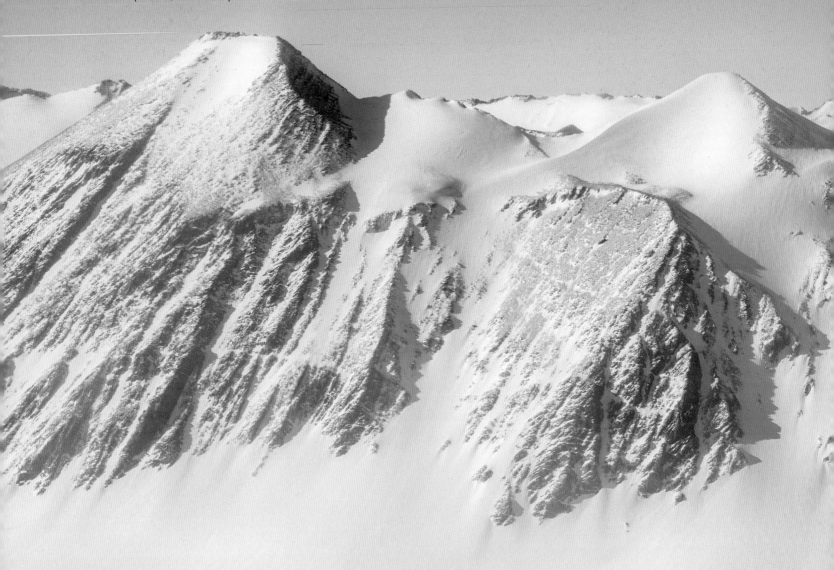

For my husband, Chris
We're not perfect, but we're perfect for one another

ISBN: 978 185149 902 1

Printed in China
for ACC Art Books Ltd., Woodbridge, Suffolk, IP12 4SD, England
Design by Simon Bishop Design for ACC Art Books Ltd

www.accpublishinggroup.com

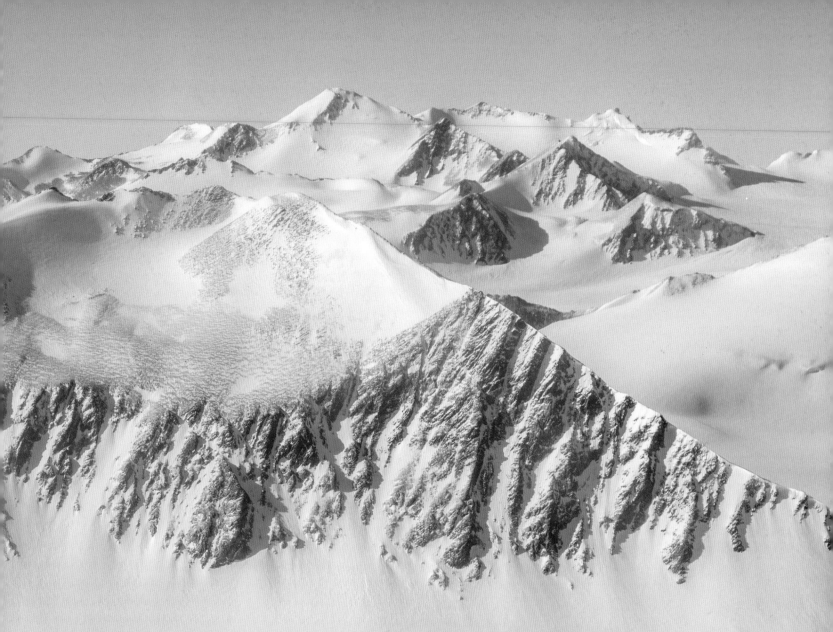

CONTENTS

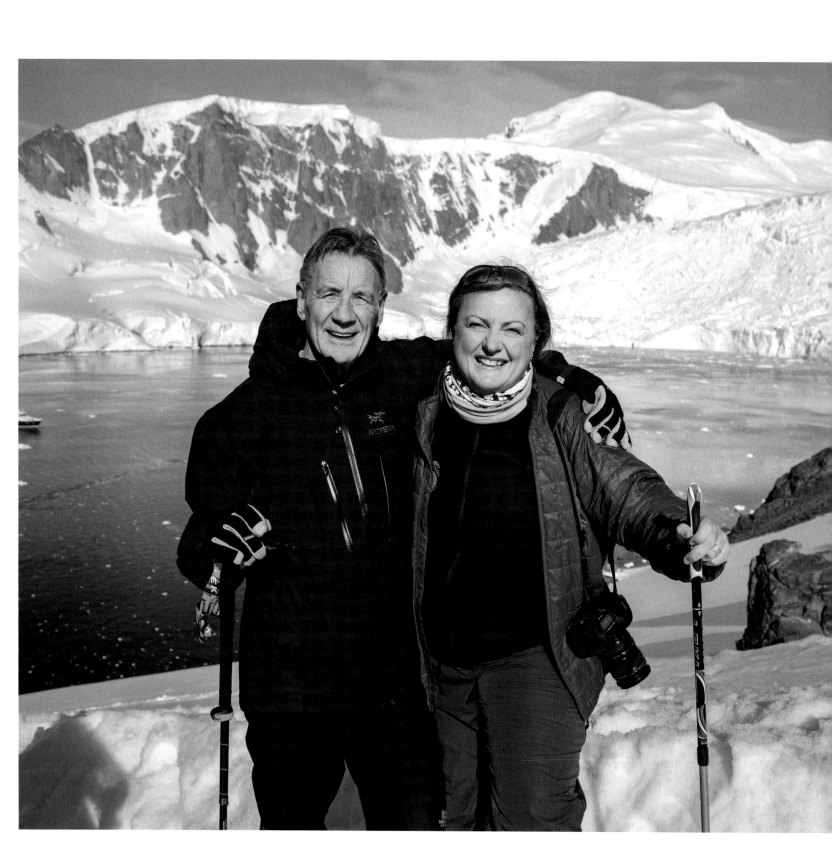

FOREWORD

Sue Flood is one of the elite wildlife photographers working today. Just turn over a few pages of this breathtaking book and you will know what I mean. Quite recently we were both fortunate enough to be amongst a small group exploring the Antarctic Peninsula. Well, I was exploring. Sue had been to the Antarctic many times before and has returned there many times since. She was giving talks on how to take photographs of the wildlife we encountered, but having seen some of her work already I realised that for me, this was a bit like being taught maths by Albert Einstein.

So I pocketed my iPhone and instead of trying to imitate Sue, I watched her at work to see if I could learn any basic secrets. The one that seemed to sum it all up was 'Be There'. Sue has a sixth sense of when and where to get the best picture. If anything was happening she was pretty much the first to notice it. This instinct seemed to be part innate talent and part natural empathy with the wildlife and an awareness of the conditions in which they live. To get the quality right, you have to know an awful lot about your subject.

I couldn't help admiring how completely at ease she was with all the equipment, deploying lenses and cameras in the harshest conditions with speed and skill. It took me an hour and a half every morning just to locate all the various hidden pockets, zips, Velcro strips, shoulder-bag straps, liners and gloves, and that was before I'd even left the ship. Sue was always unfeasibly well organised and unfazed by the conditions. Snow, driving sleet, hand-cramping cold held no terrors. Her trigger-finger was always on full alert.

The other rule I learnt from watching Sue at work was 'Do Whatever You Have To Do To Get the Best Shot'. The photographs of the emperor penguins in this book, in all their crispness and clarity, show a real love and affection for the subjects and particularly for the relationship between parent and young. To capture the intimacy in some of these requires patience and stamina. I've seen Sue lying flat on an icy shore, camera at the ready, penguins all around her, for what seemed like hours, waiting for the moment or the expression that no one had ever caught before. I've seen her lugging telescopic lenses the size of small submarines up the steepest, most slippery slopes because this might just be the day she gets a storm petrel scratching its ear. And I know from my own experience that the Antarctic is not an easy place to work. What she makes seem so easy and so relaxed can be fiendishly difficult and uncomfortable to achieve.

I think what keeps Sue going, beside her enviable gift of patience, is the infectious sense of joy she brings to her work. Sue doesn't do complaint but she does do celebration. And this makes her not just a spectacular photographer but a good teacher and a good companion.

She opens our eyes wide. And then opens them wider.

Michael Palin

INTRODUCTION

It all began with a treasure chest: a camphorwood chest crammed with myriad exotic items, brought back to England by my father during his travels with the Merchant Navy. I'd open the lid of the chest – inhaling the heady scent of camphor – to reveal carvings from Java, kimonos from Japan, intricately woven hats from Burma, head-hunters' swords from Borneo. I'd sit and listen, as my father regaled us with tales from his travels - 'When I was in Rangoon… Shanghai… Sarawak…' It all seemed impossibly exciting and exotic to a little girl growing up in a tiny village in North Wales.

Meanwhile, I would watch enthralled (and still do) as David Attenborough, with his infectious enthusiasm, presented documentaries from around the world. Watching him as he rolled around the forest floor with mountain gorillas, swam with humpback whales in the South Pacific, journeyed to the Galapagos, the Antarctic, the Amazon jungle… I never dreamt then that one day I'd have the opportunity to do these things too. But these images, combined with my dad's tales, ignited a spark within me. As a teenager, and later at university, when asked what I wanted to do when I grew up, I replied that I wanted to make wildlife films with David Attenborough. This was met with a great deal of scepticism from my teachers and tutors at the time: 'No one gets to do that!'

Nevertheless, I persisted. I volunteered for the Queensland National Parks and Wildlife Service in Australia; I assisted the marine biologists at the Bermuda Biological Station for Research; I trained and then qualified as a dive instructor. Seven years after writing my first letter to the BBC Natural History Unit, I finally succeeded in landing a research job there. This was the start of an adventure that has since taken me to all seven continents, both above and below the waves.

During the next eleven years, I worked hard to acquire the necessary skills to climb the industry ladder from researcher to - eventually - director and producer. I fulfilled that childhood dream to work with David Attenborough, and am proud to have worked on some of the BBC's most successful series including *The Blue Planet* and *Planet Earth*. It was during my BBC shoots to the Arctic and Antarctic that I fell in love with polar environments - and also transformed what I initially saw as a hobby into a deep passion for photography.

I realised that I was enjoying my camerawork even more than my production role, and so took the momentous step to leave the security of the BBC after *Planet Earth* to pursue a freelance career in photography. My work soon became recognised in international photographic competitions, and I knew I was on the right path when one of my images was chosen for the cover of a *National Geographic* magazine. I was offered a wonderful opportunity to join a three-month expedition to the Antarctic, where I had my first experience with emperor penguins. I was hooked.

One of the loveliest moments you can ever hope to experience is to stand in the middle of an emperor penguin colony, hundreds of miles from civilisation, surrounded by the extraordinary

cacophony of chicks and adults calling to one another. This stunning bird, the Antarctic's hardiest resident, captured my heart and inspired me to produce this book.

Emperors are extraordinary! The largest and most charismatic of the 17 species of penguin, they never go to land. They spend their entire lives either out on the sea ice in extremely challenging conditions or feeding in the Southern Ocean. They walk up to 100km across the frozen sea to bring food back to the colony for their solitary chicks. For me, they are the most enigmatic creatures on the planet, which is why I've returned again and again to photograph them.

In 2016, I spent several weeks at Gould Bay Camp in the Antarctic. It lies in front of the Ronne Ice Shelf in the Weddell Sea and is one of the most remote camps in the world. I was there to photograph the residents of the world's southernmost colony of emperor penguins. My home was a tiny unheated tent, in temperatures that at times plunged to -30°C… but for me, it was heaven.

My job – the best job in the world – has already given me memories that will last a lifetime: from being invited to meet Her Majesty The Queen at Buckingham Palace to the time when I managed to tip a hood-full of my own pee over my head on the first day of a polar shoot. I've dived under the Arctic ice with narwhals, swum with humpback whales in the South Pacific, been rescued by helicopter whilst adrift on an ice floe, have been stepped on by a Silverback gorilla in Rwanda, and I've zip-wired to my wedding ceremony at Richard Branson's home in the British Virgin Islands.

It's a privilege to document the natural world in this way, though whenever people say 'you're so lucky to do what you do', I reply that the harder I work the luckier I get! It's been a long slog (especially in what is still a male-dominated field), but it has certainly been worth it. Someone recently asked me if I thought I was successful. I replied, 'Yes, because I'm happy'.

They say that at the end of one's life, nobody ever wishes they'd spent more time in the office. I'm very fortunate that my office is a stunning wilderness. It's a job that I love, and it's incredibly fulfilling for me to have the opportunity to use my photography to engage people with the natural world. I hope that my images in *Emperor – the Perfect Penguin* will do just that.

Sue Flood

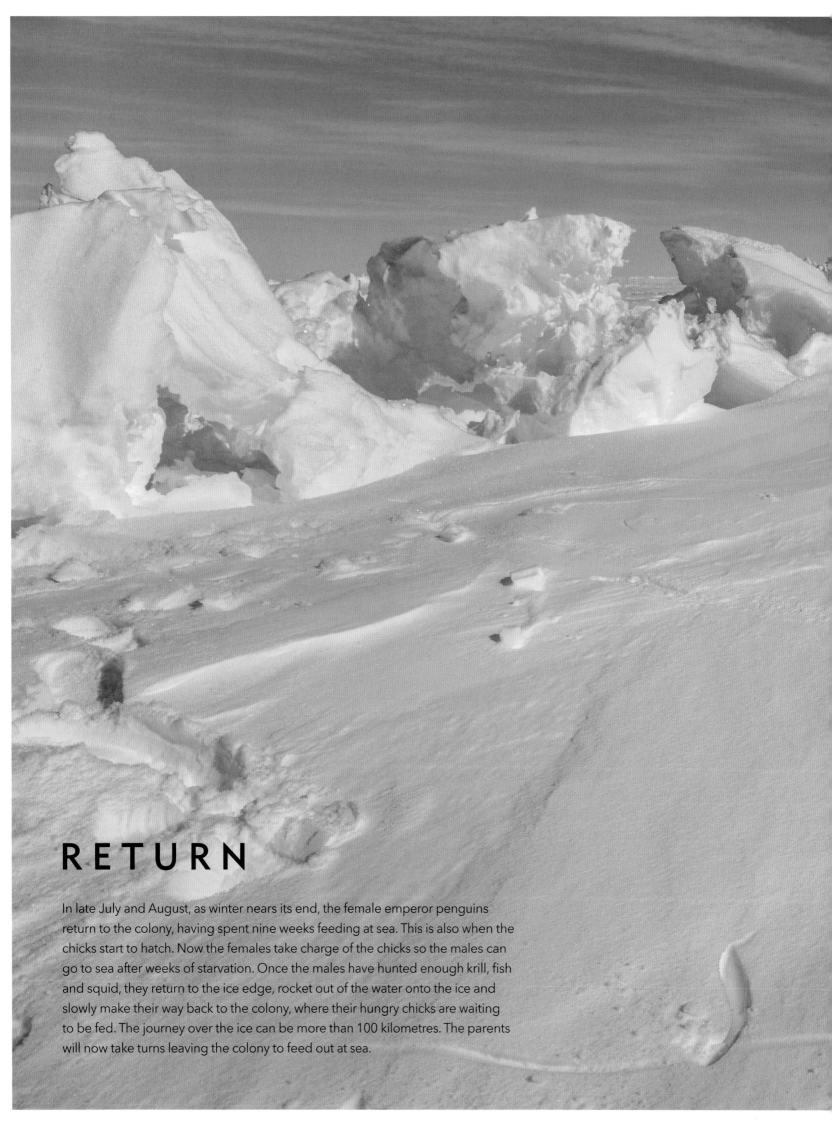

RETURN

In late July and August, as winter nears its end, the female emperor penguins return to the colony, having spent nine weeks feeding at sea. This is also when the chicks start to hatch. Now the females take charge of the chicks so the males can go to sea after weeks of starvation. Once the males have hunted enough krill, fish and squid, they return to the ice edge, rocket out of the water onto the ice and slowly make their way back to the colony, where their hungry chicks are waiting to be fed. The journey over the ice can be more than 100 kilometres. The parents will now take turns leaving the colony to feed out at sea.

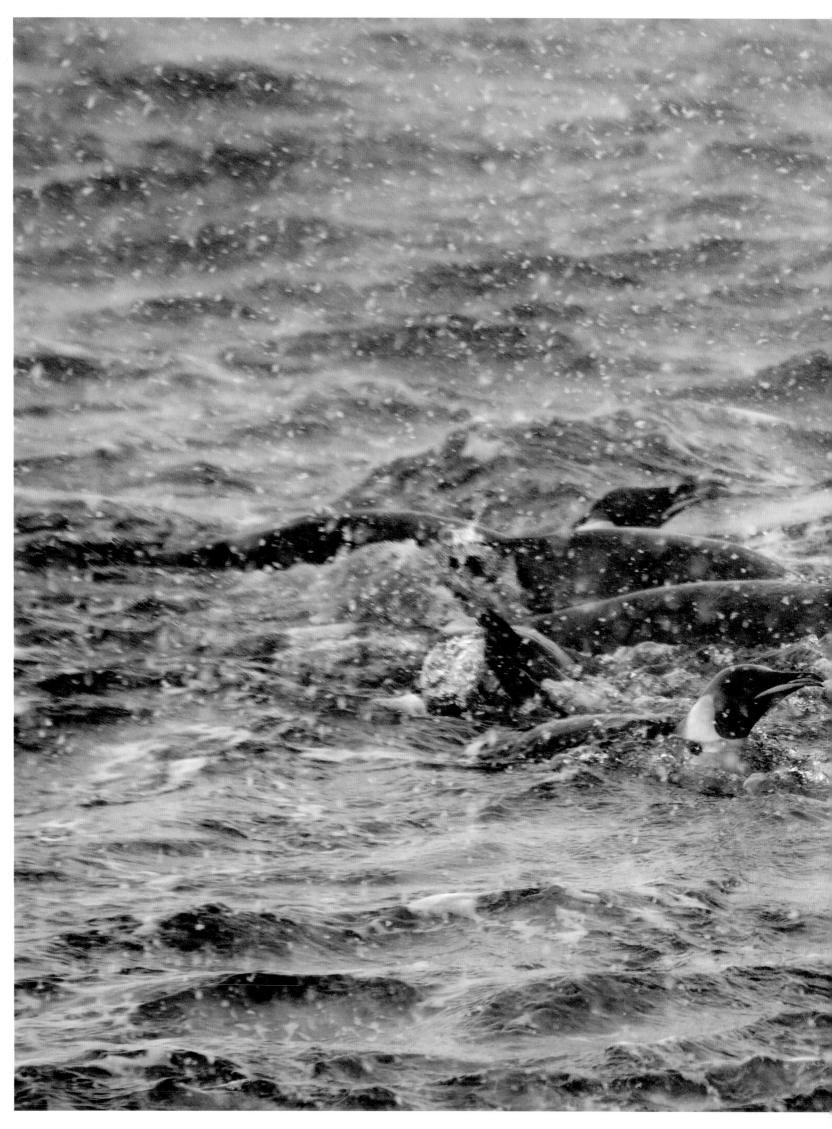

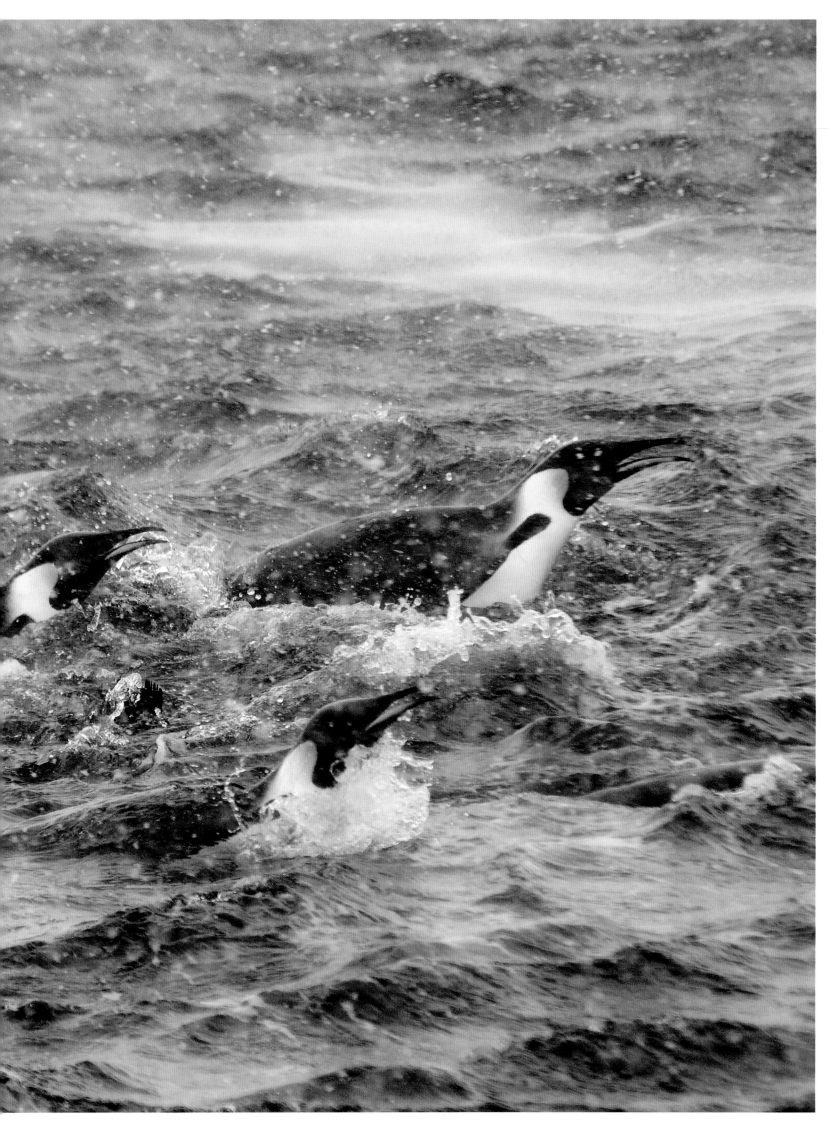

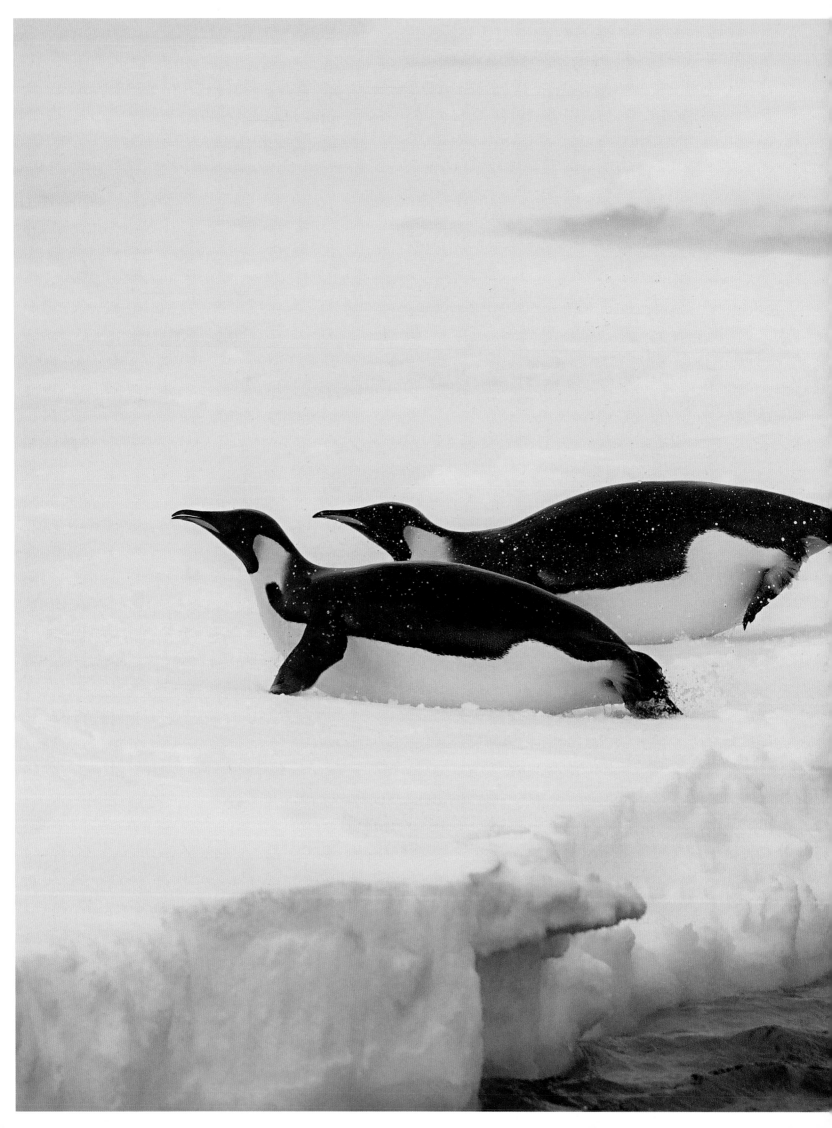

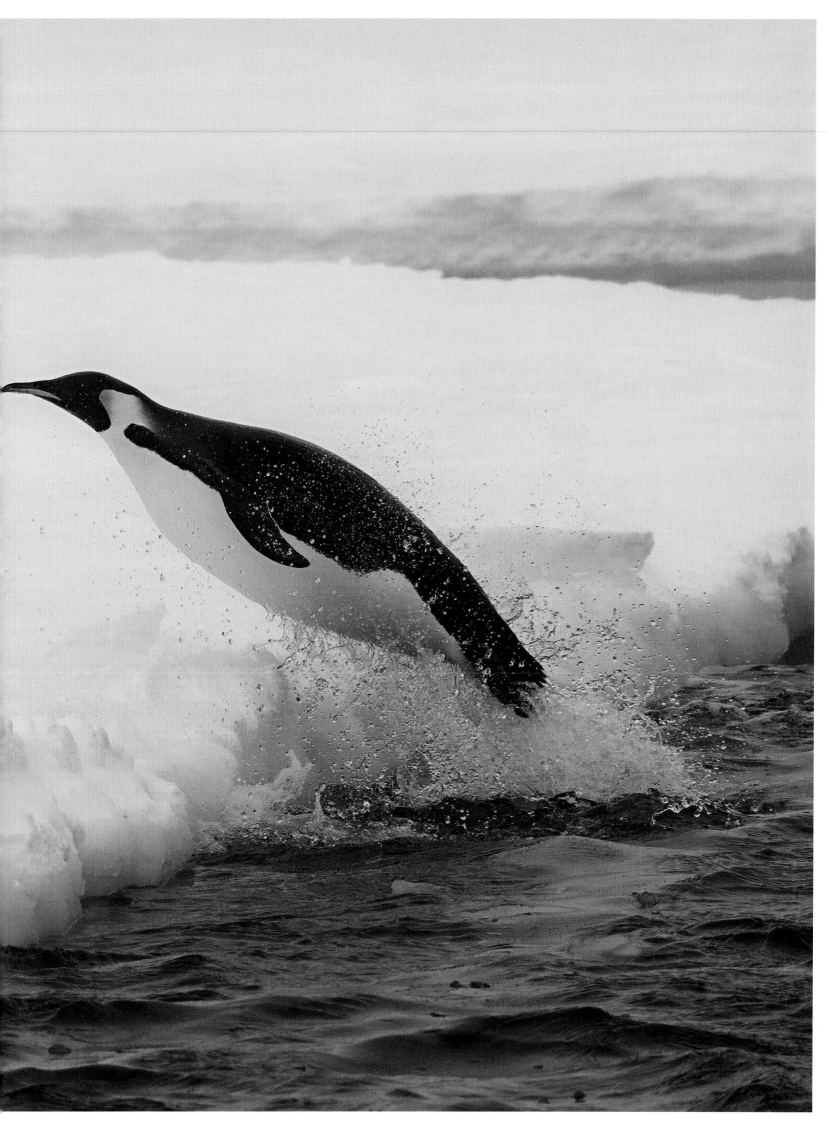

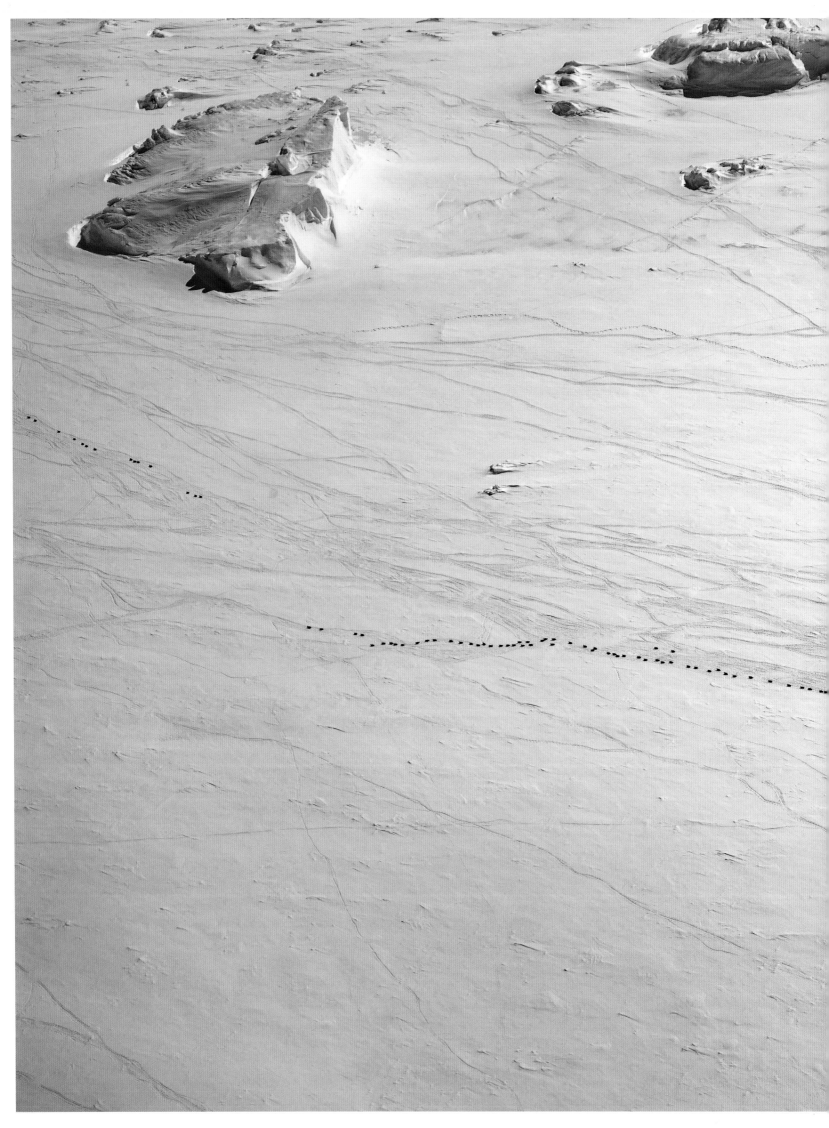

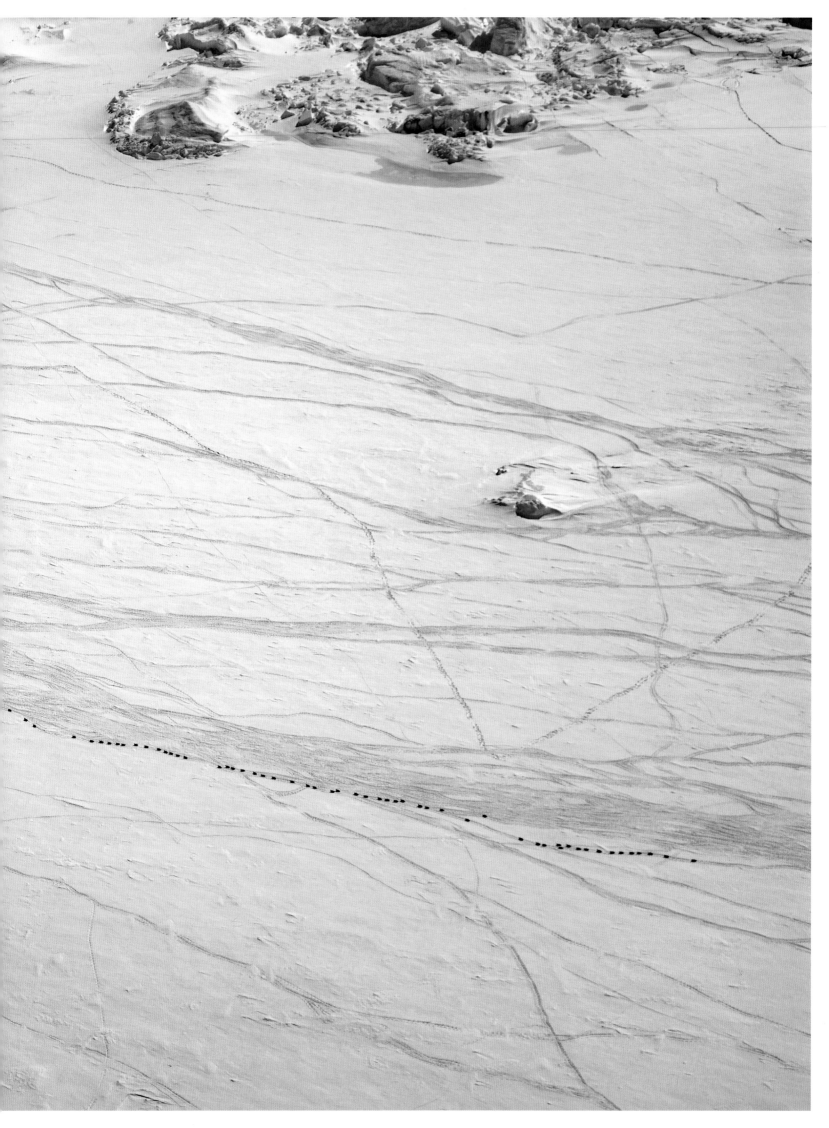

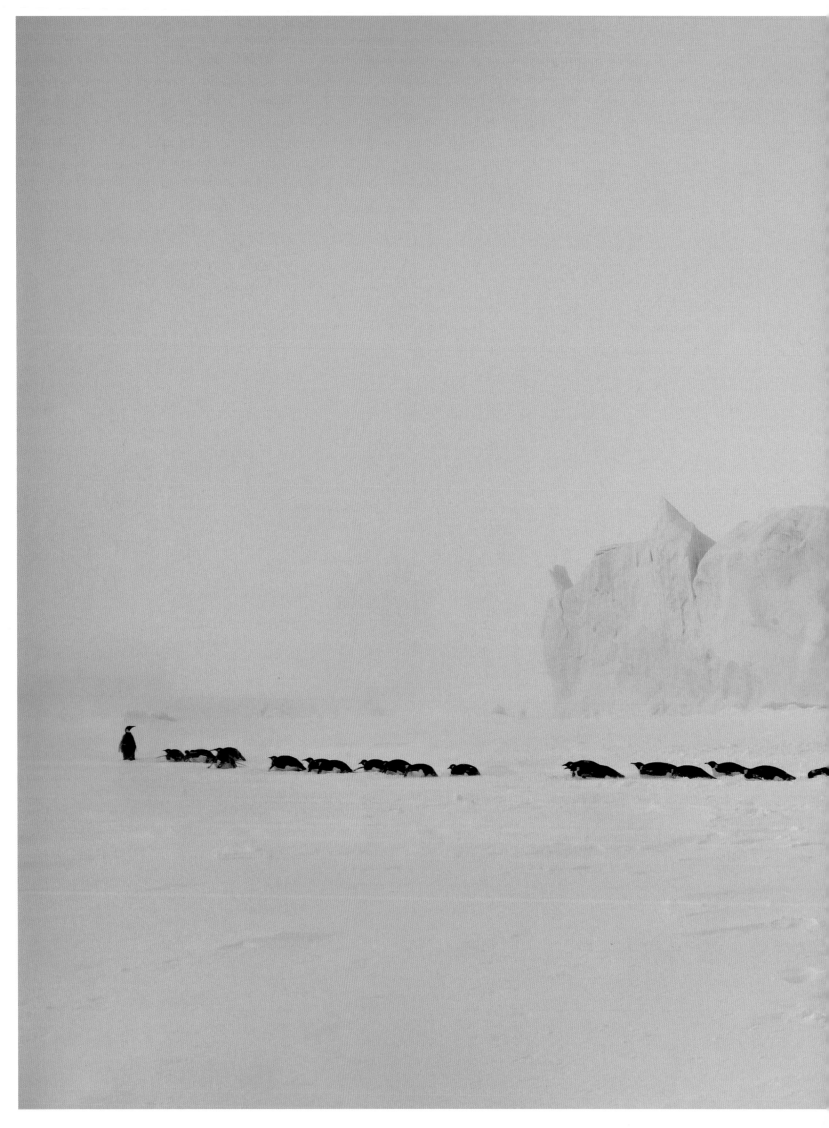

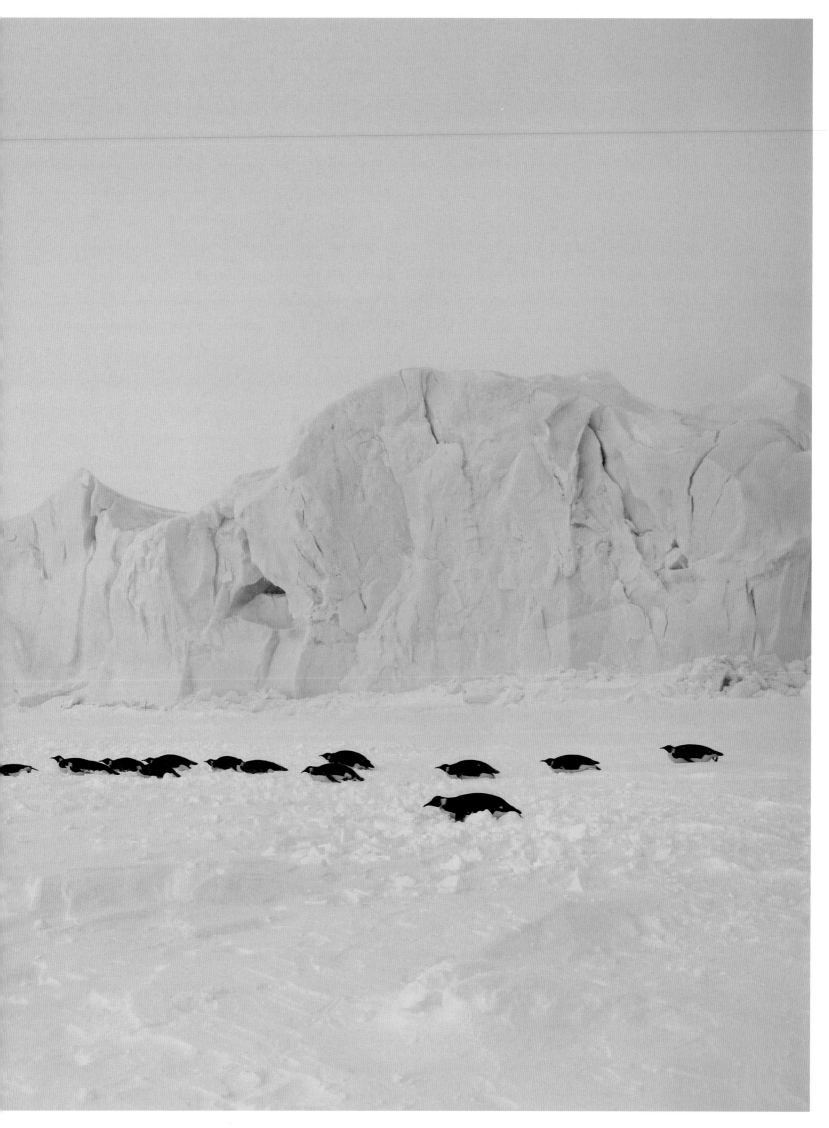

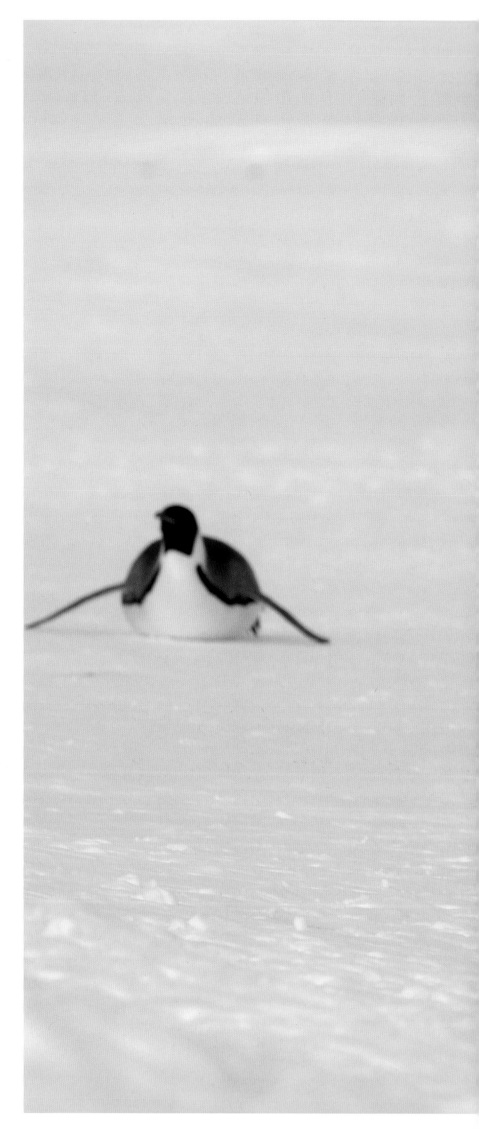

Seen from the air, a procession of emperors looks like a long, dotted line stretched out over the ice like a series of ellipses on a white page. Seen from ice level, their follow-the-leader journey is equally impressive. When the penguins have had enough of walking, they use their wings and claws to propel themselves along on their bellies, leaving striking patterns in their wake.

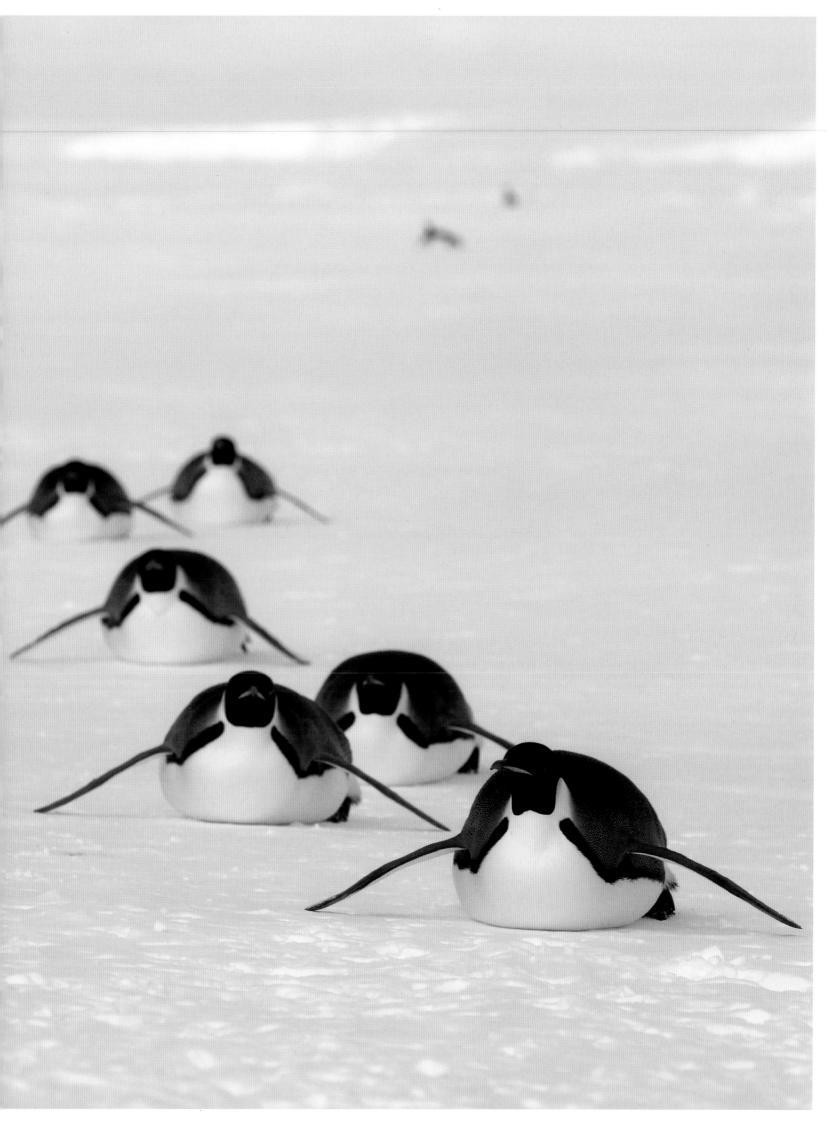

This image of an adult emperor penguin is one of my favourite wildlife shots from the past 30 years. It reminds me of Herbert Ponting's famous shot of the *Terra Nova*, taken through the hole in an iceberg during Scott's expedition in 1911.

I was part of the Quark Expeditions team on board the Russian Icebreaker *Kapitan Khlebnikov* in the Weddell Sea, where we were visiting the Snow Hill Island emperor penguin colony. The expedition leader, Jonas Wikander, pointed out the hole in the iceberg to me, and I knew it would make a fabulous photo if only an emperor penguin would wander by in just the right position. I set up my tripod and waited – and waited.

I had plenty of time to experiment with some test shots, as I wanted to have a decent depth of field with everything in focus, from the stunning blue block of ice to the penguin in the distance. Eventually, I was rewarded as an emperor crossed in the perfect position. Good things come to those who wait!

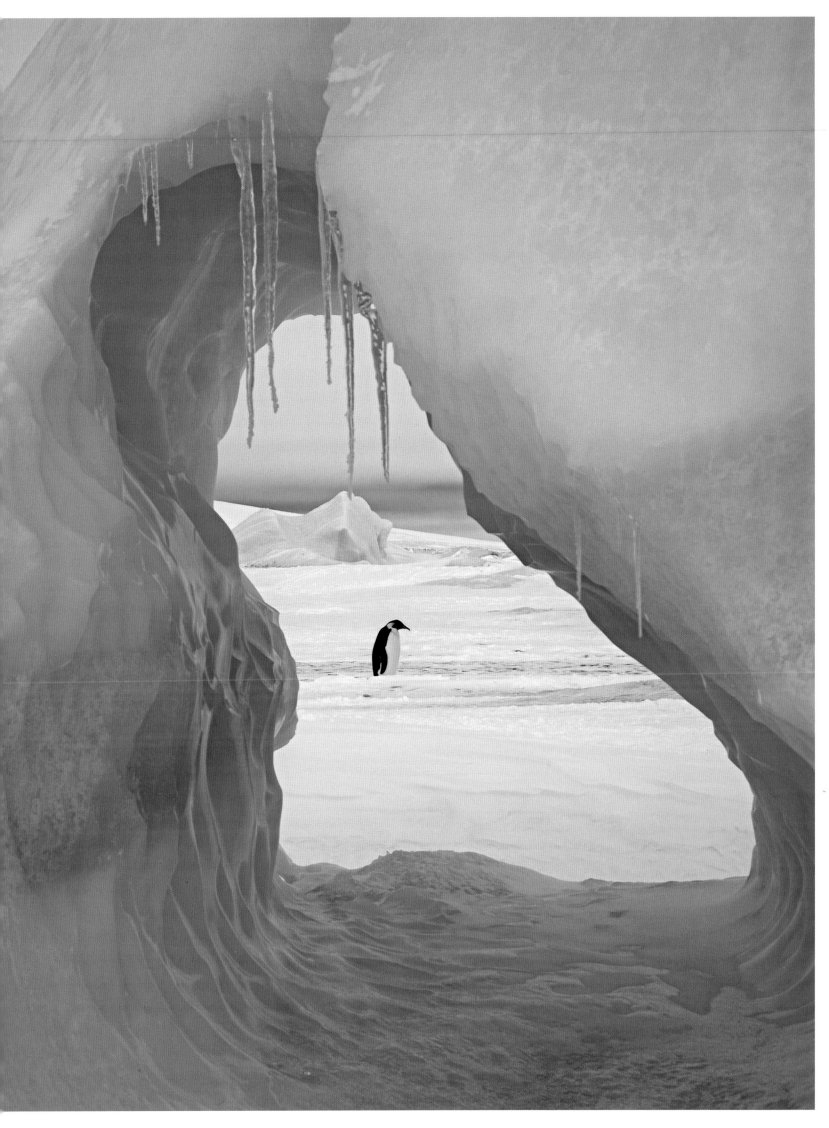

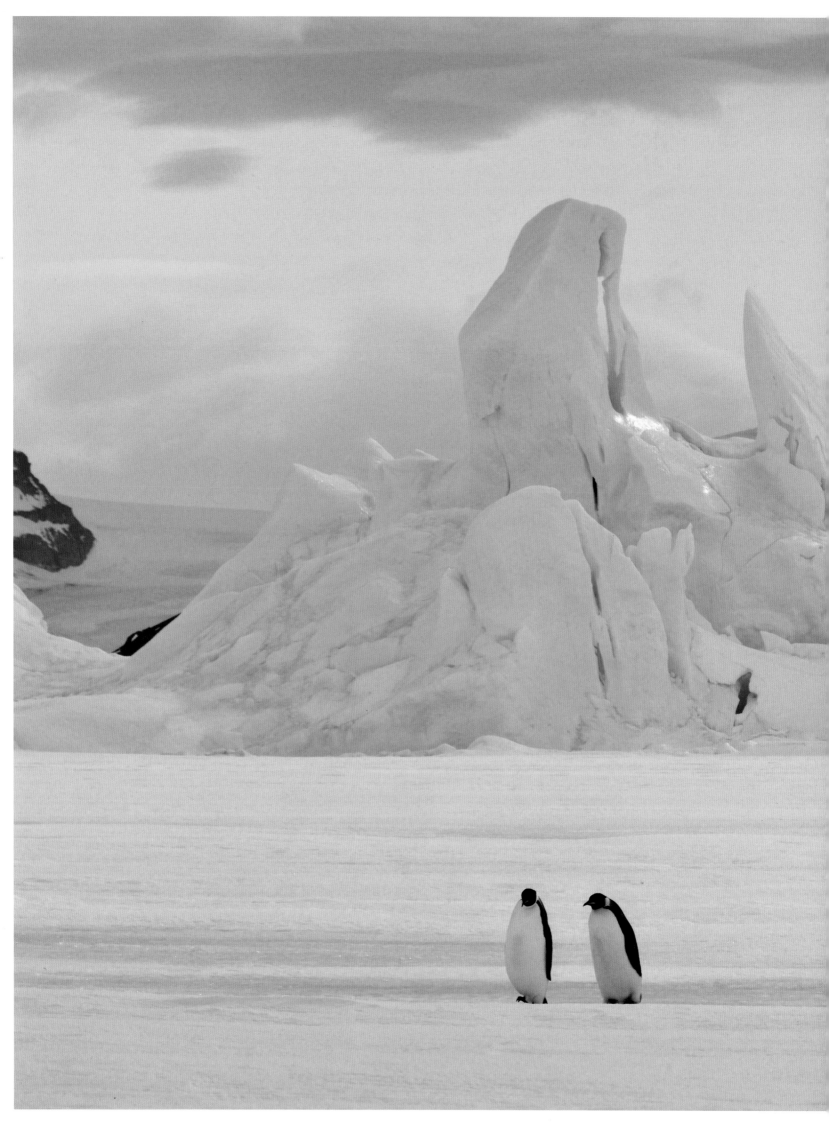

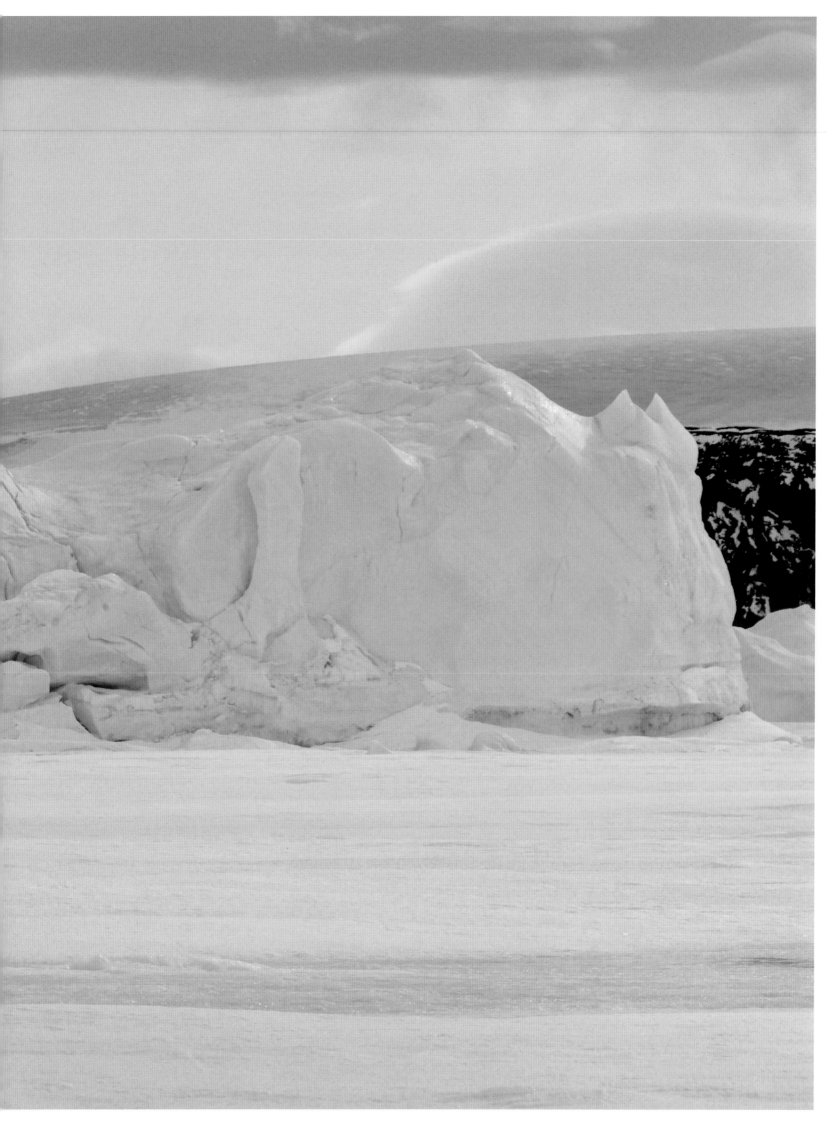

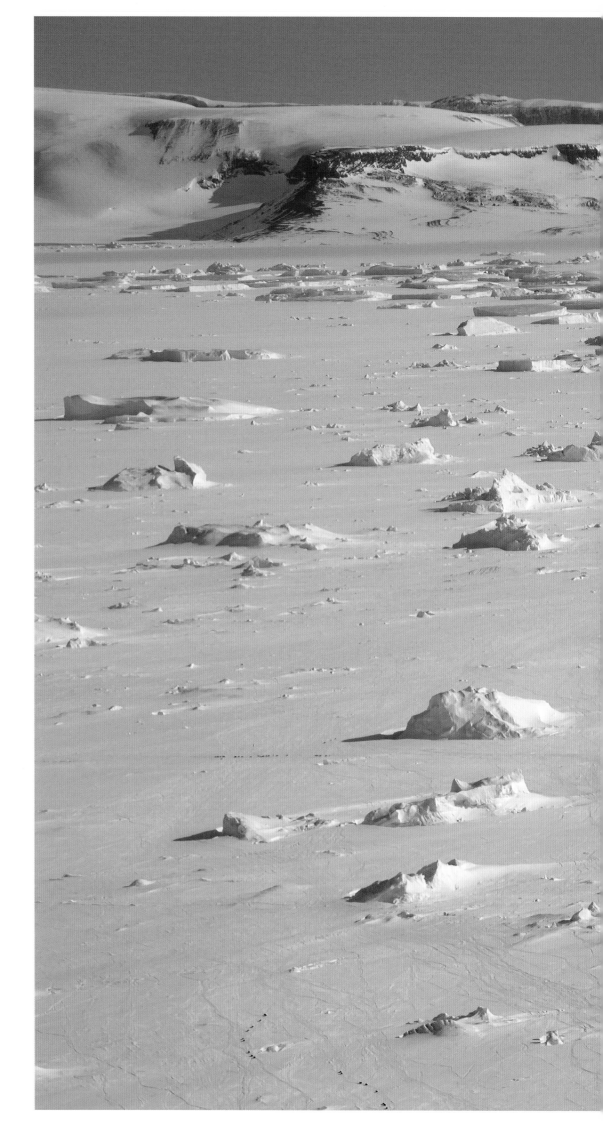

At first glance, when seen from the air, the colony resembles a dirty smudge on the pristine snow. Then you realise that you're looking at thousands of birds living out on the open ice – a seeming impossibility in this harsh environment.

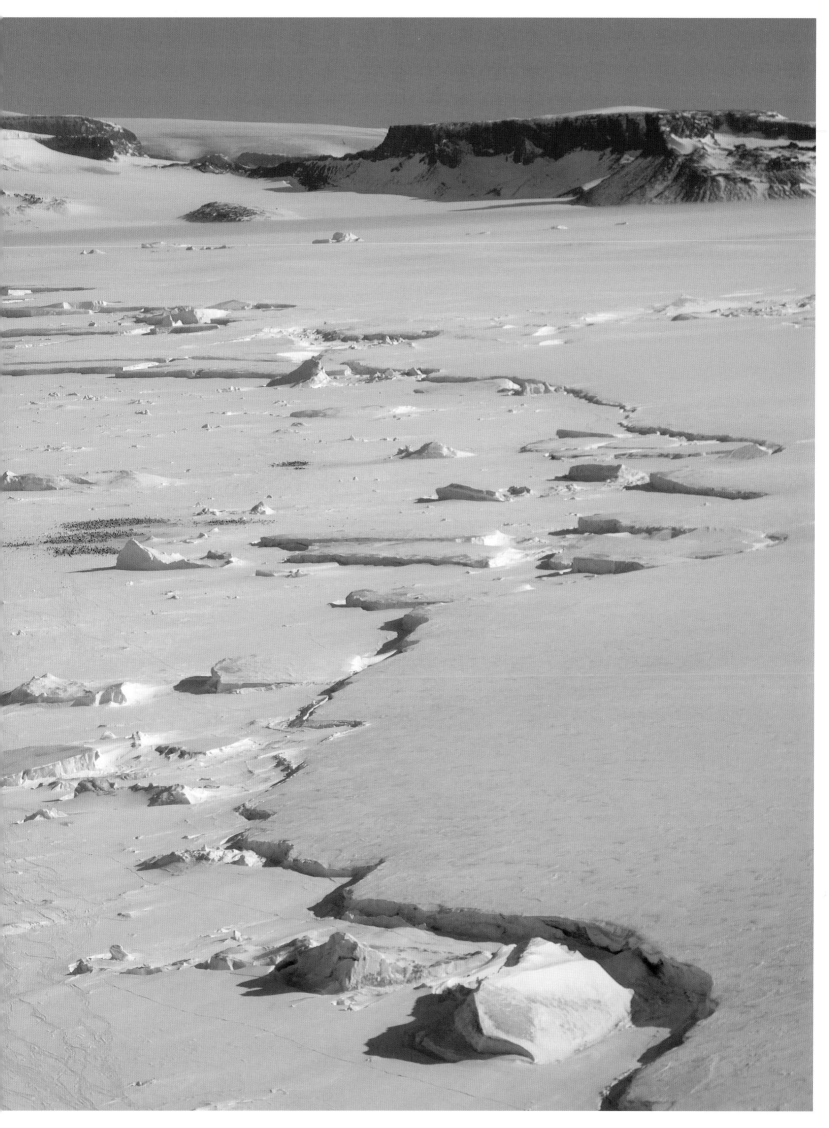

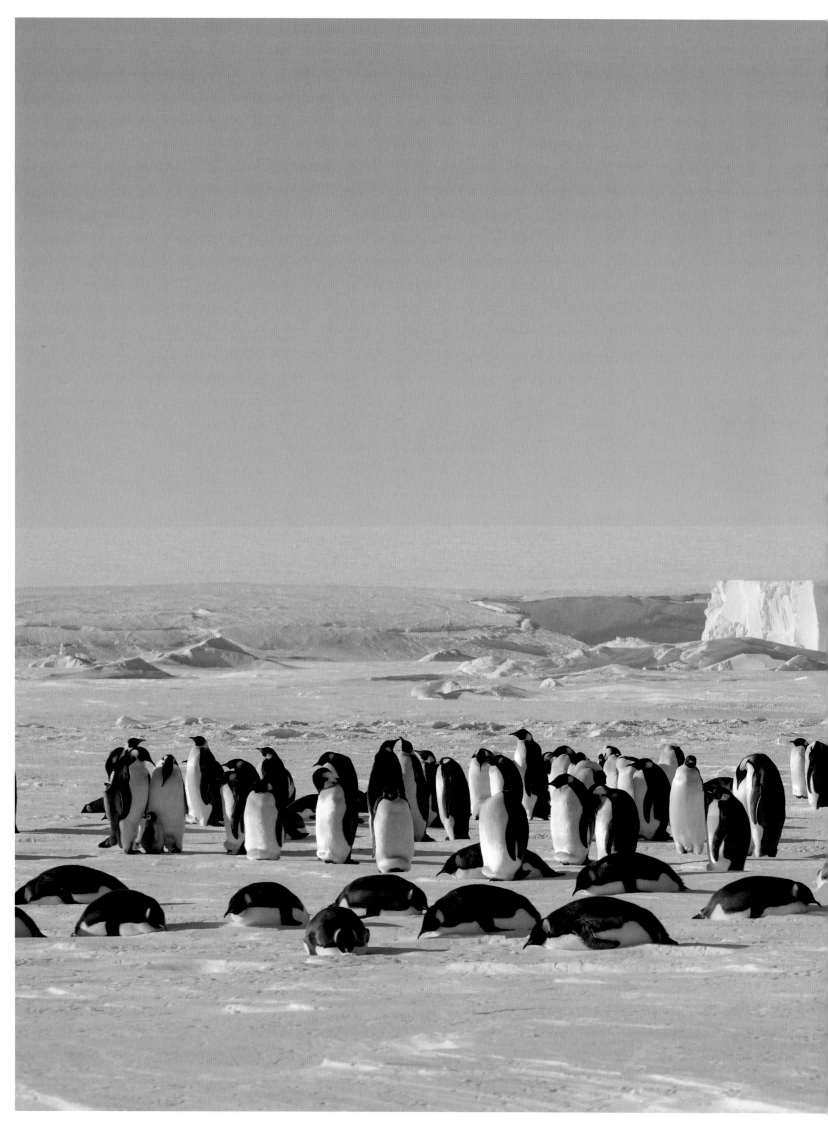

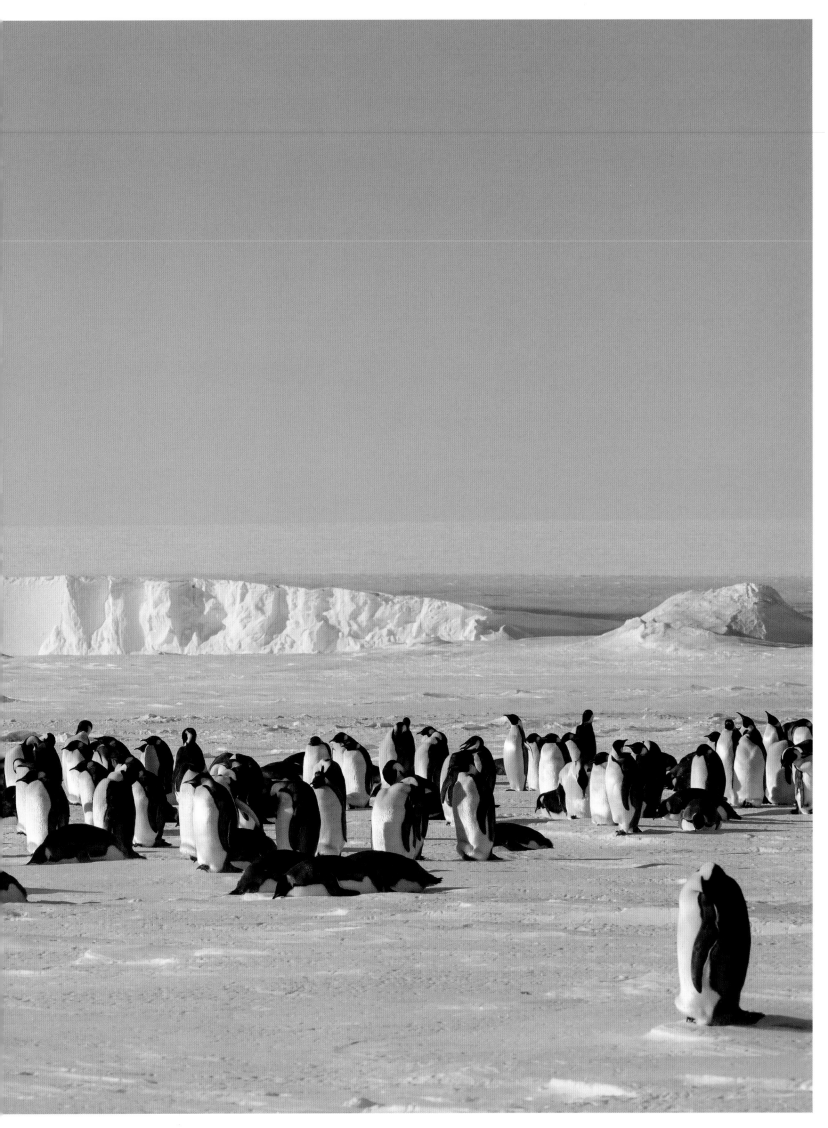

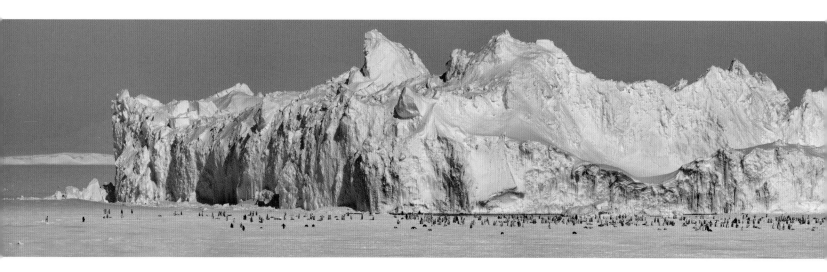

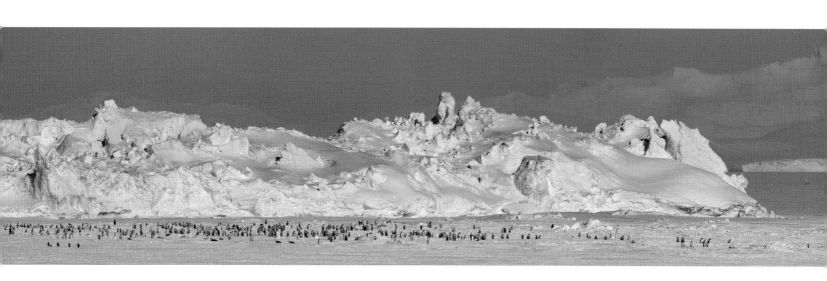

SURVIVAL

Emperor penguins are supremely successful at surviving
in some of the planet's most extreme and inhospitable
conditions. On the sea ice, winter temperatures can drop to
-50°C, and winds can reach more than 150 kilometres an hour.
When you are struggling to keep warm in your expensive,
thick down clothing, you can't but be impressed at how these
extraordinary birds manage to survive with relative ease,
maintaining a body temperature of 38 degrees.

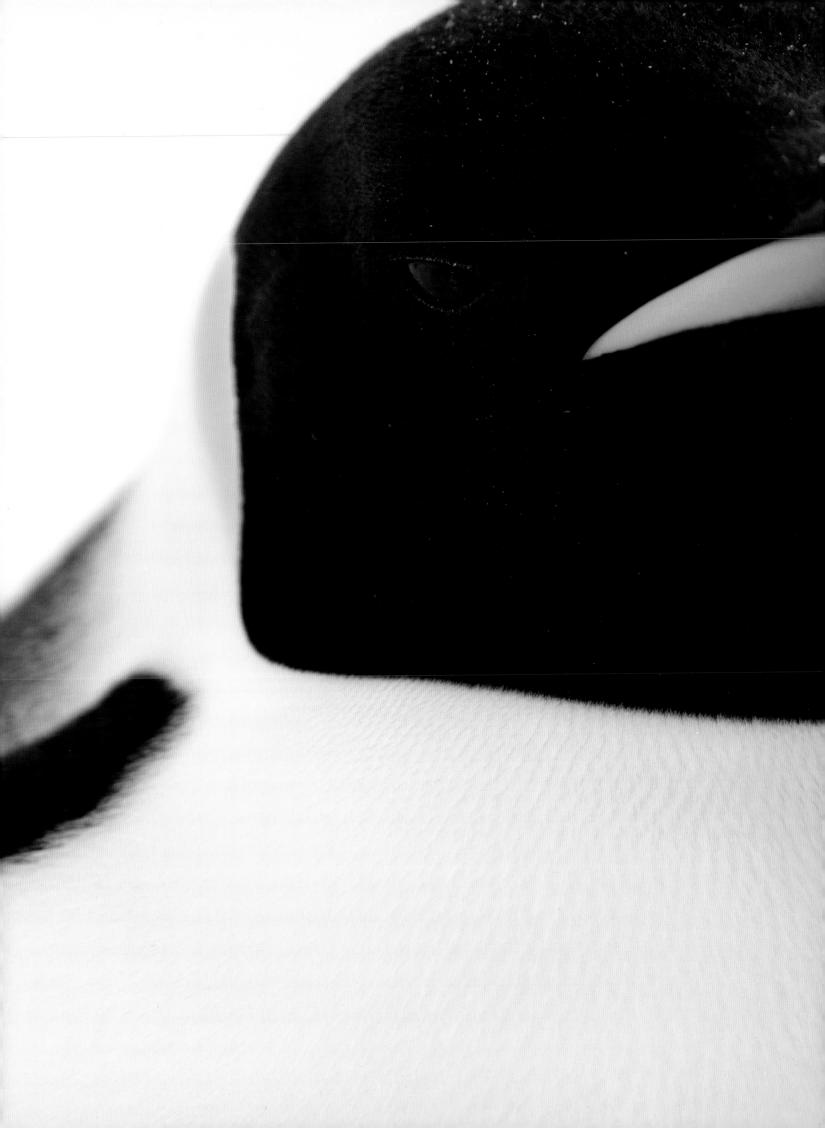

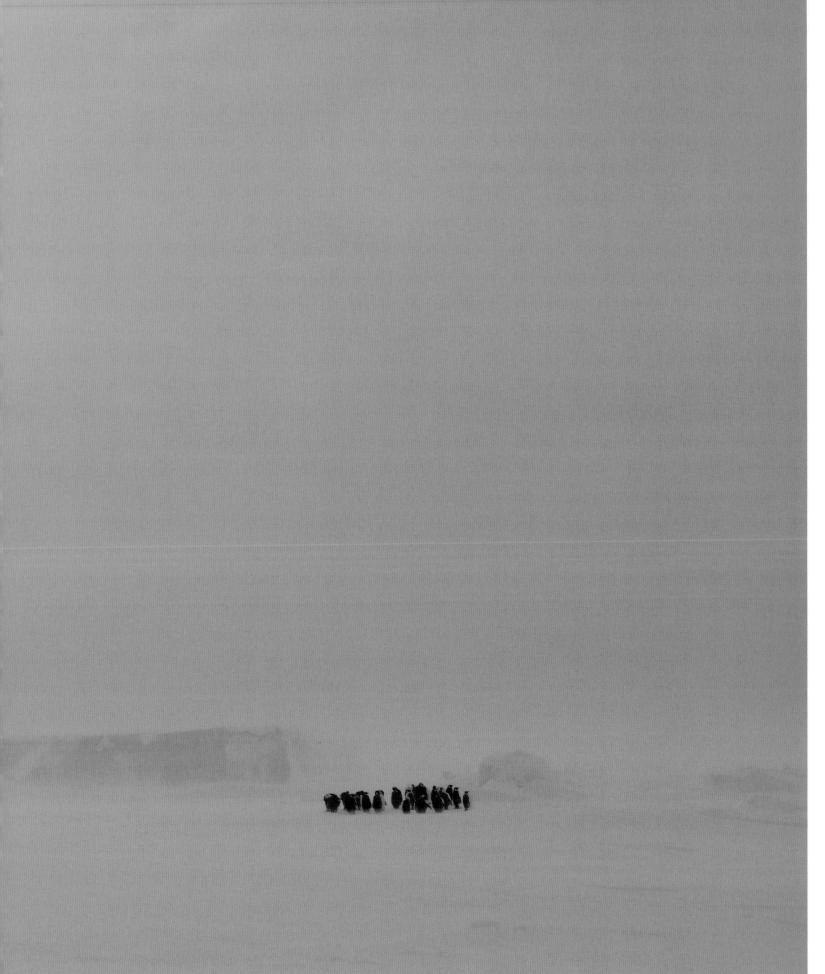

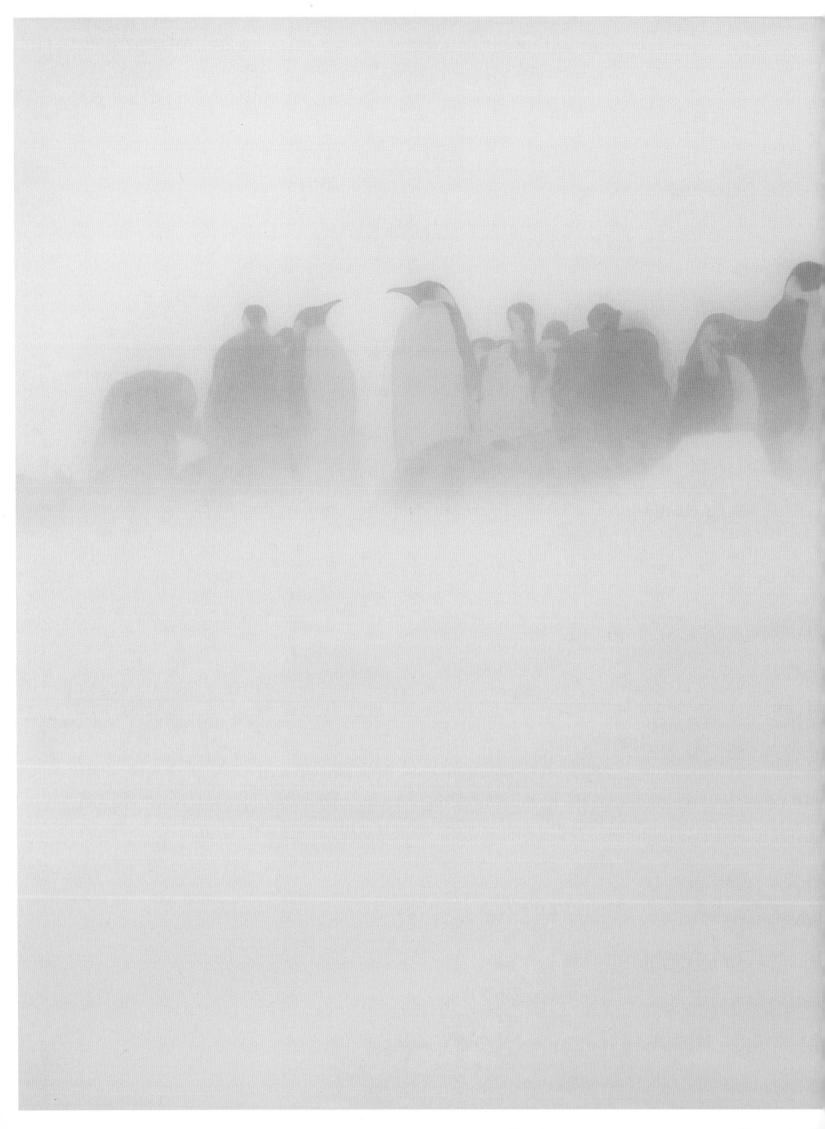

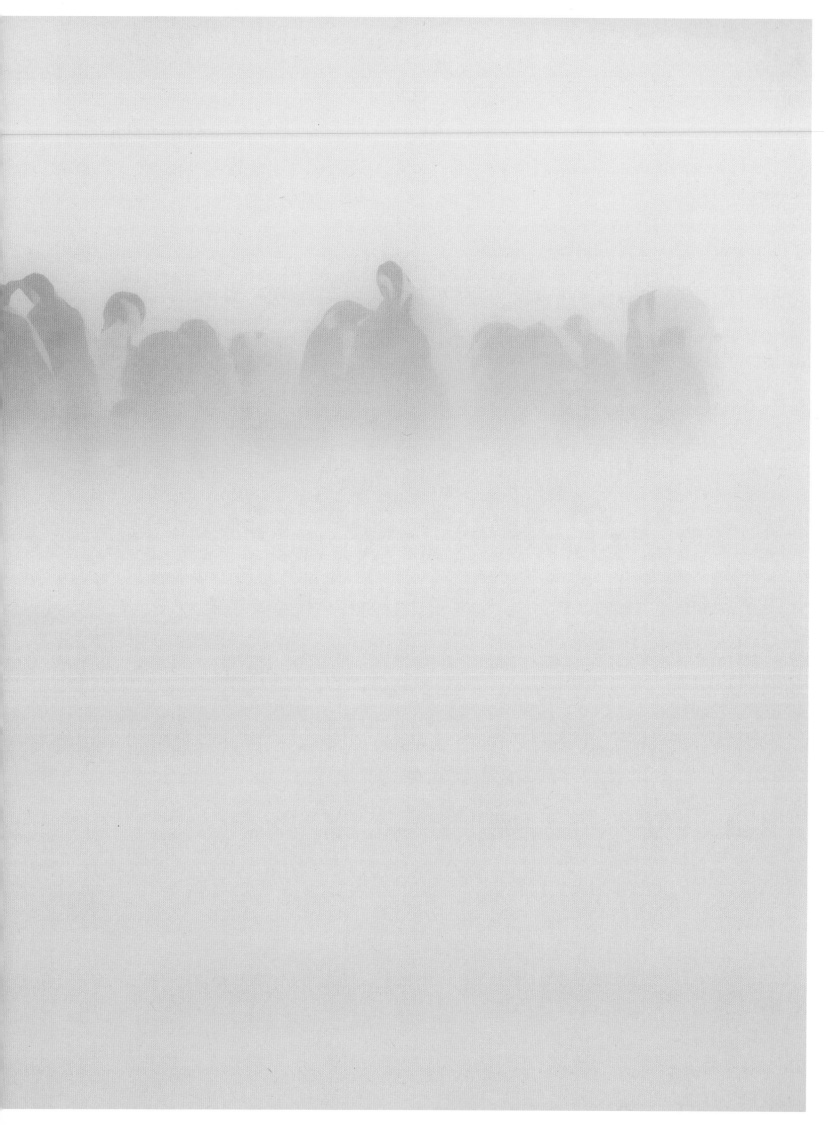

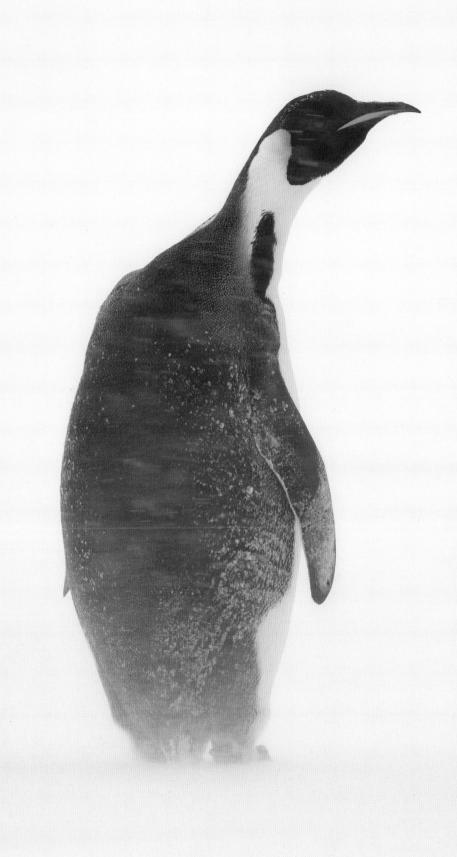

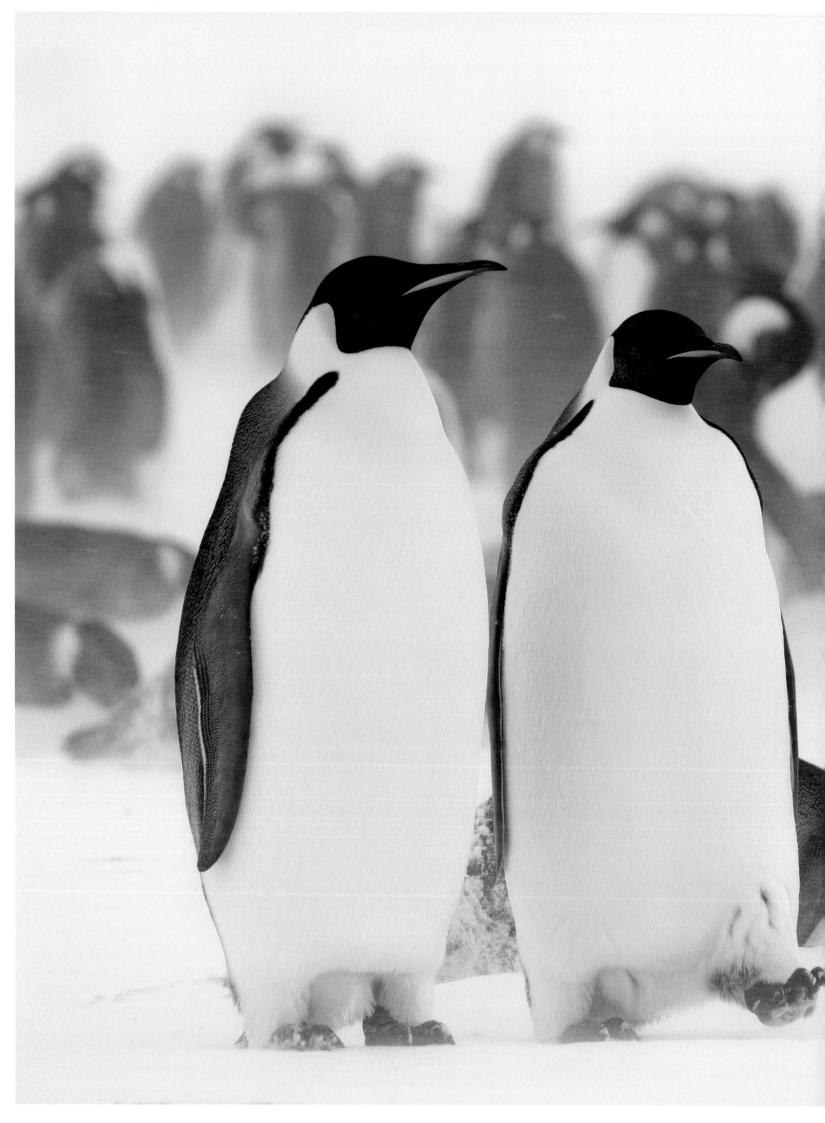

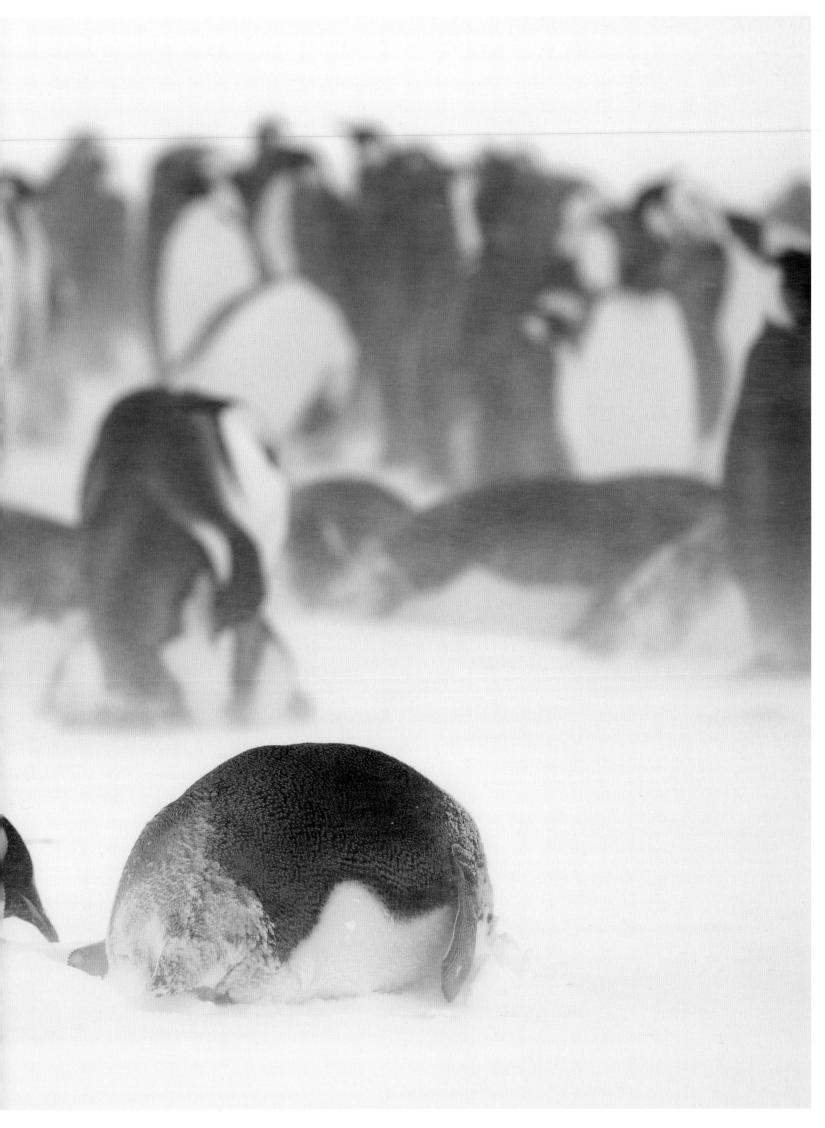

What makes emperors so
successful in this environment?
Their shape is streamlined, with
head, flippers and feet relatively
small in relation to the body.

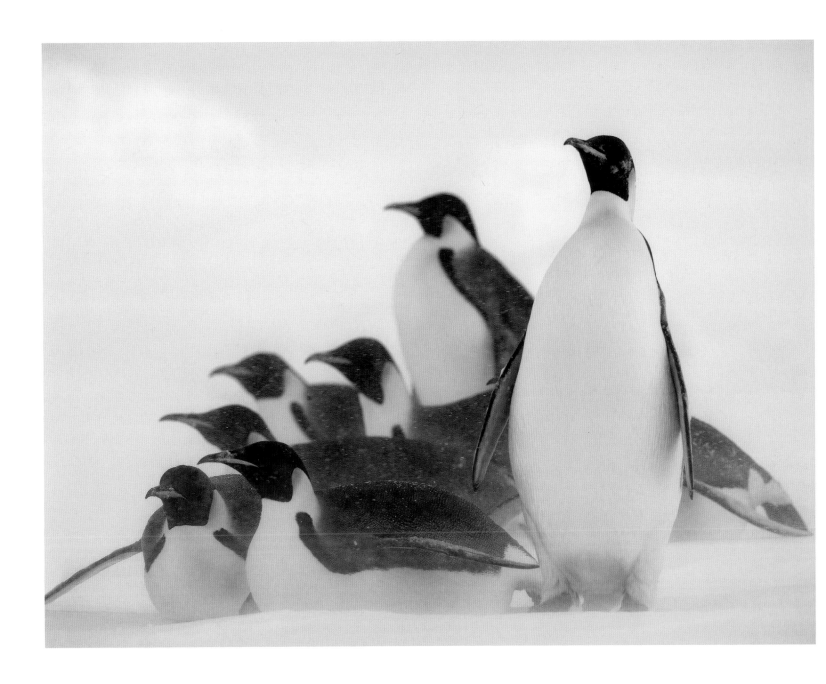

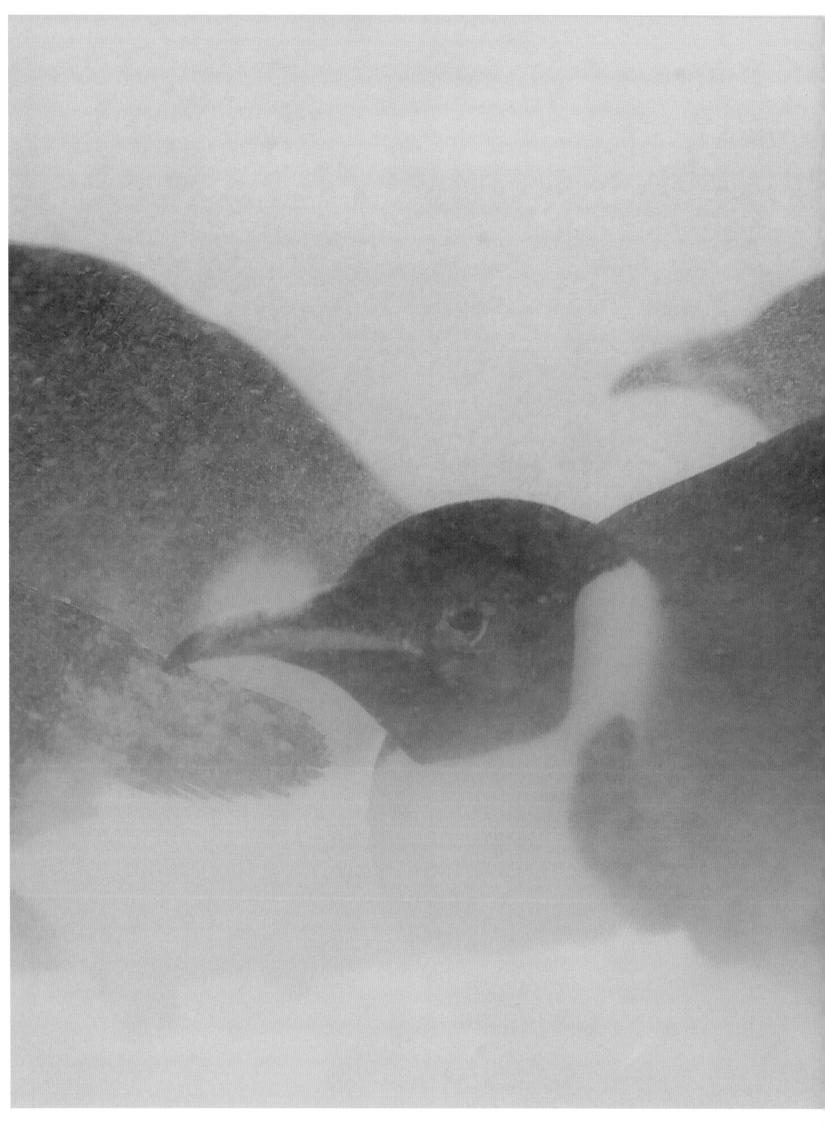

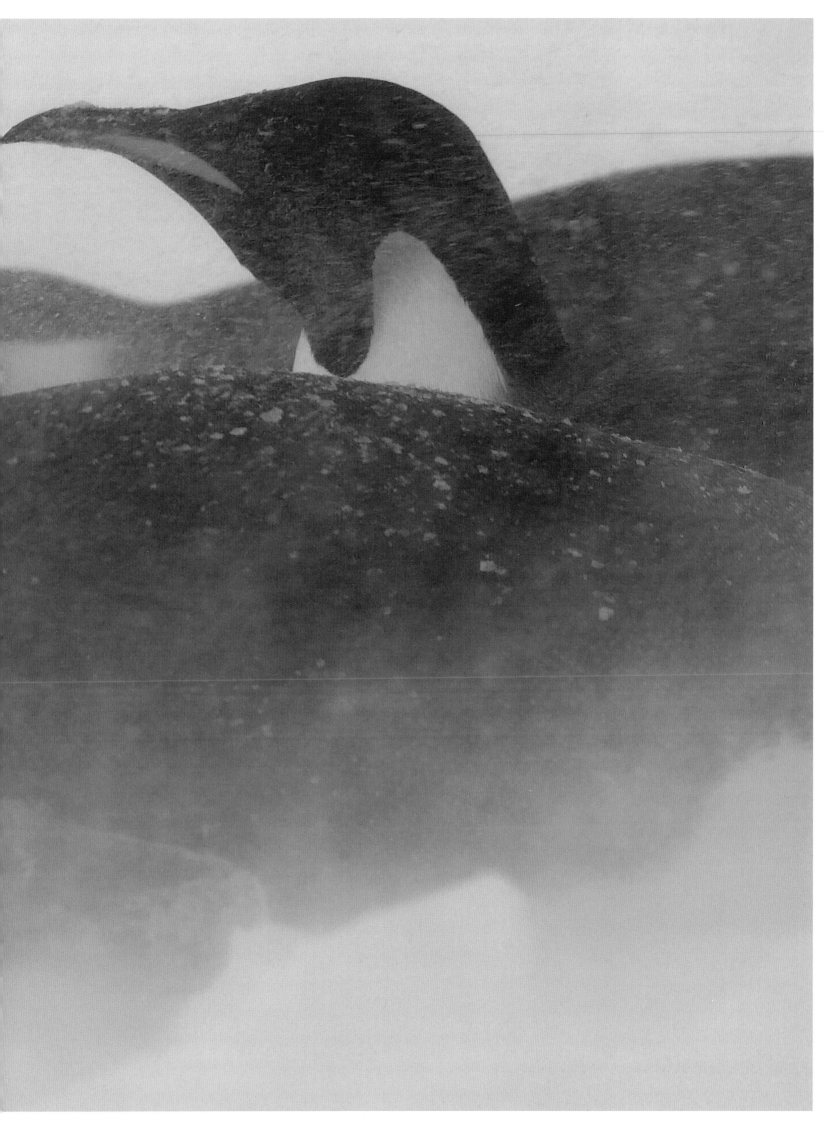

An emperor's feet are strong and sturdy, with large, gripping claws to help propel them across the ice. Blood vessels are arranged so there is a counter-current heat exchange between warm and cold blood, ensuring that their feet don't freeze.

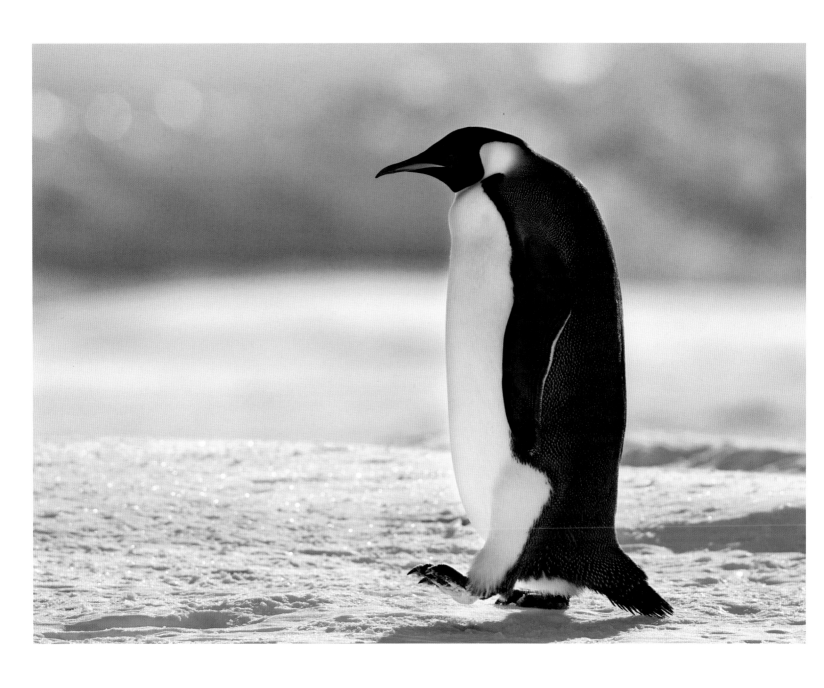

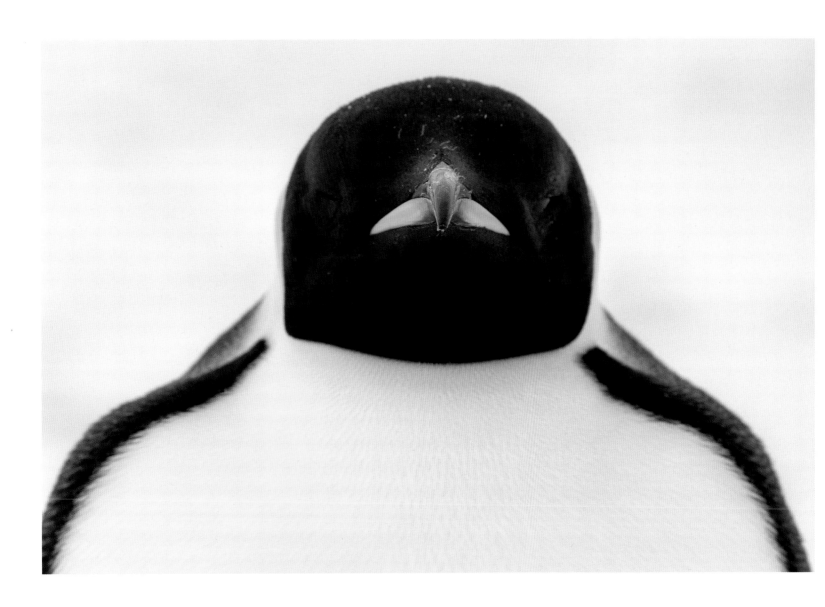

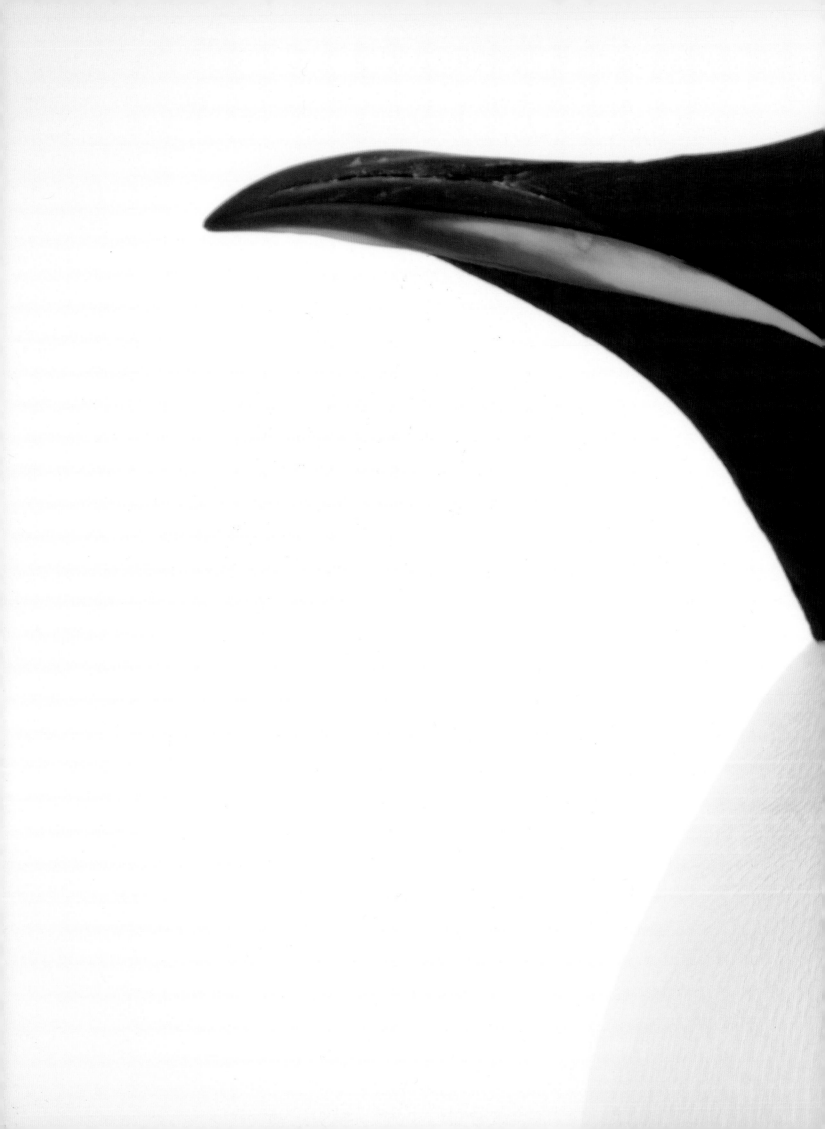

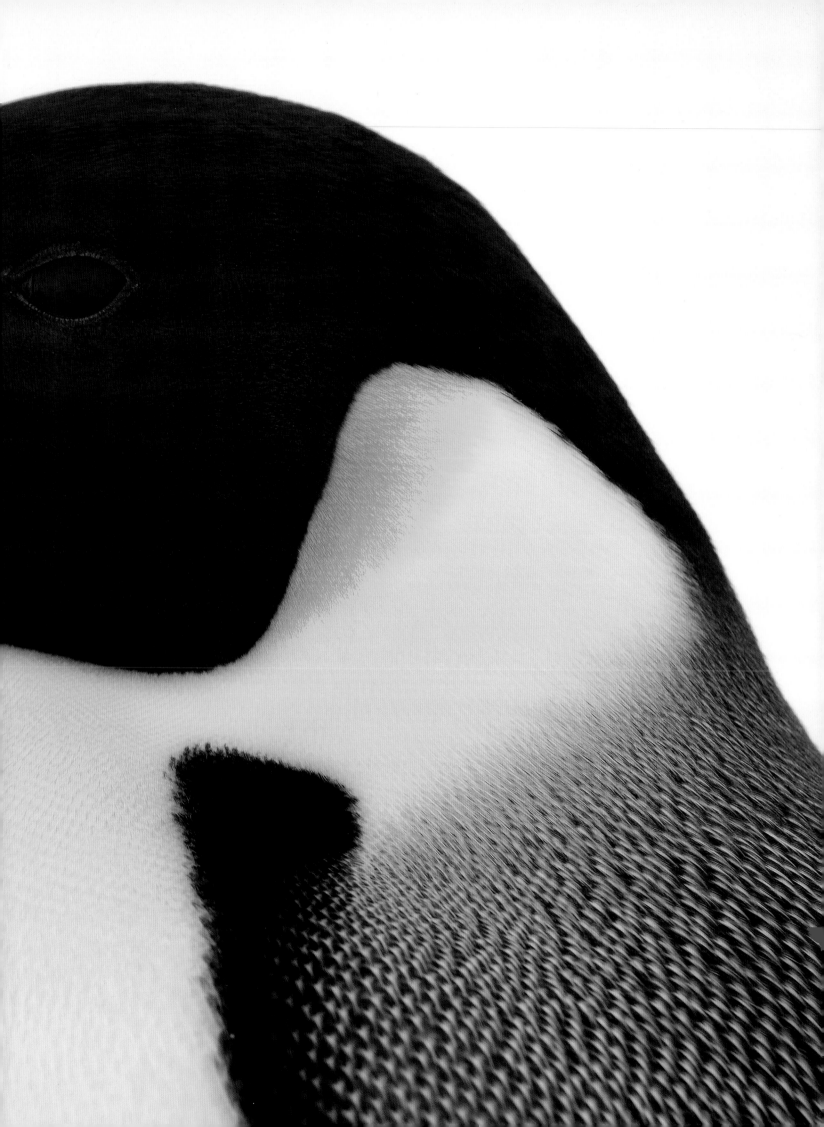

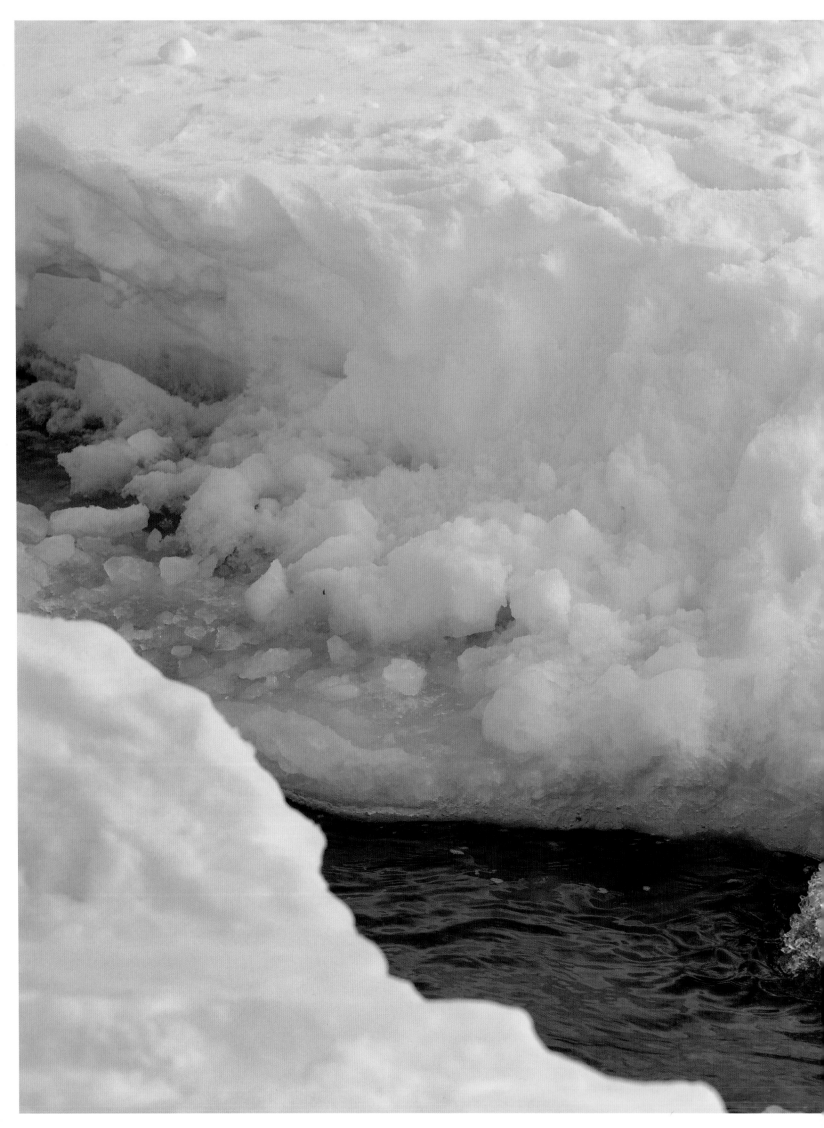

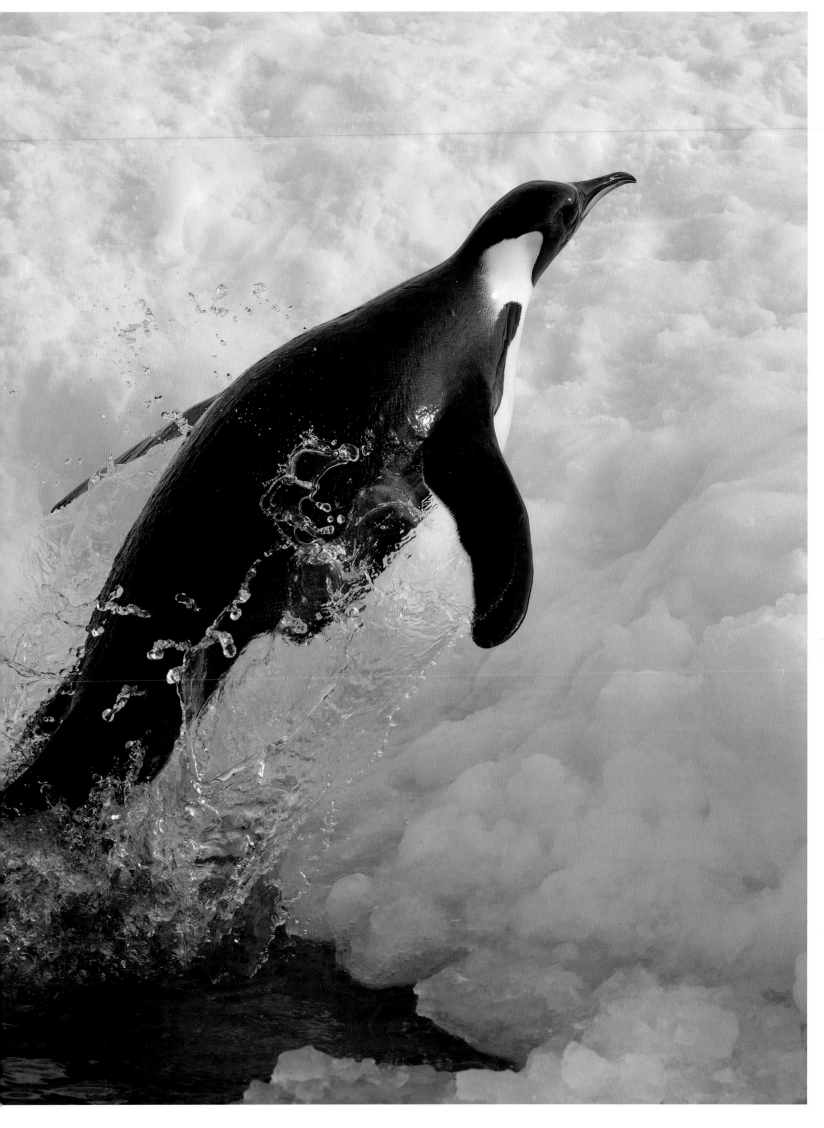

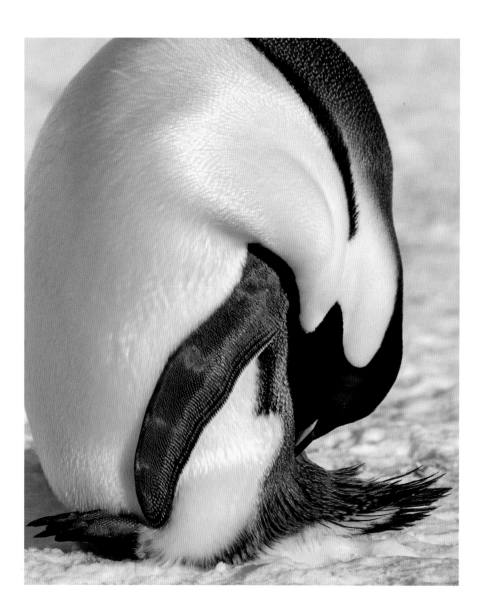

The birds are insulated by several dense layers of scale-like feathers, which they keep waterproofed and windproofed with frequent preening, using oil from a gland at the base of their tail. Indeed, they're so well insulated by this jacket and their layer of blubber that, on a 'warm' day, you will see them lying on their stomachs and eating snow to cool down.

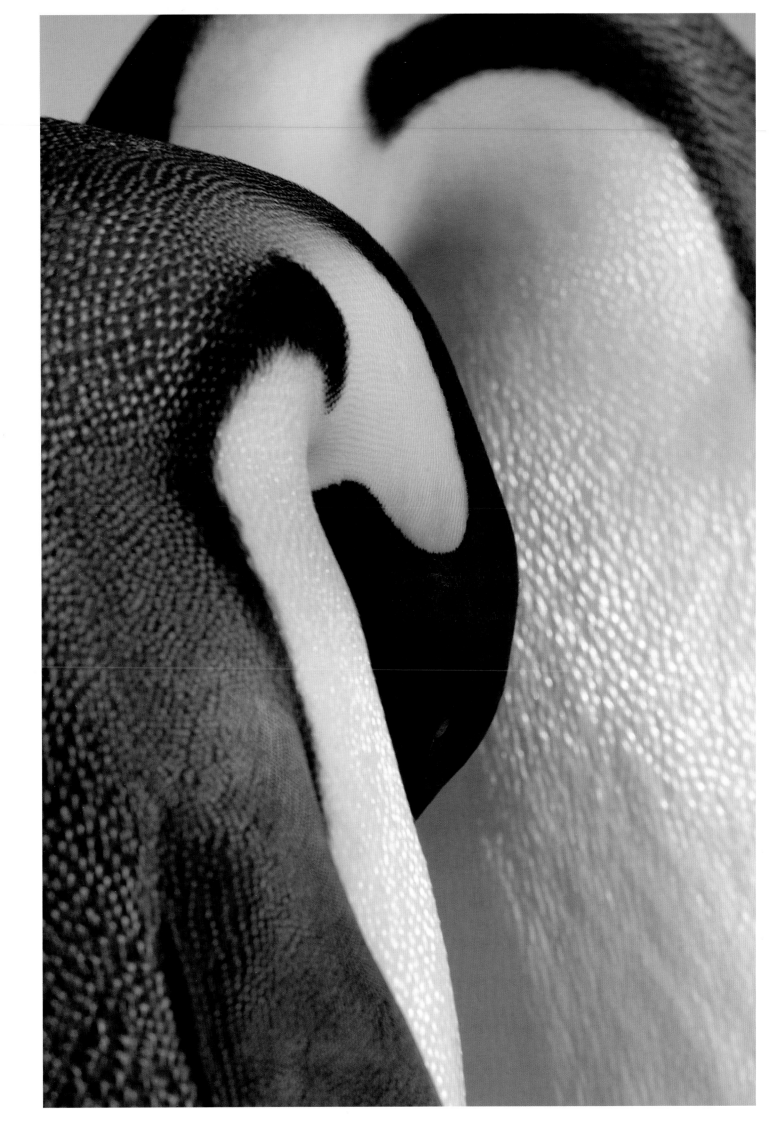

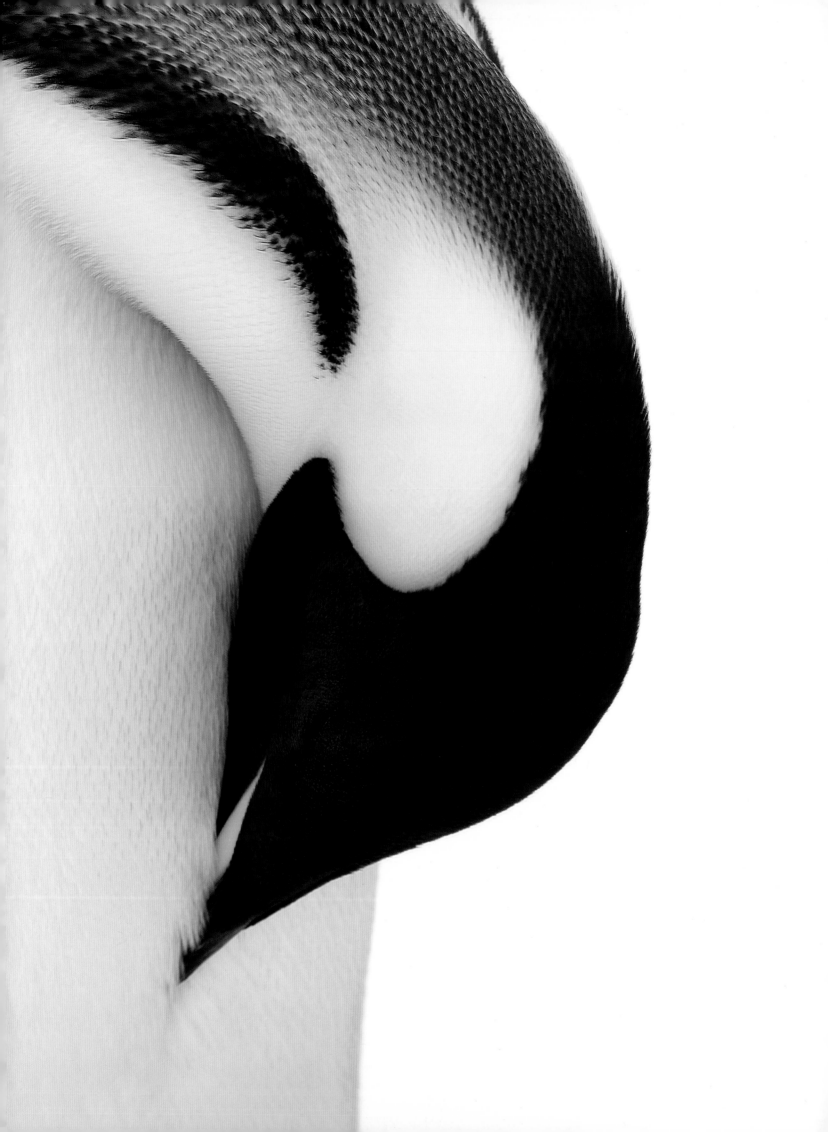

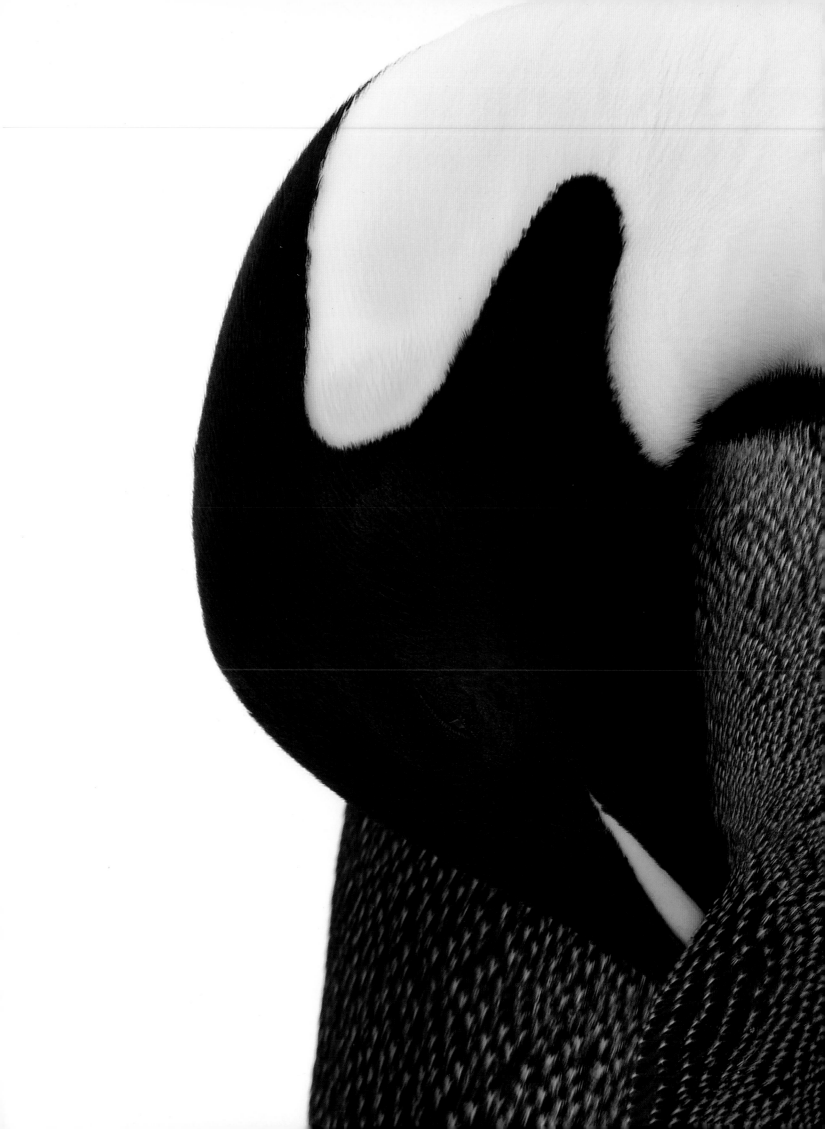

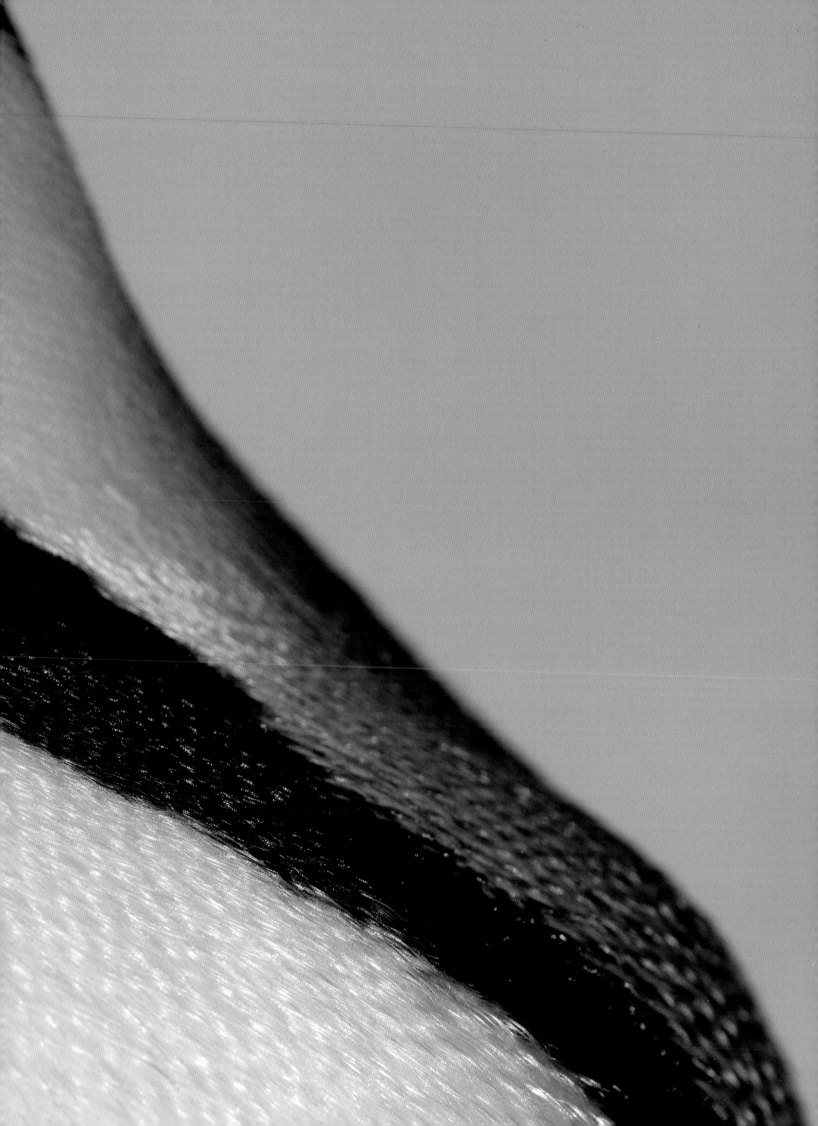

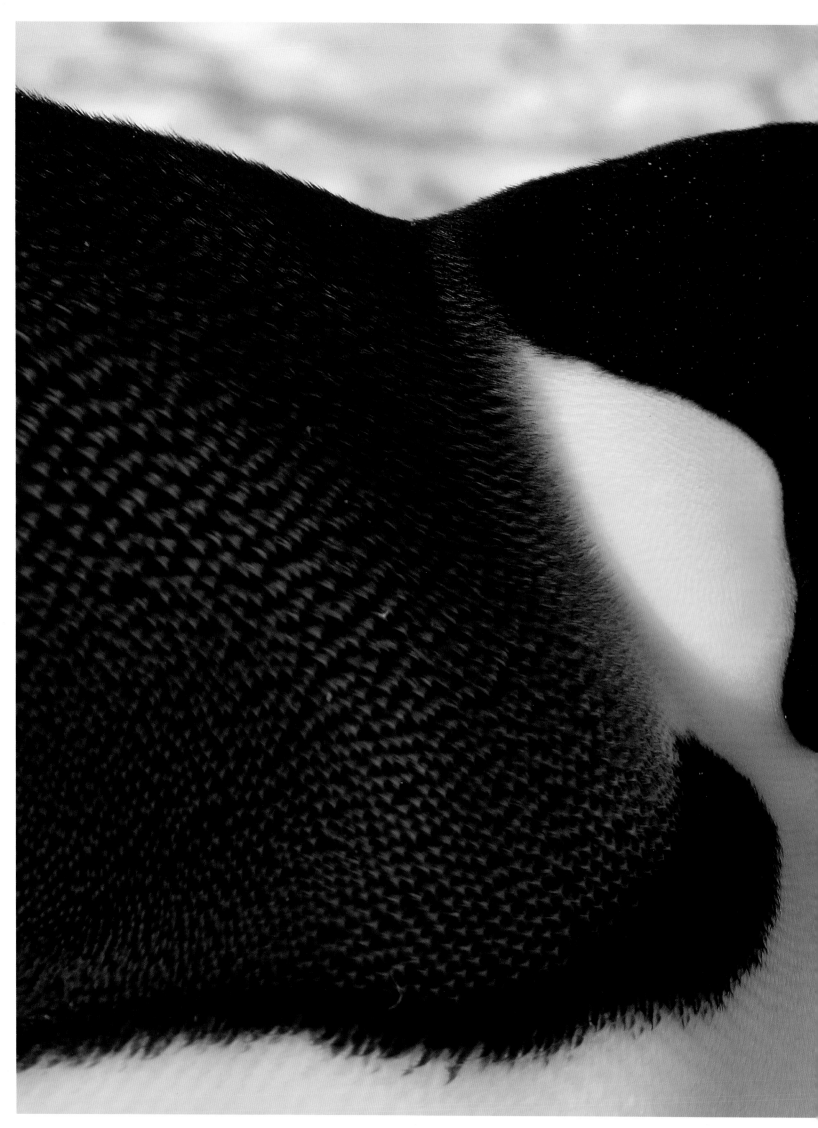

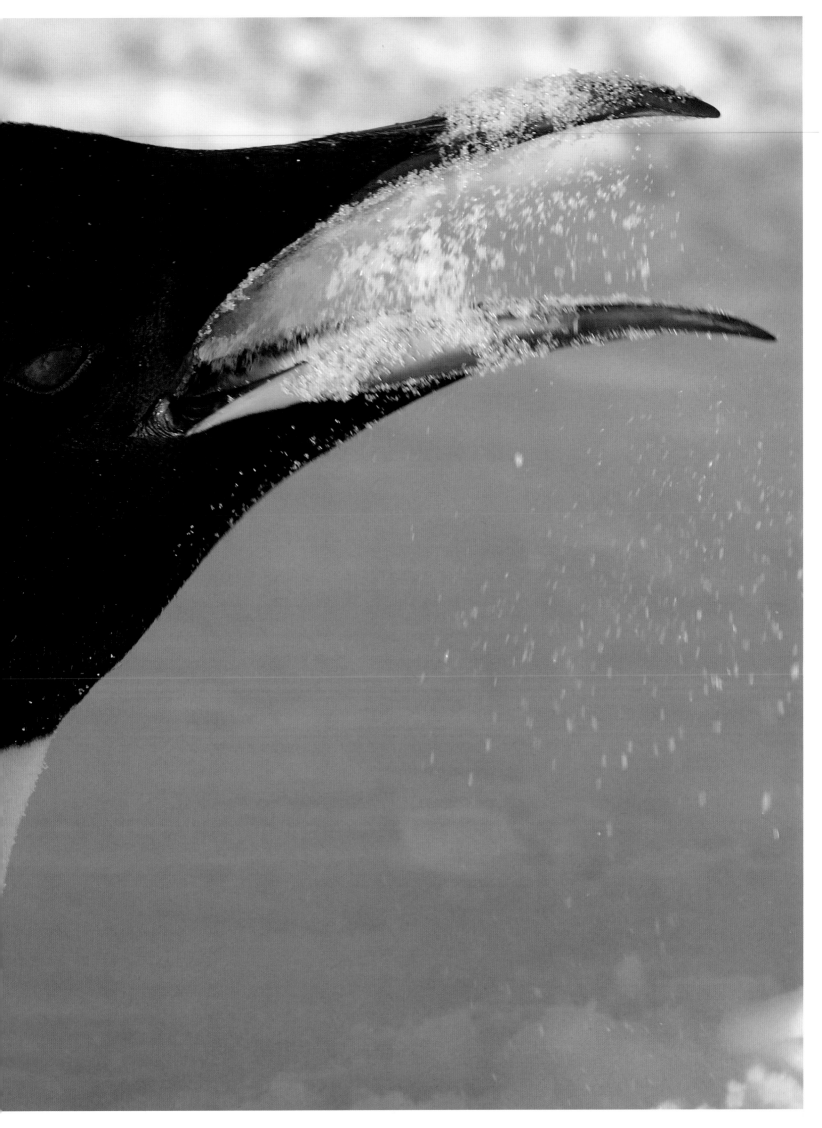

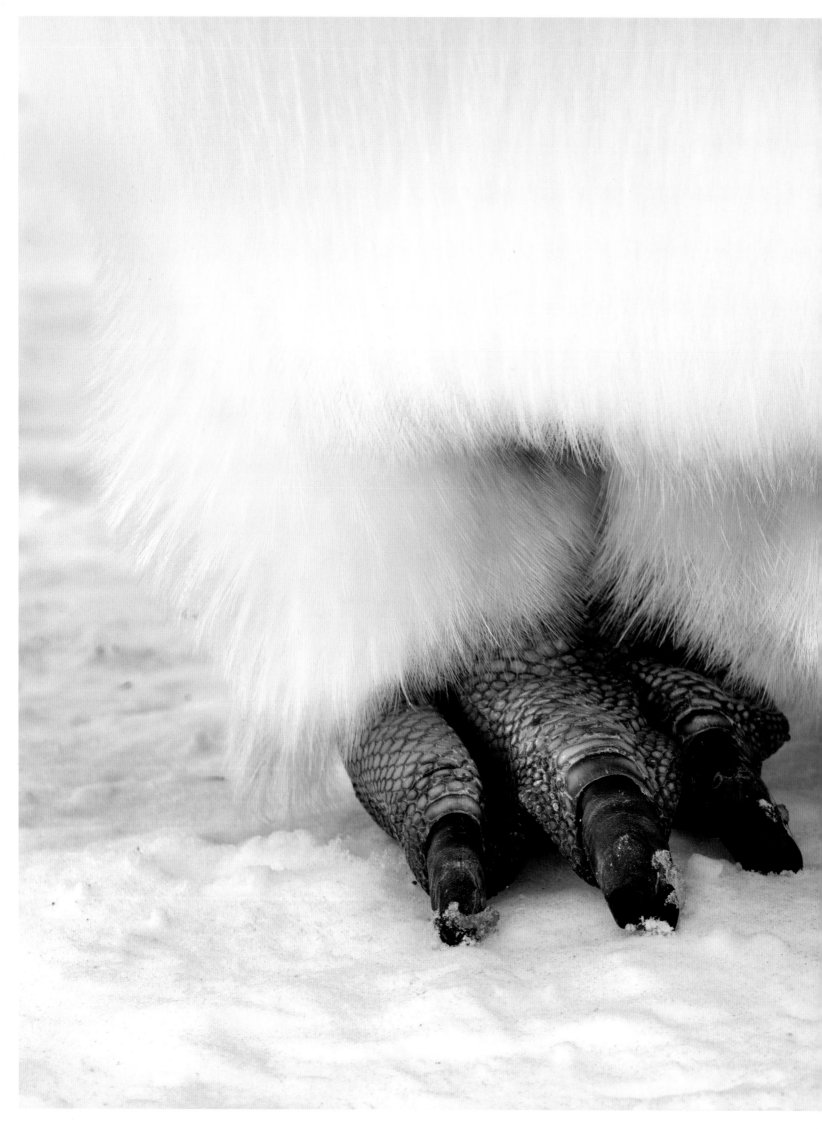

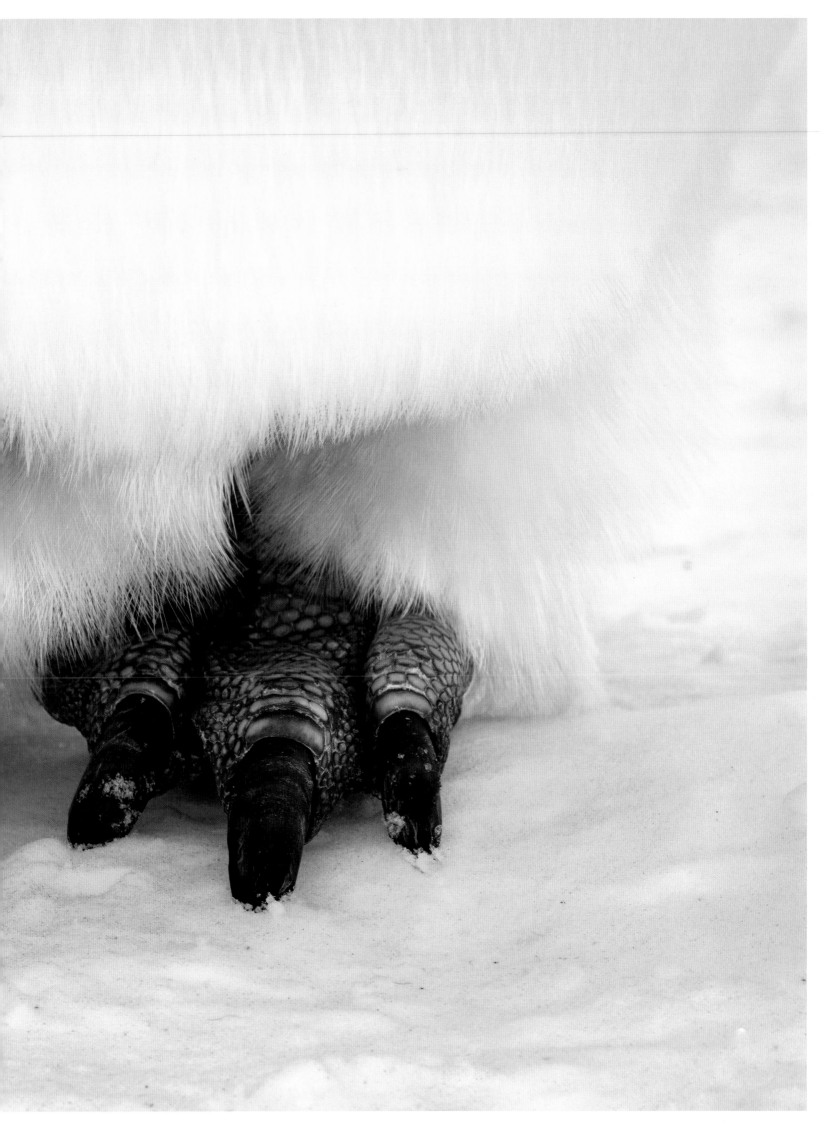

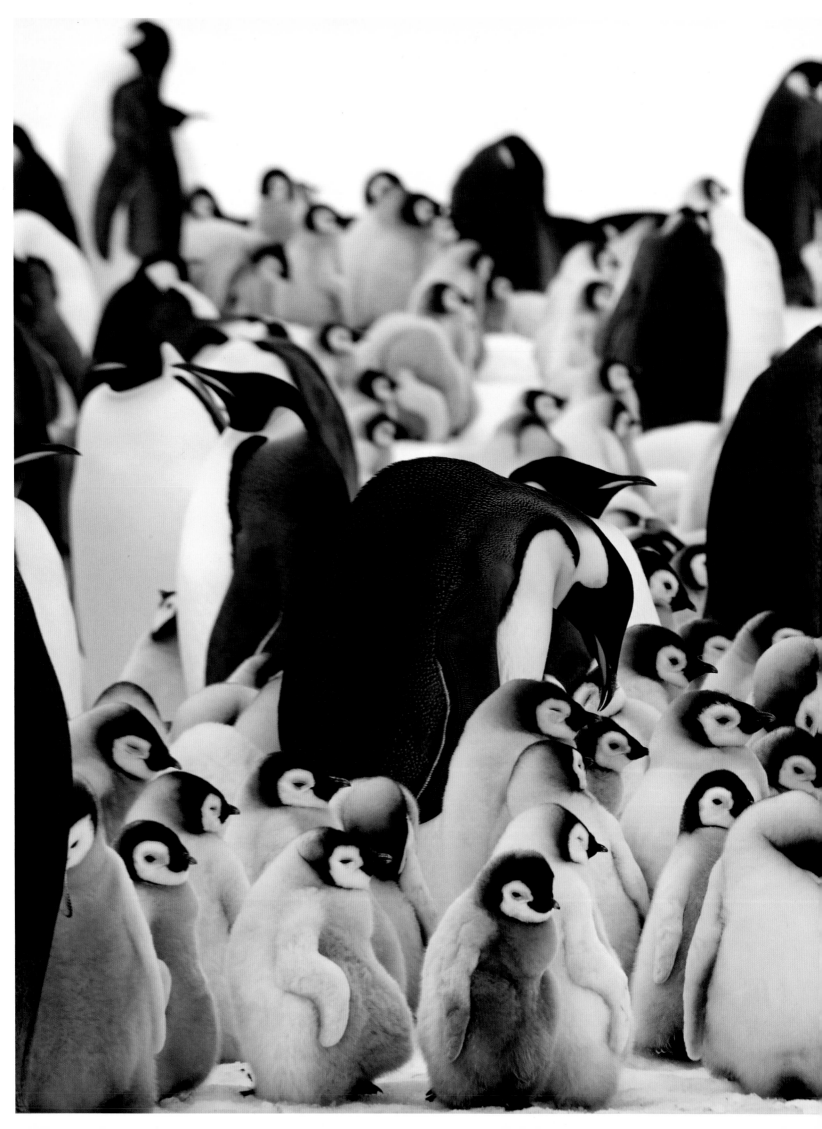

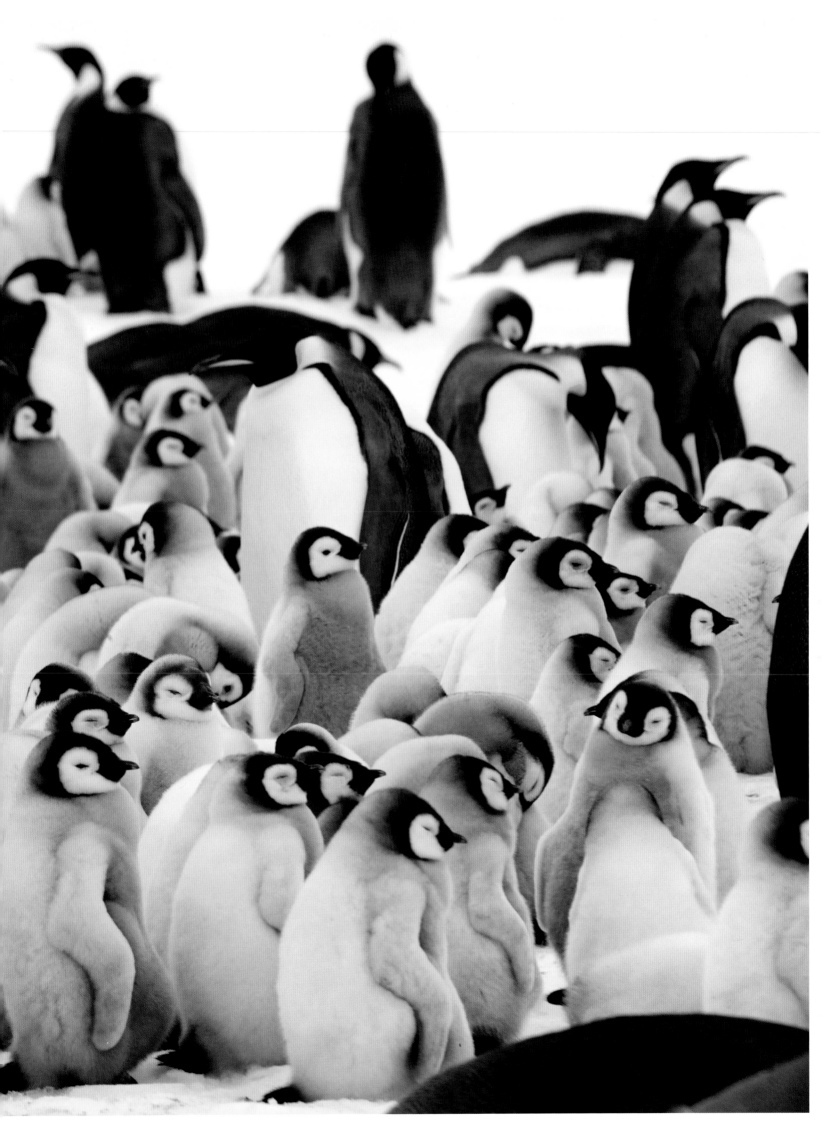

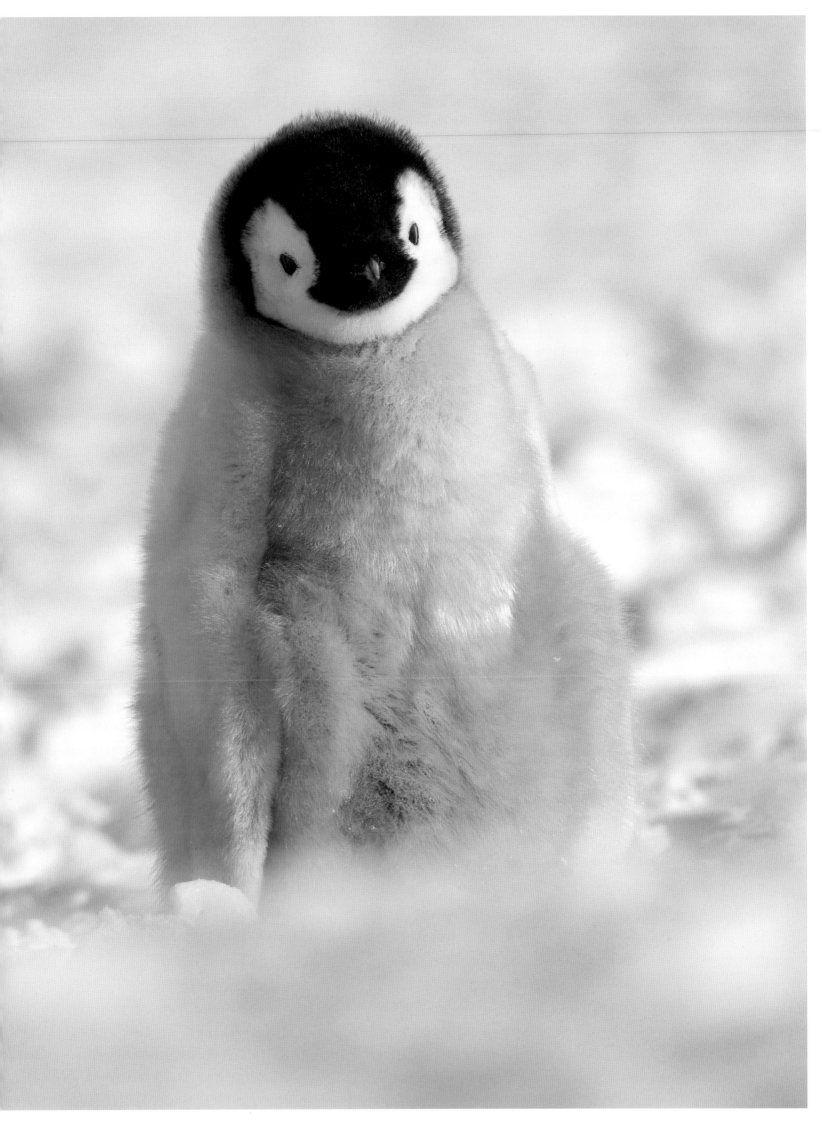

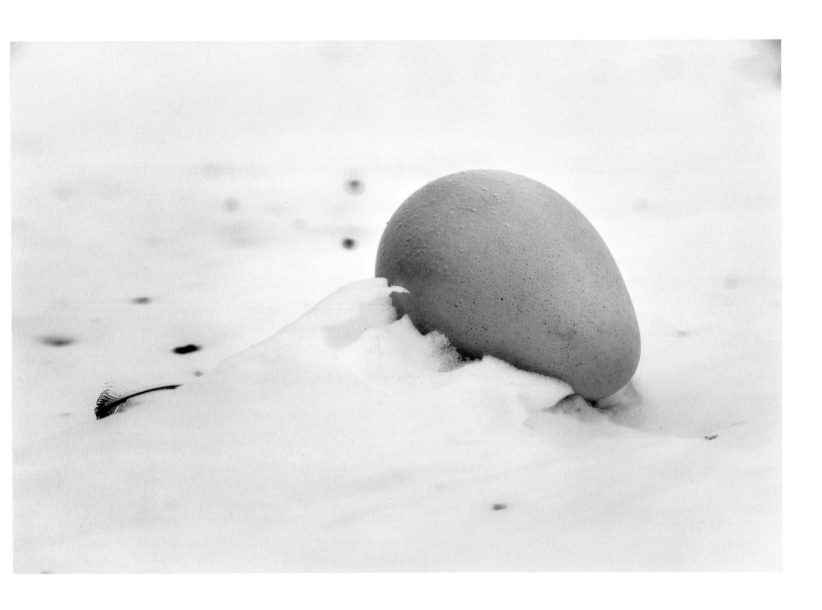

Emperor chicks don't have the dense
feather layers of the adults, but they do
have downy insulation, and they huddle
together when they need to. A dead chick
or an abandoned egg on the sea ice is
a poignant reminder that, in this harsh
world, only the fittest survive.

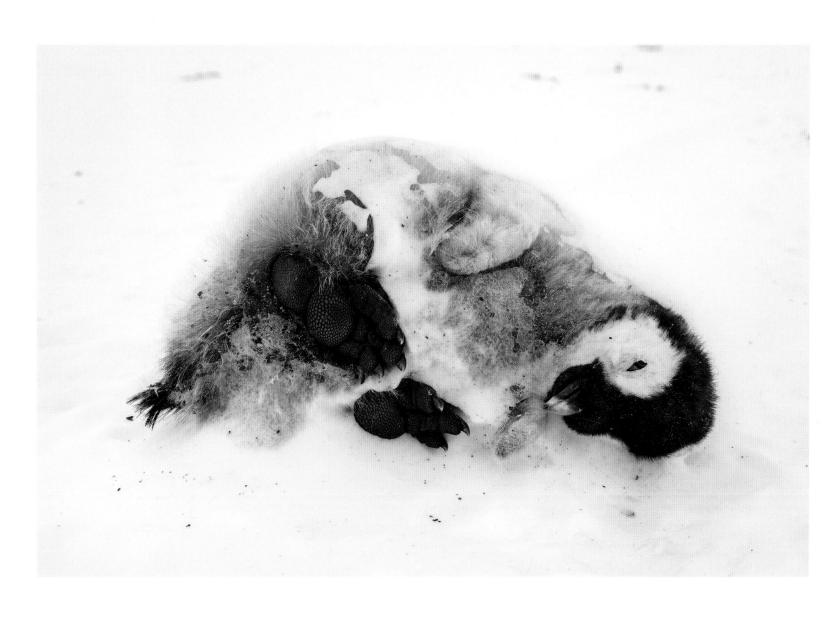

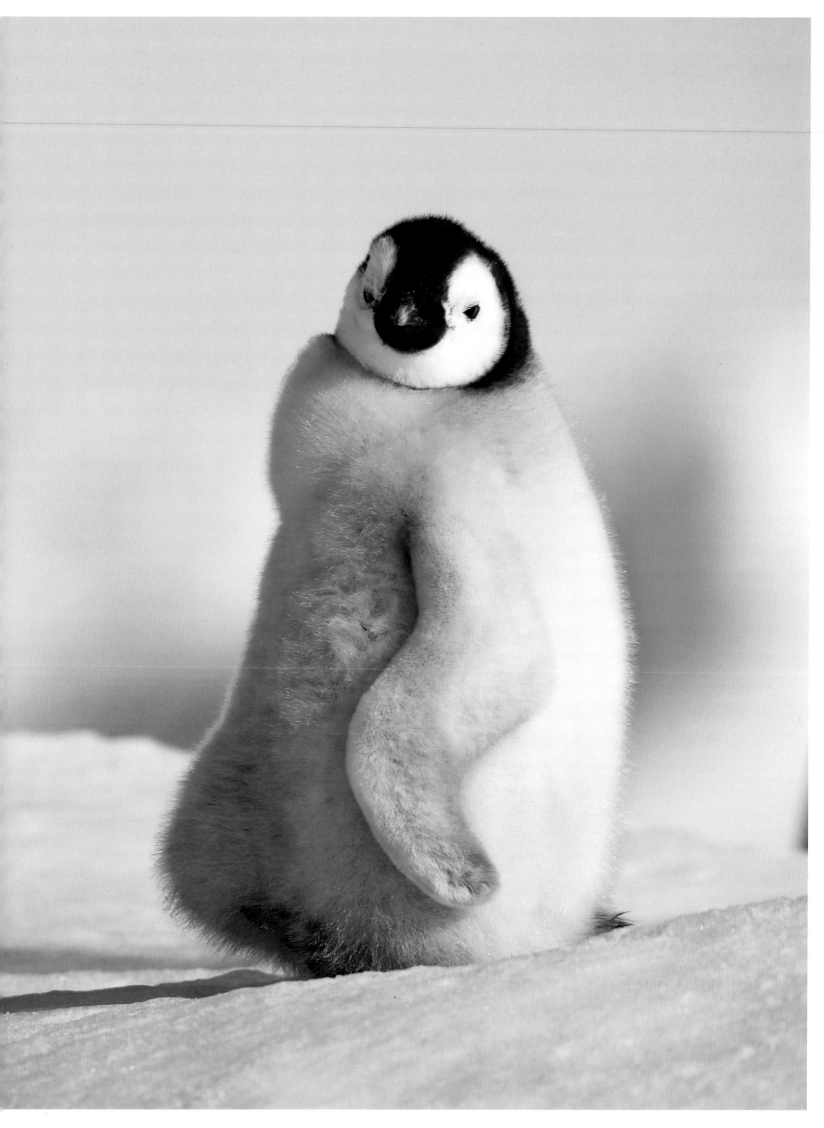

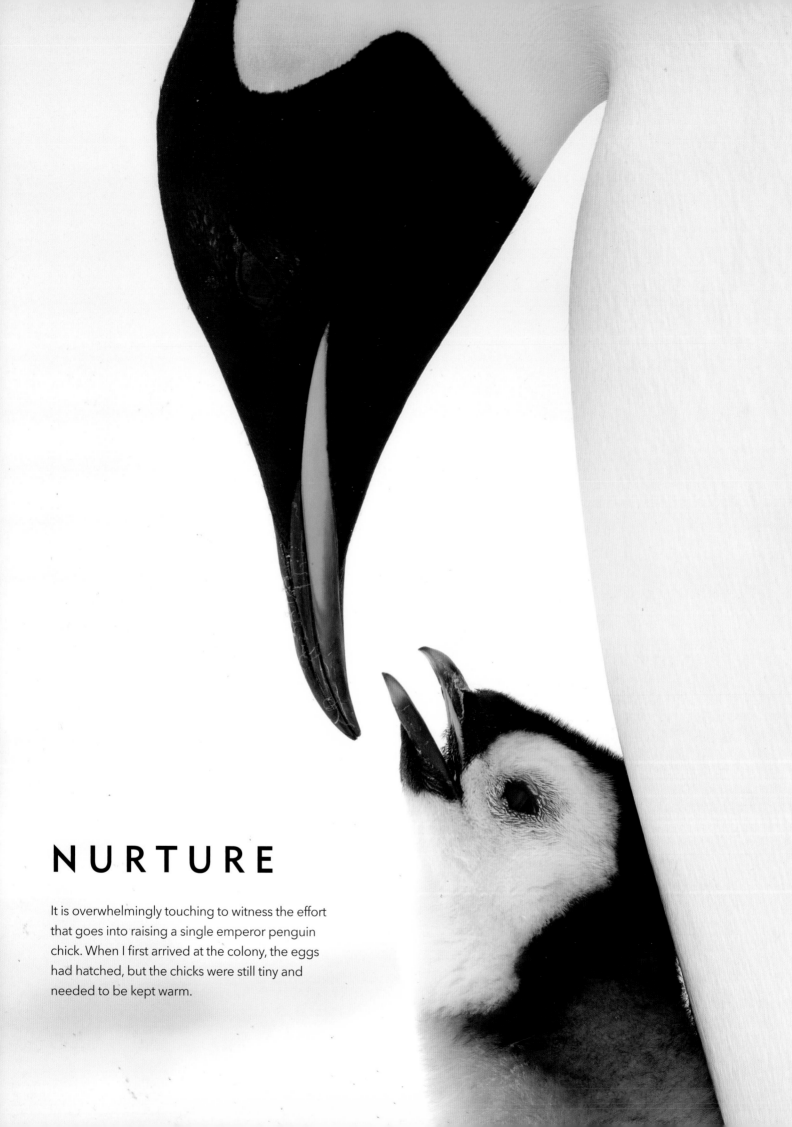

NURTURE

It is overwhelmingly touching to witness the effort
that goes into raising a single emperor penguin
chick. When I first arrived at the colony, the eggs
had hatched, but the chicks were still tiny and
needed to be kept warm.

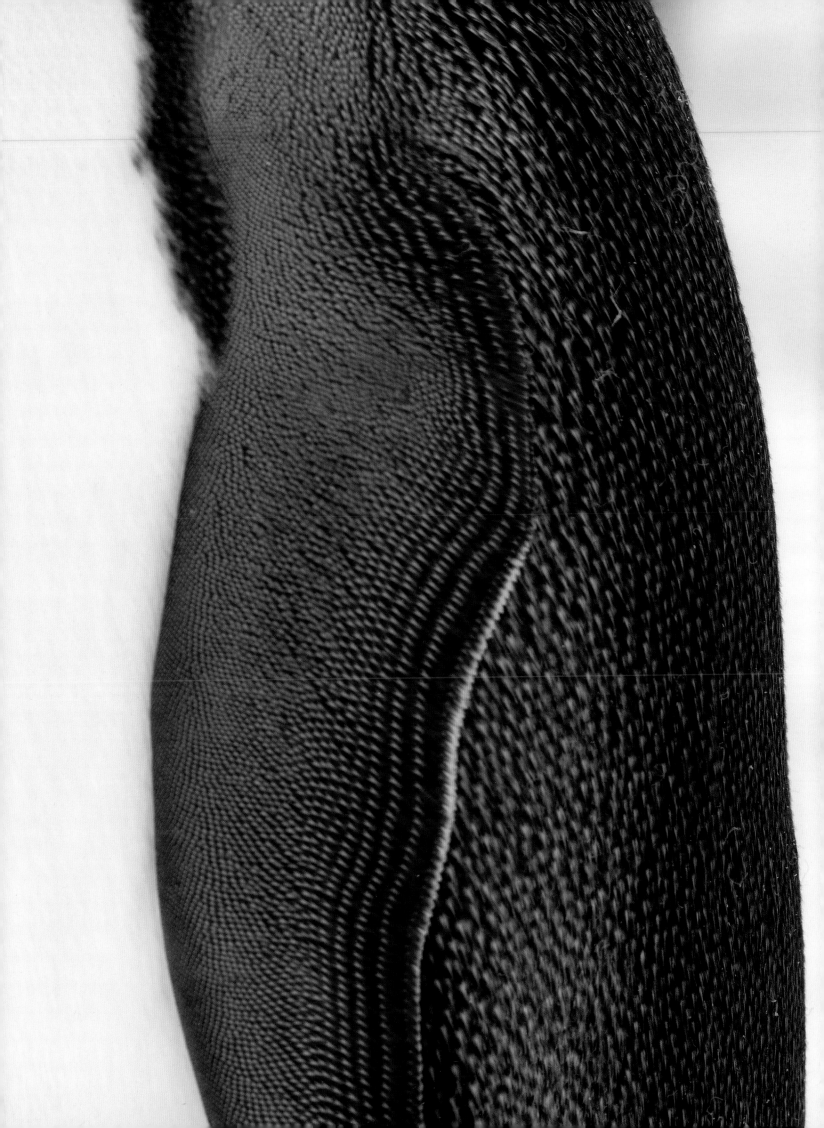

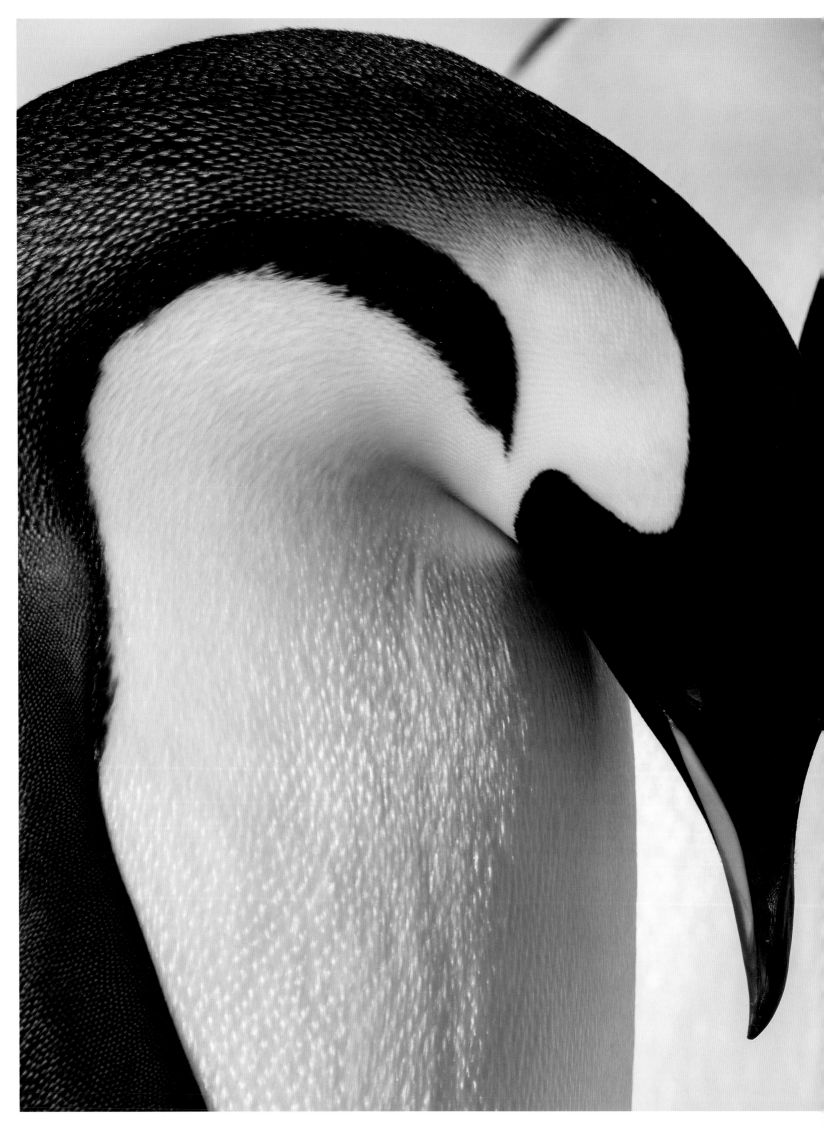

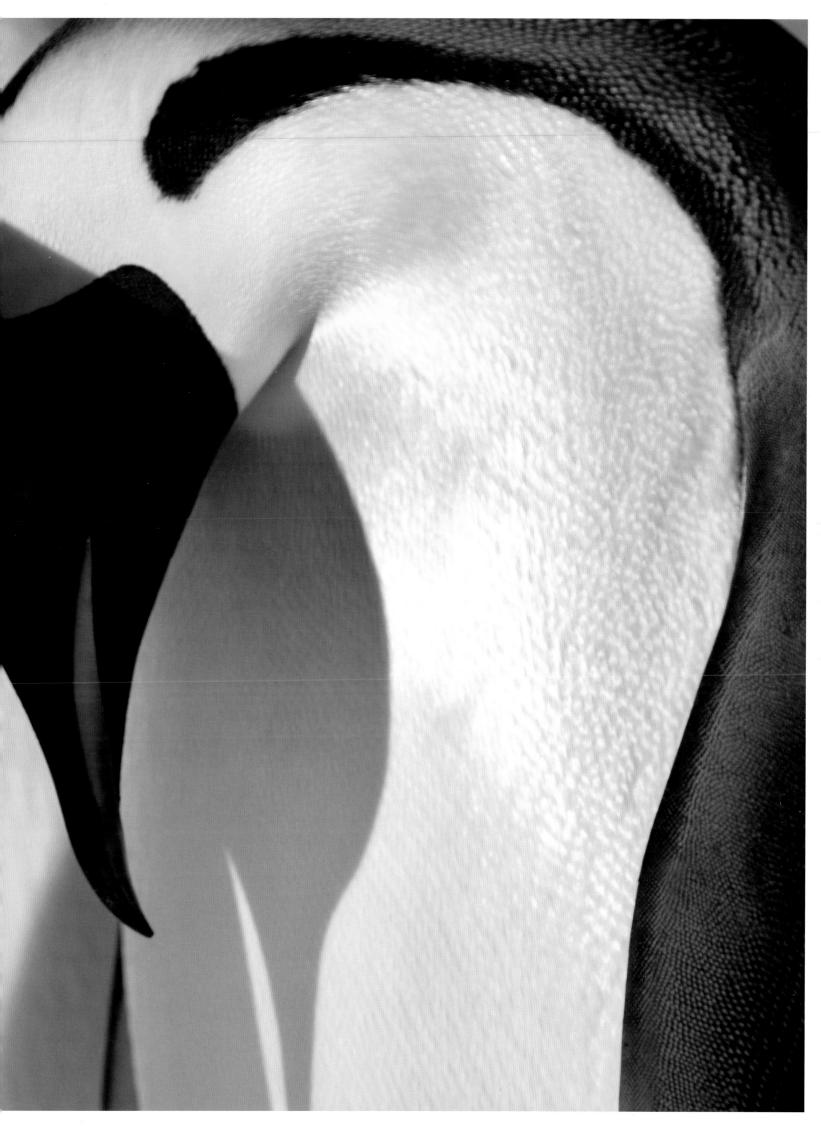

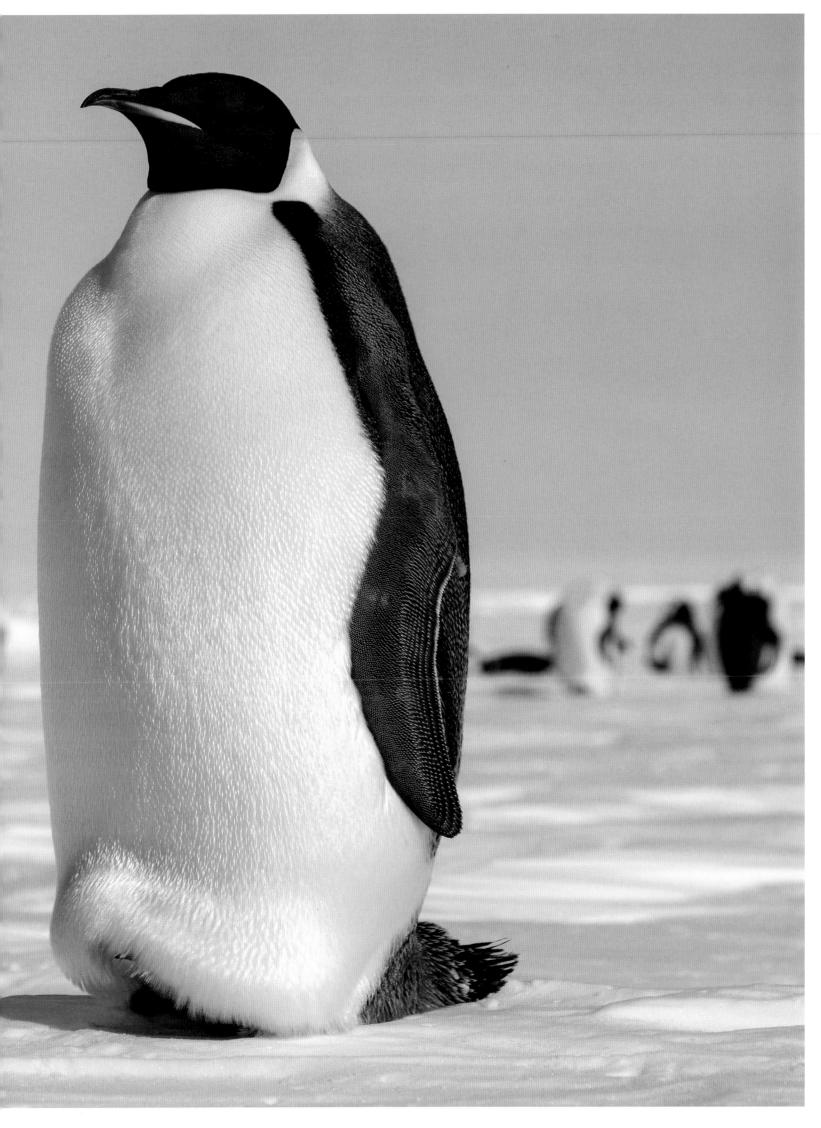

Resting on their parents' feet, they snuggled in under the brood pouch, a patch of hot, bare skin, overhung by a dense duvet of blubber and feathers. Amazingly, in the coldest weather, a chick can be kept up to 70^0C warmer than the outside air temperature.

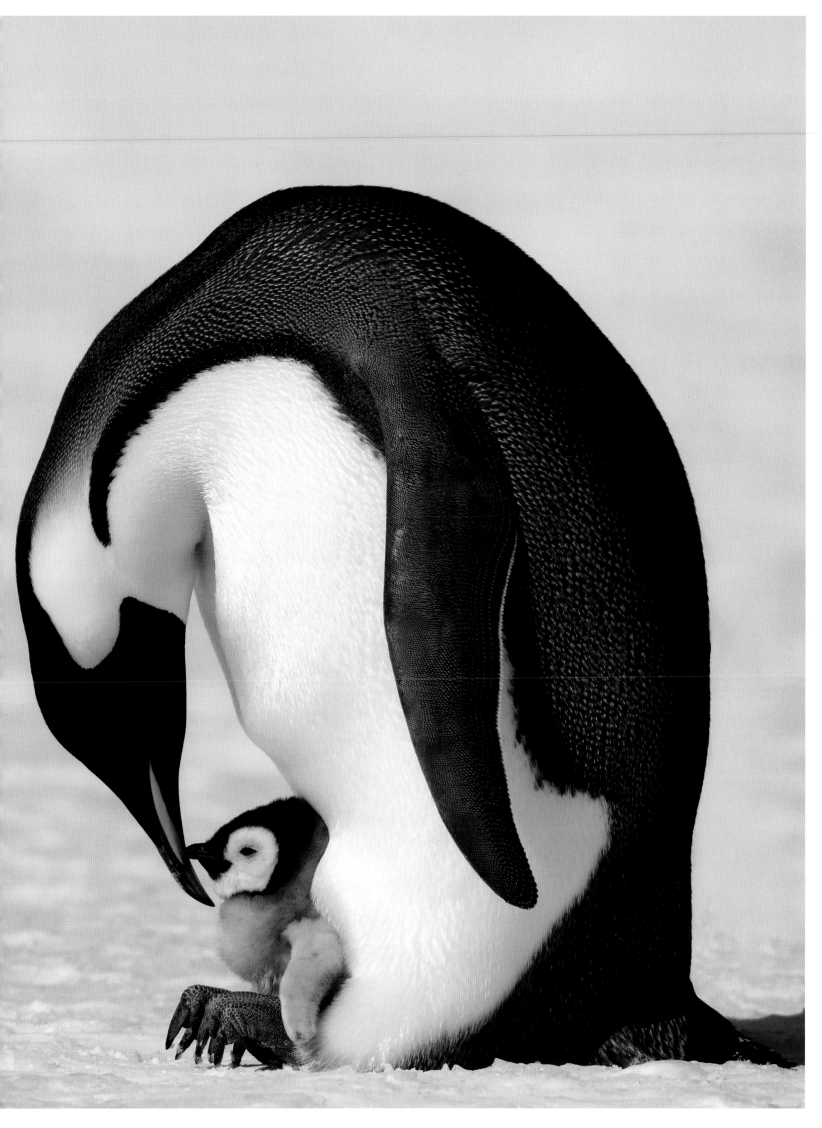

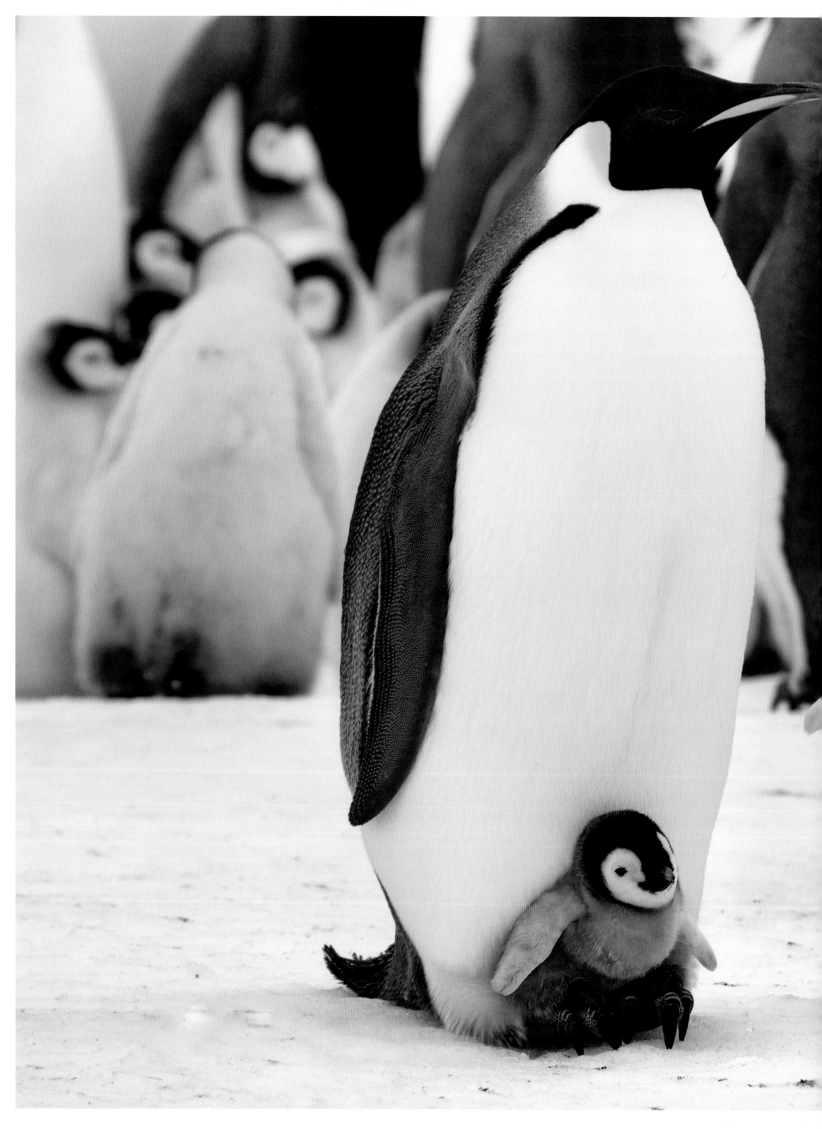

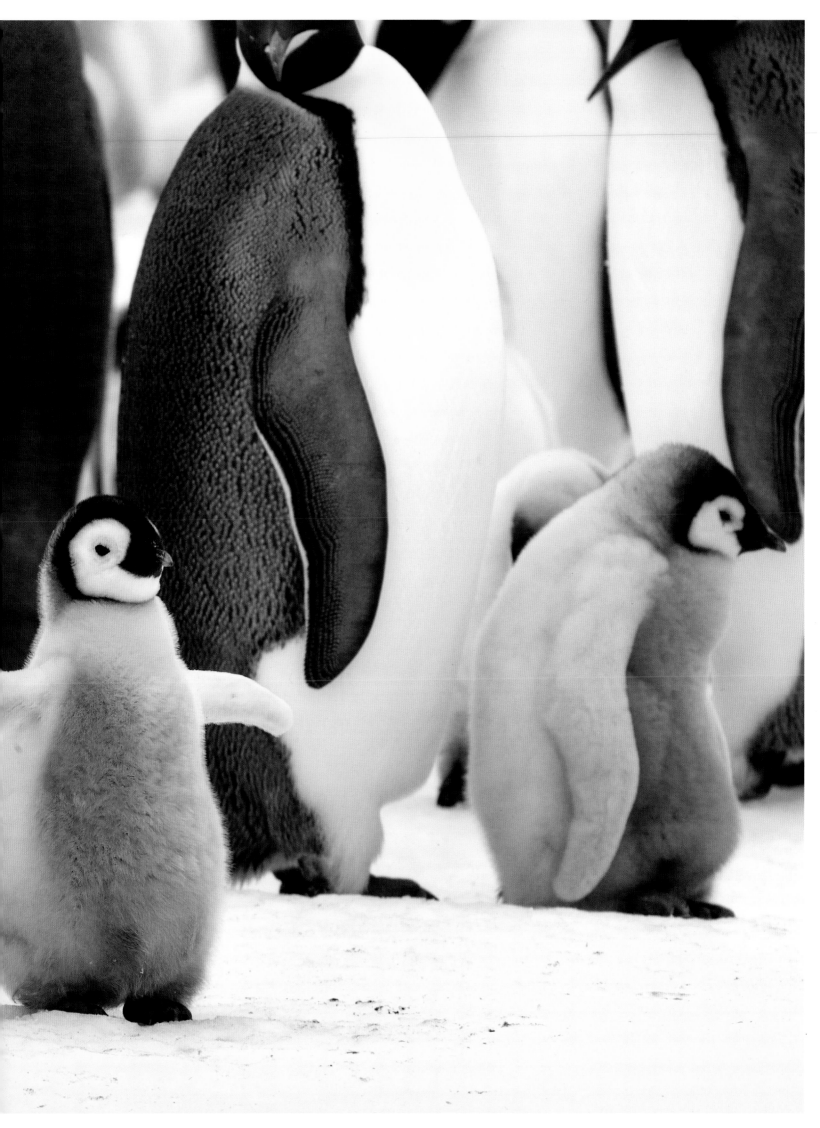

The eggs are laid over a period of several weeks, and so you can see chicks of different sizes, some looking tiny and defenceless, others chunky and strong. The adults hurry back and forth between the colony and the sea, ferrying food in their crops, which they regurgitate in response to the plaintive cries from the chicks demanding their next meal.

As the chicks pile on weight, the adults embark on constant trips to stock up on supplies. It's a round-the-clock job for the adults and a race against time to enable their offspring to fledge before the sea ice breaks up.

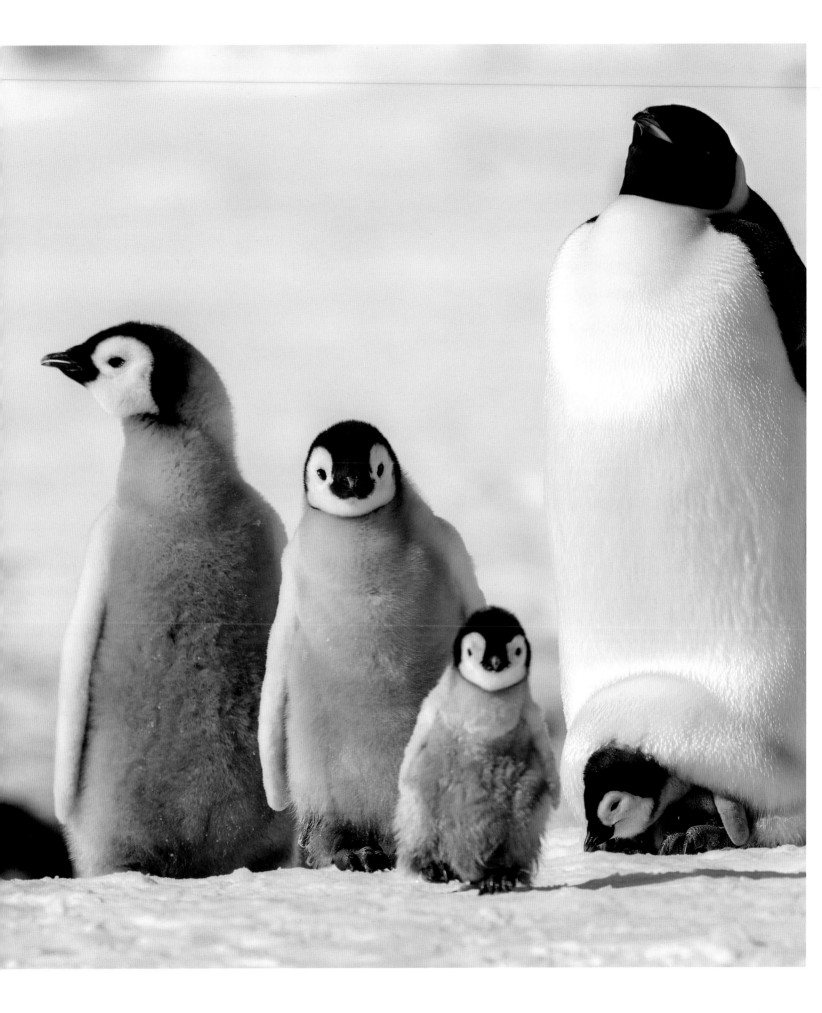

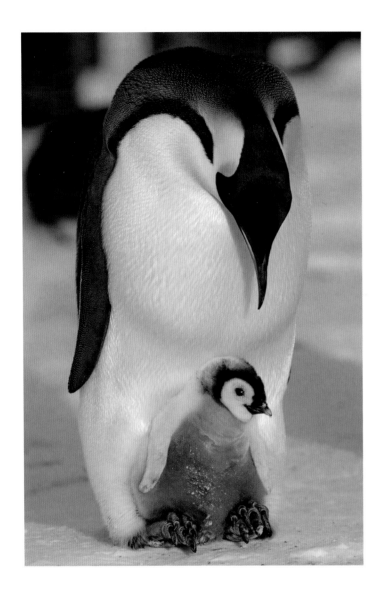
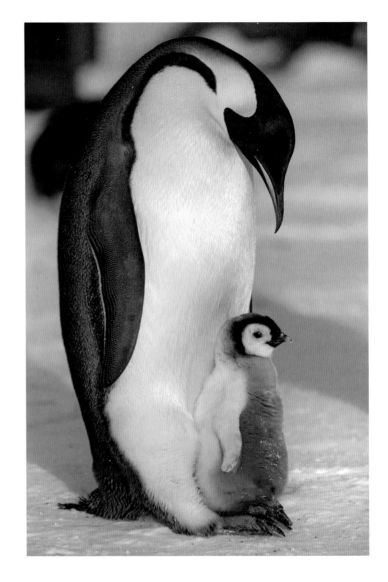

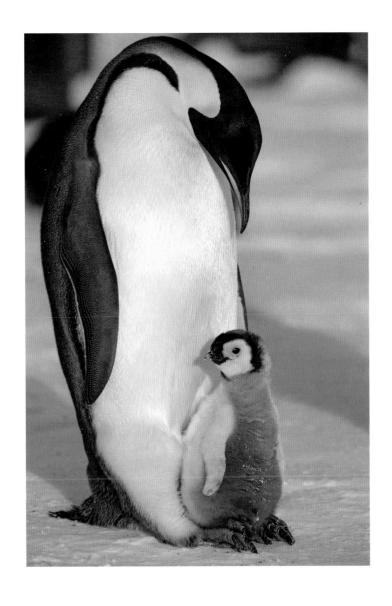
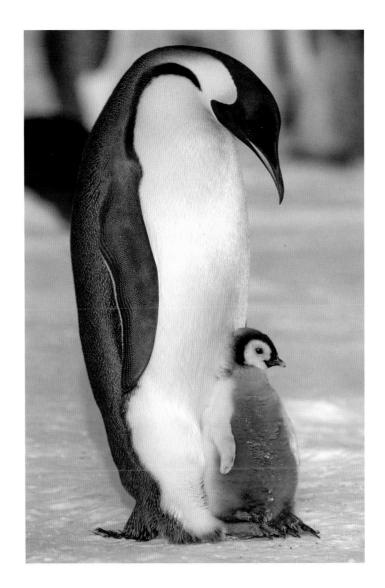

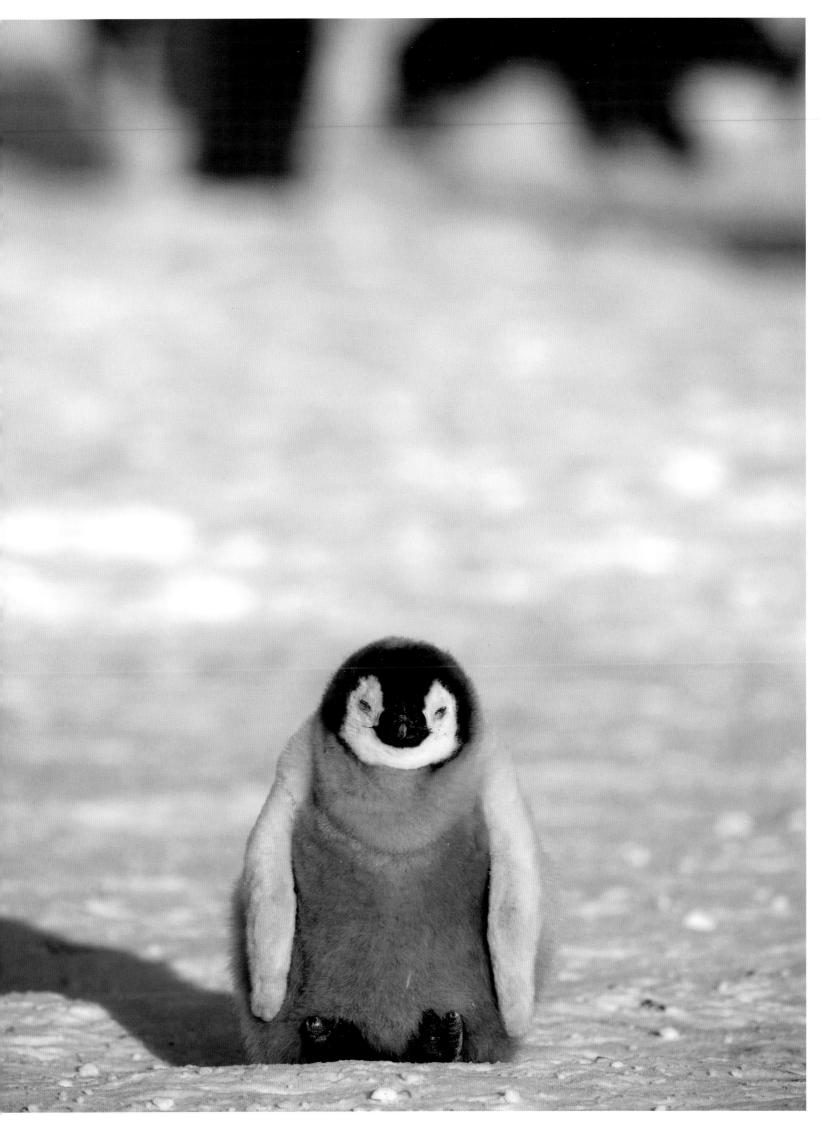

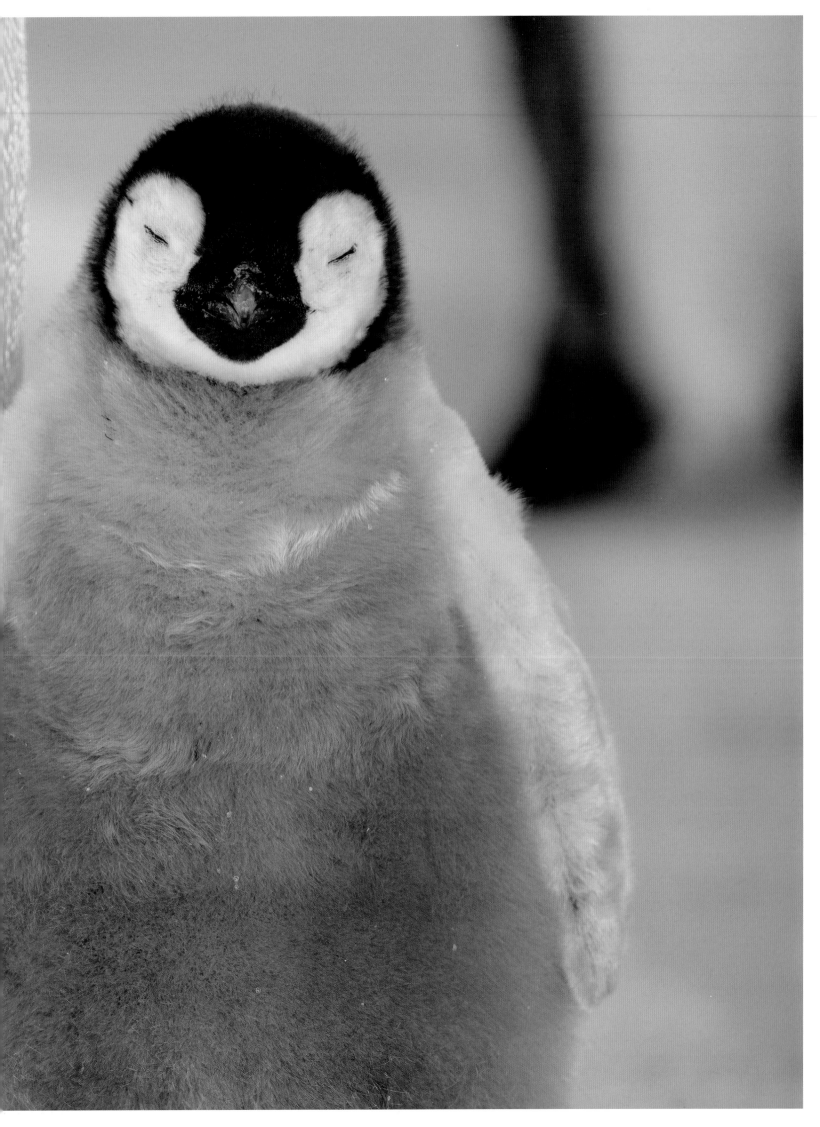

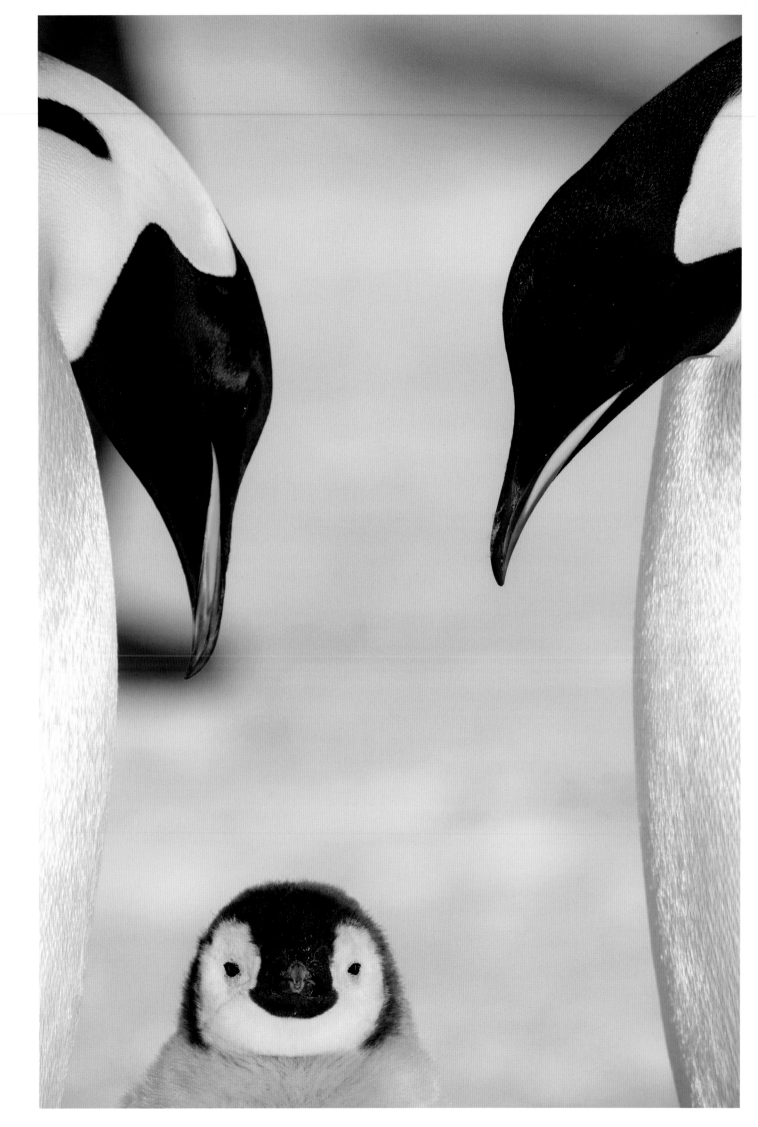

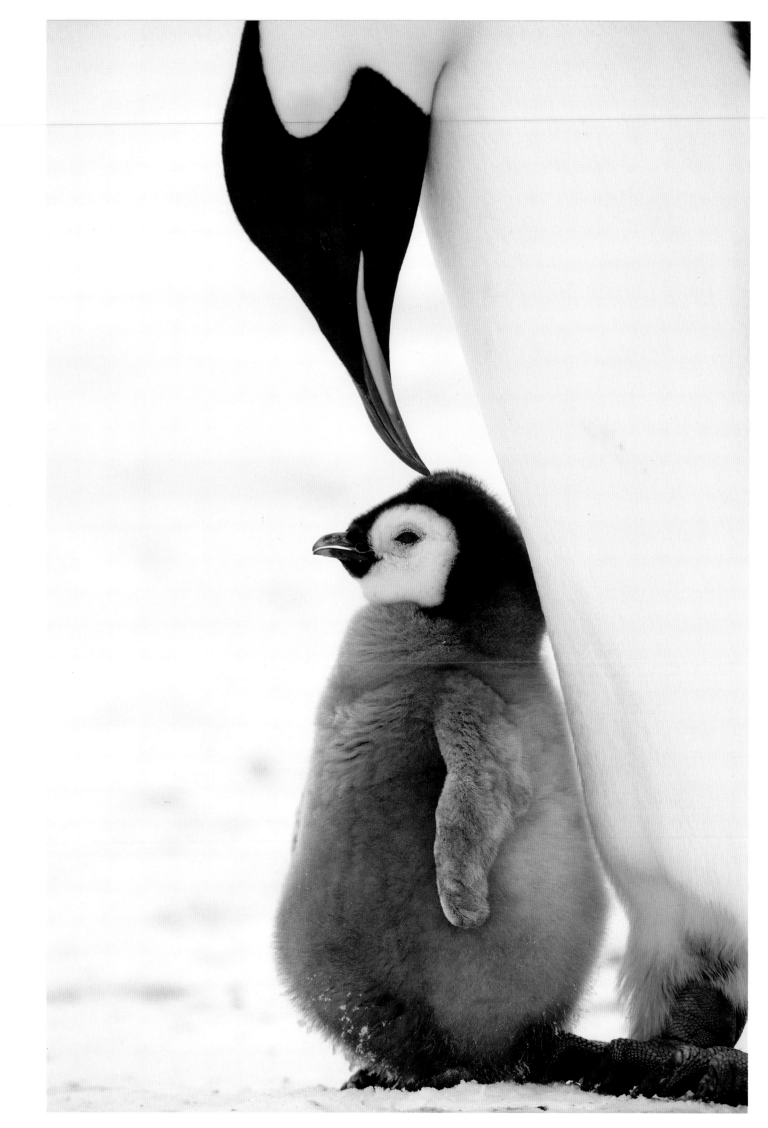

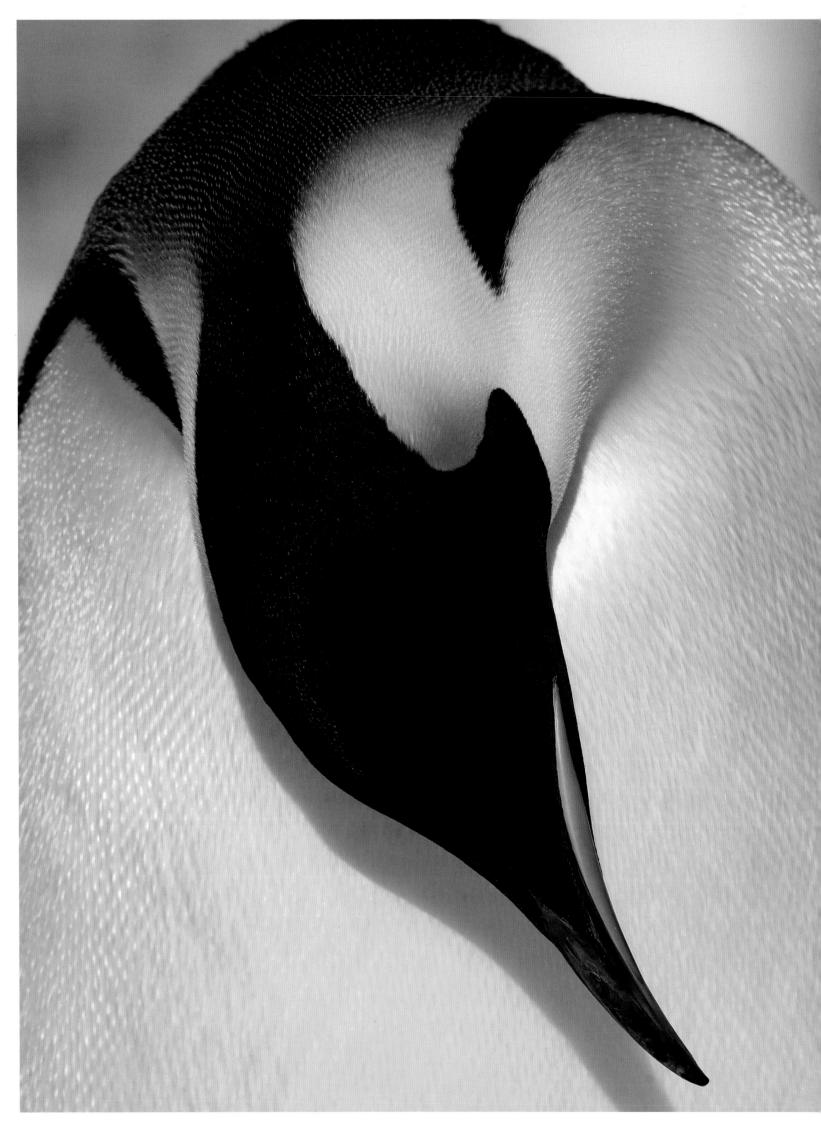

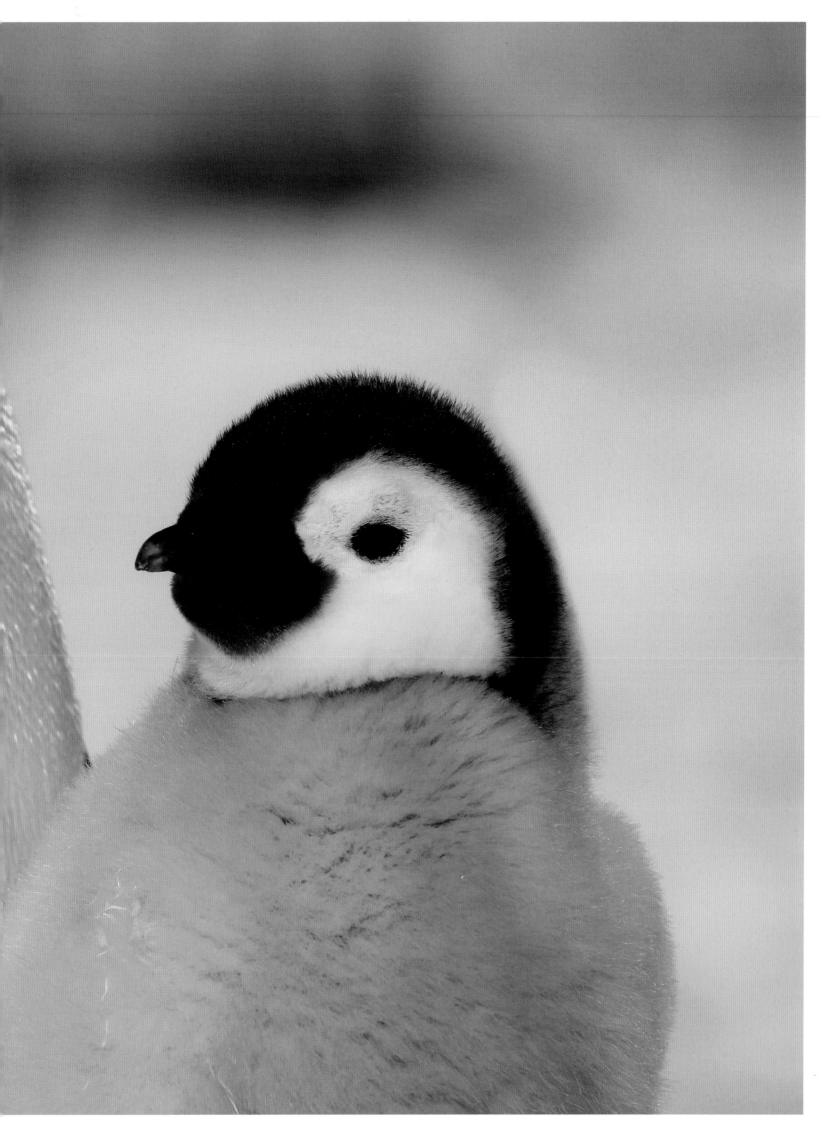

The chicks will try their luck, begging for a meal from any passing adult. But a parent will expertly home in on its own offspring, picking out its unique call from the cacophony.

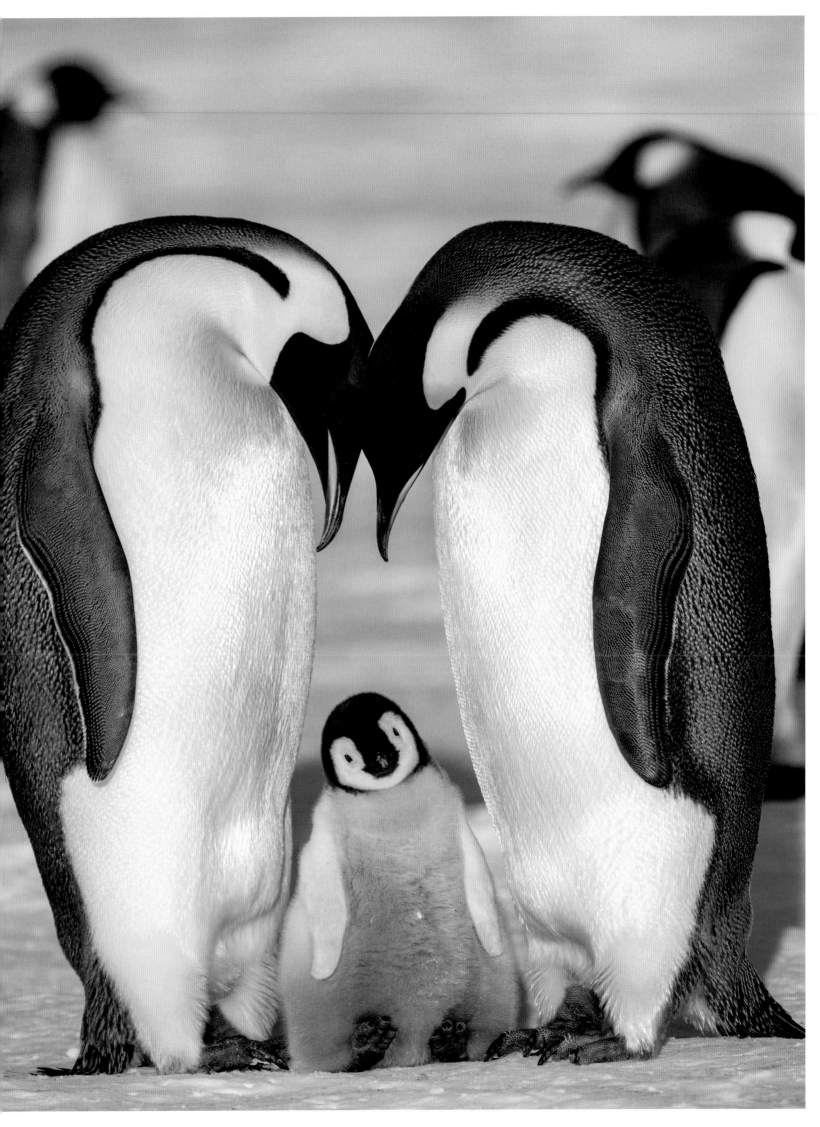

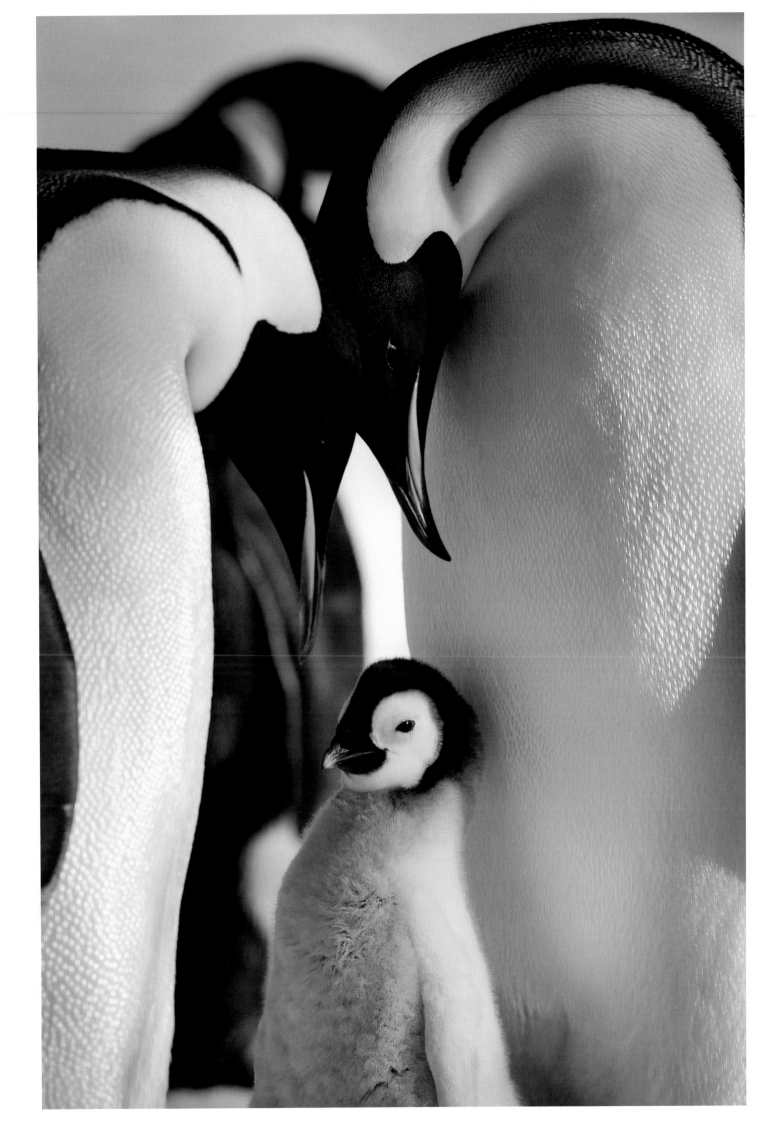

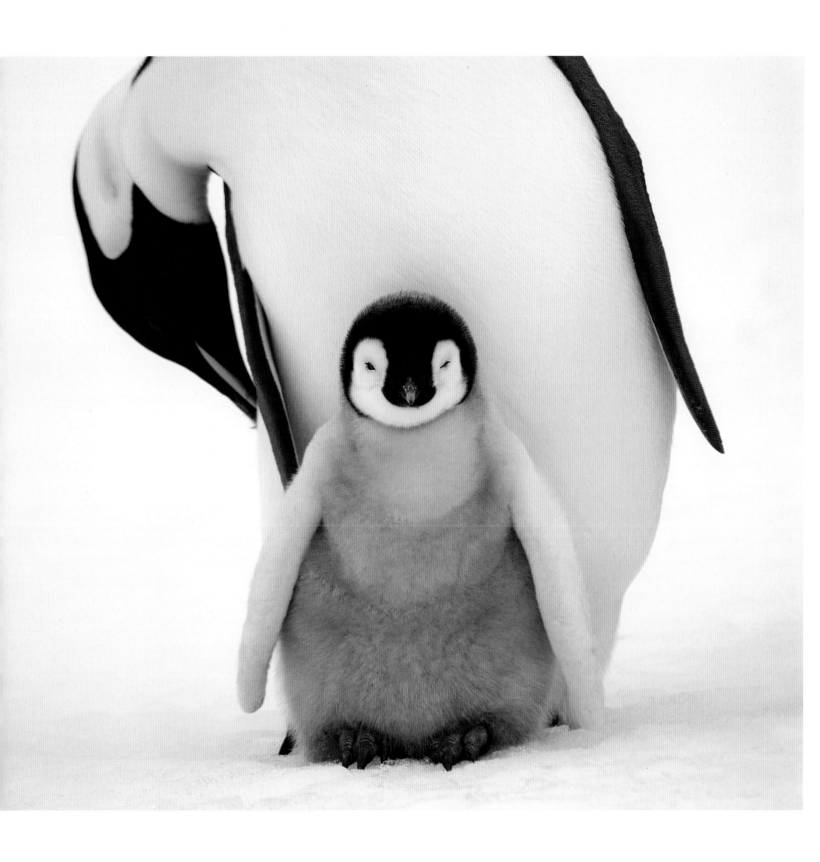

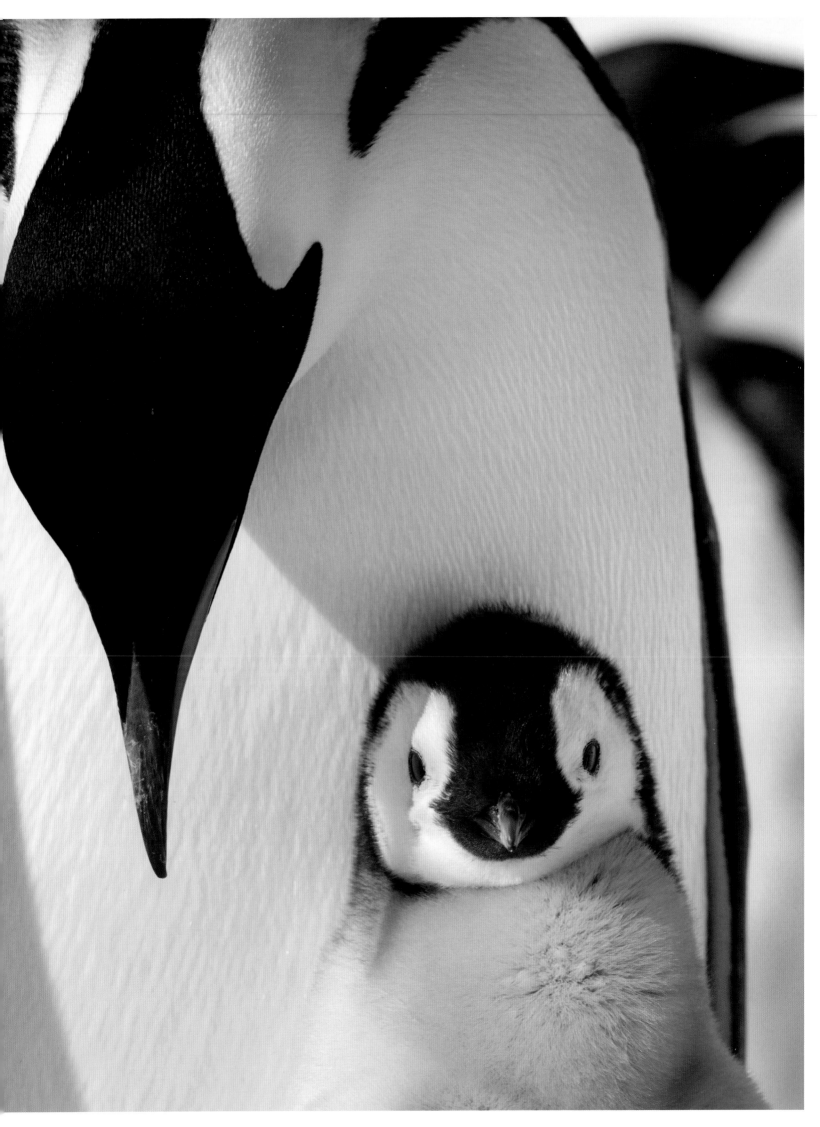

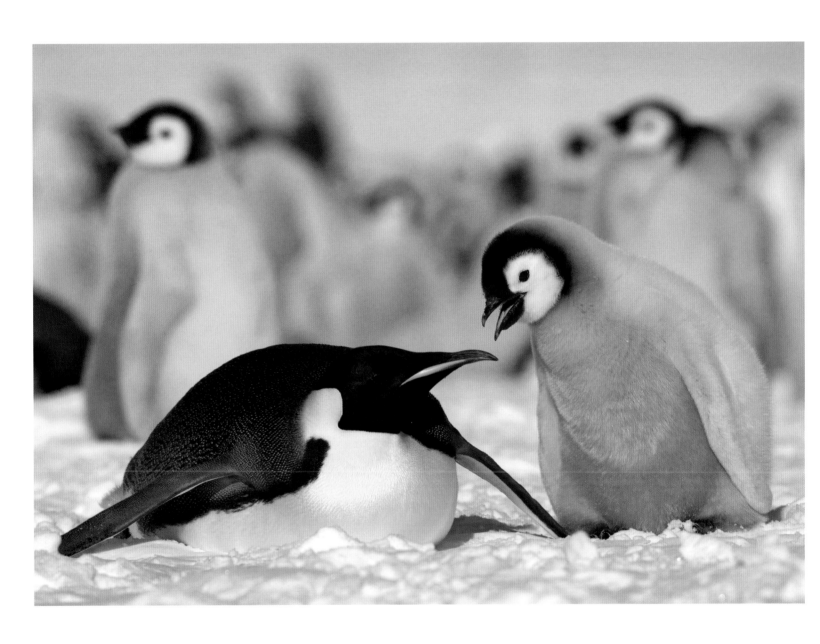

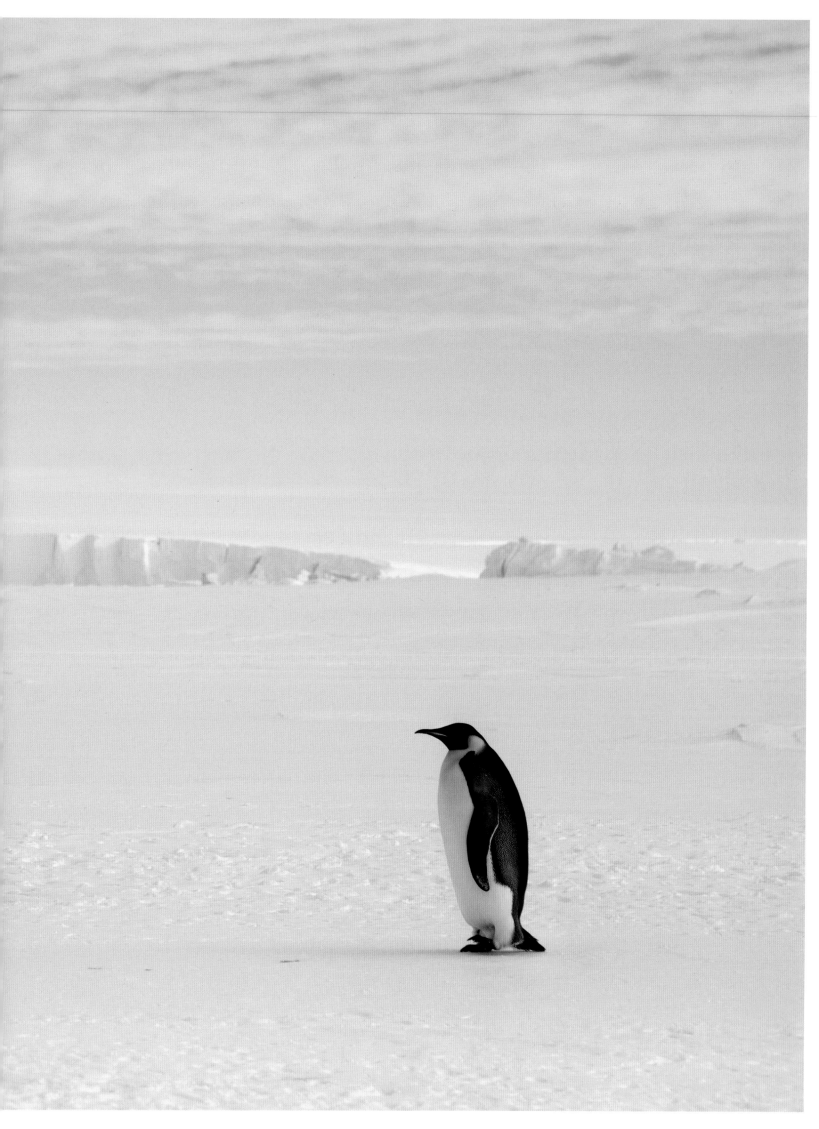

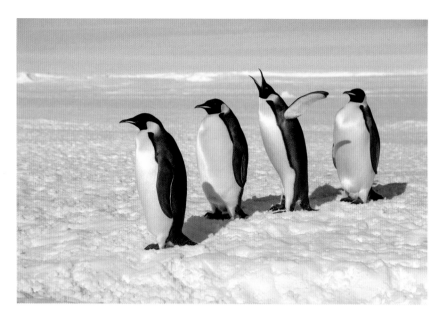

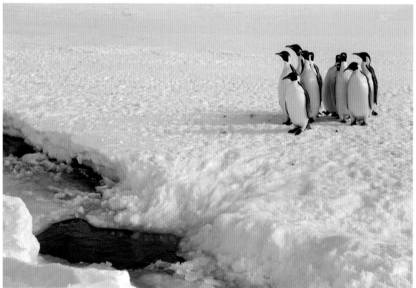

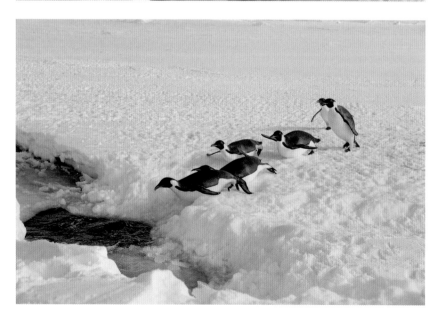

As temperatures increase, leads (cracks) open up in the sea ice, and the emperors use these as a shortcut to the colony. When they exit the water, they rocket out in an effort to avoid being grabbed by any leopard seals that may be lurking around the ice edge.

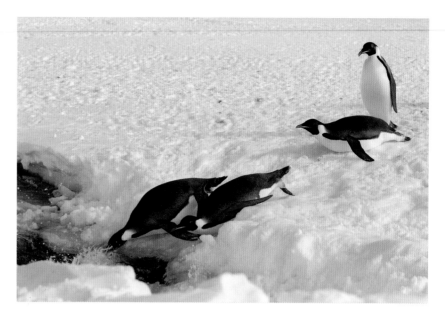

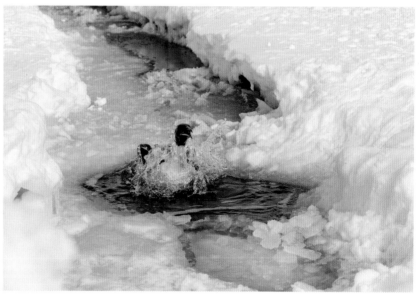

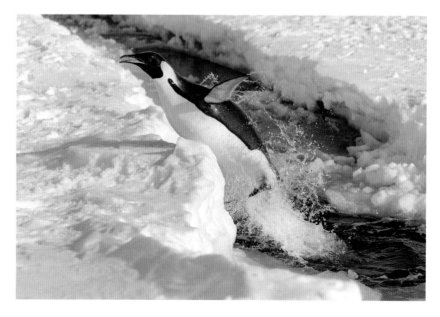

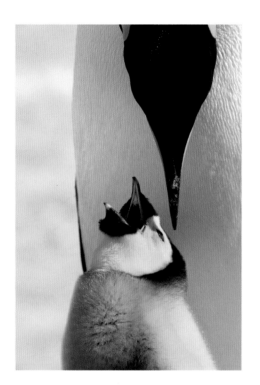
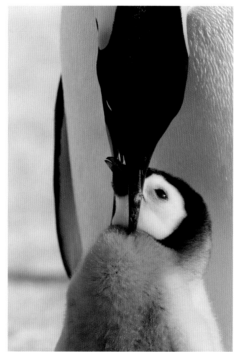
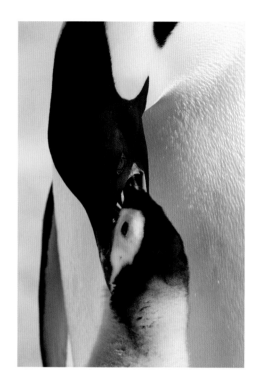

After regurgitating a recent meal of krill or fish, the adult will head back across the ice to forage for the next meal. The penguins usually feed at depths of 100-200 metres but have been known to dive down to more than 500 metres - deeper than any other bird.

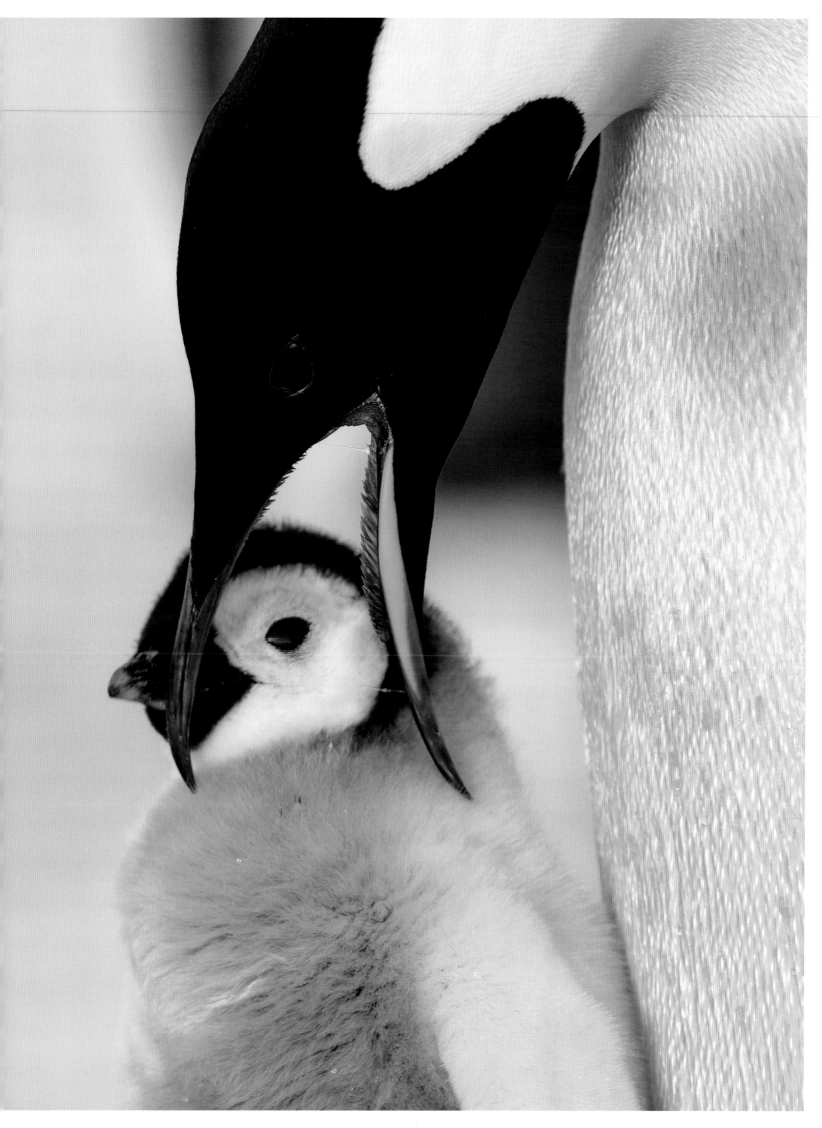

Before I ever saw an emperor penguin, I had a strong image in my mind's eye of a photograph that I wanted to take – an emperor penguin family, with the adults standing together with their chick between them, as symmetrical an image as possible.

One day at the colony at Snow Hill Island, I was watching a small chick standing next to its parent when an adult bird slowly approached them. The chick started calling, begging to be fed by the adult that had just returned from feeding out at sea.

I quickly realised that this adult must be the parent of the chick in question as it immediately hunched over and started making signs that it was about to regurgitate some food. After several feeds, the adult finally stopped, and then shuffled together with the other adult for just a few seconds in this perfect pose, before the chick moved and the spell was broken.

In all the many hours of watching these wonderful birds this is the only time I've seen this shot, but I'm always looking out for the next one! When I had my first exhibition at the Getty Gallery in London, this photo was blown up to nearly two metres high and it's possible to see me and my tripod reflected in the eye of the penguin on the right.

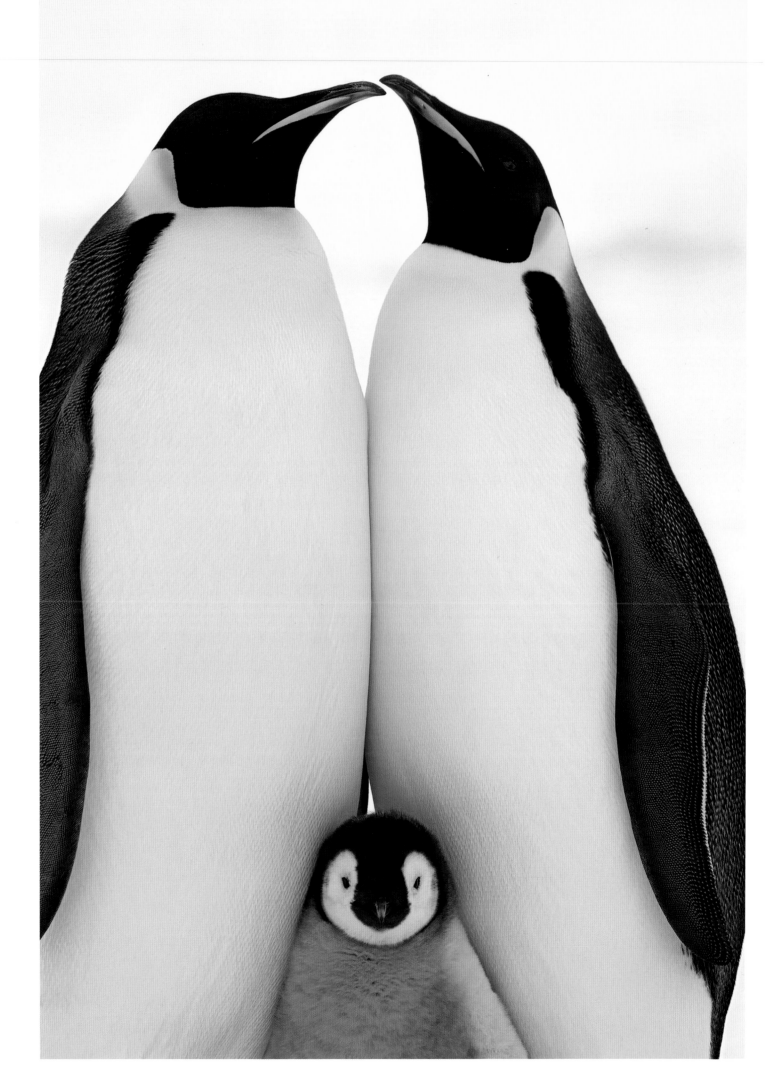

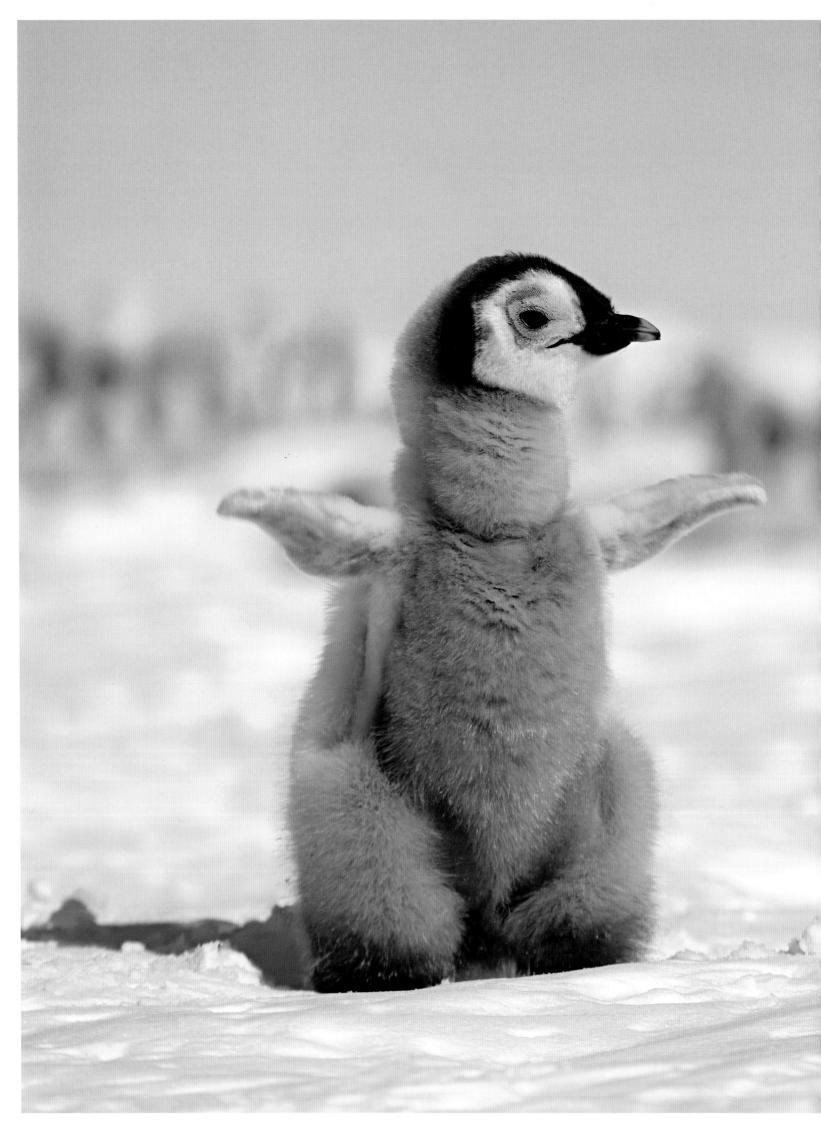

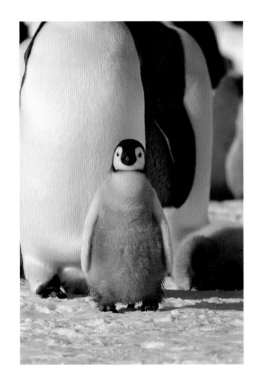 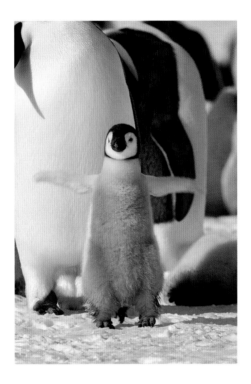 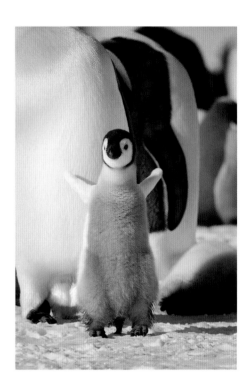

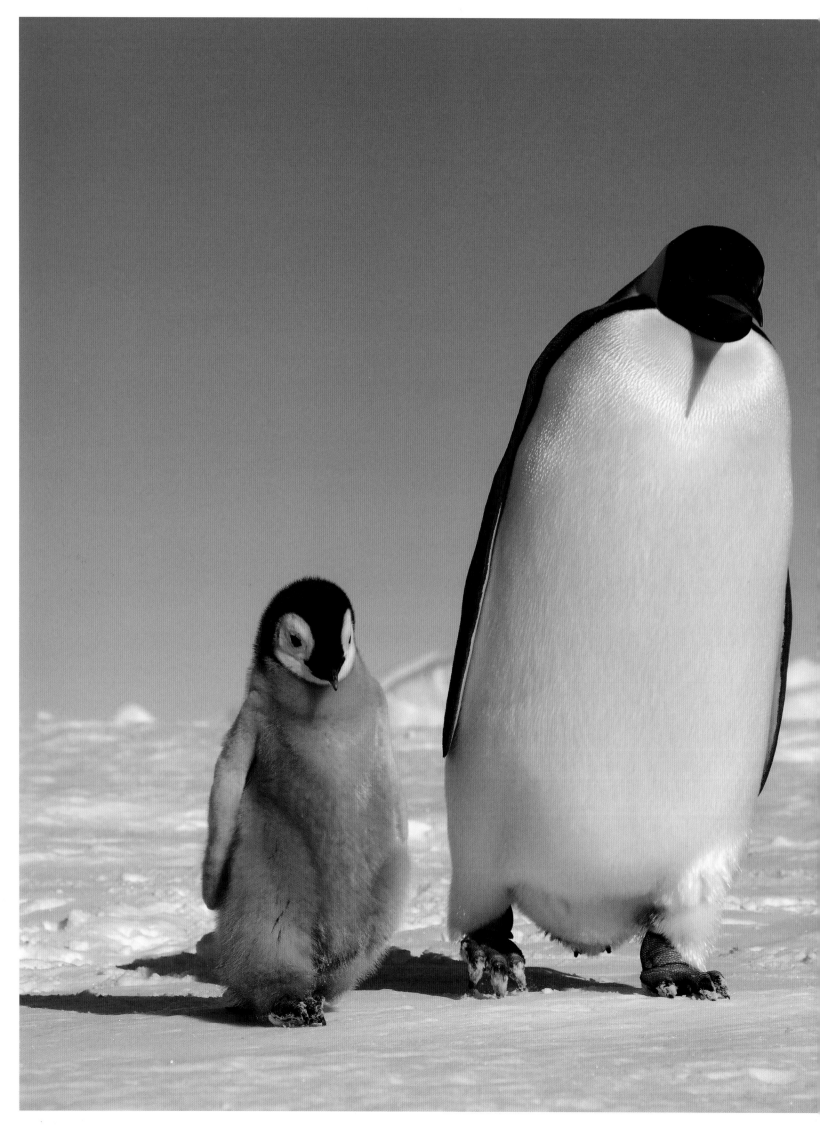

Emperor penguins are very curious. When I saw this adult and chick walking together, a long way away out on the sea ice, I had a hunch that if I simply lay down and patiently waited they'd be sufficiently interested in the unusual object to come and examine it.

Stretched out on the ice, propped up on my elbows, I watched the pair as they slowly approached to within a few inches of my camera. I could even see the snow on the bottom of their feet. The adult stretched its neck to have a good look at me, called loudly and then, curiosity satisfied, turned around and went back across the sea ice with its chick.

On the same trip, I had an even closer encounter. It was a cold but sunny day, with not a cloud in the sky. Resting at a safe distance from the penguin colony, so as not to disturb the birds, I listened to the cacophony of the thousands of chicks calling for their parents. The sound was magical. I lay down on the ice, resting my head on my camera bag and closed my eyes to listen to their calls. Exhausted after a very early start and long walk carrying my heavy equipment, I fell asleep, snuggled up in my heavy down jacket.

A short time later, I woke up, conscious of something touching me. Stretched out next to me, with its tiny wing on top of my gloved hand, was a chick. We looked at one another as I slowly came to. Then the chick stood up and pottered off to join some other youngsters who were hanging out in a crèche nearby. It was one of my most magical wildlife experiences ever.

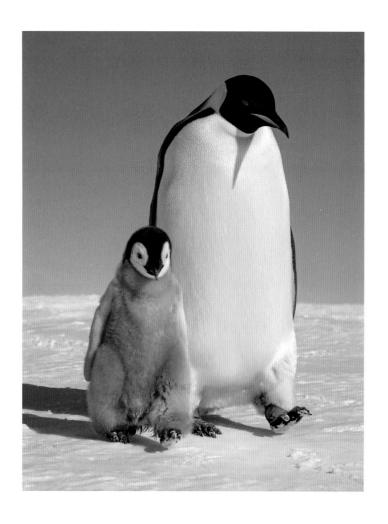
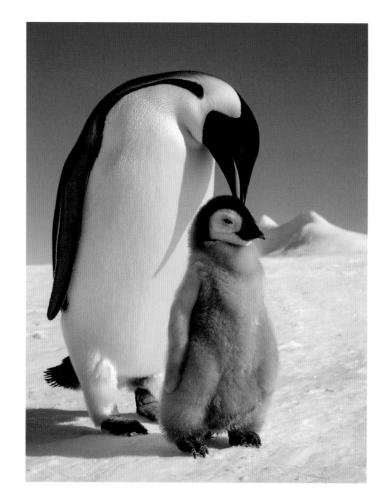

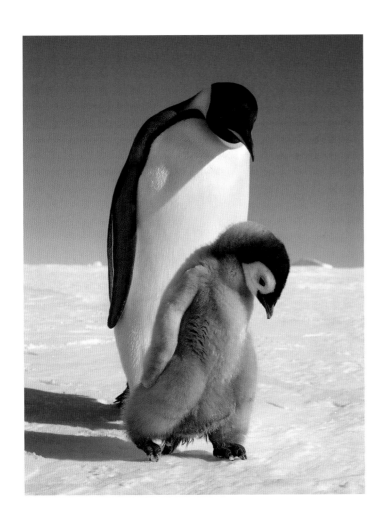

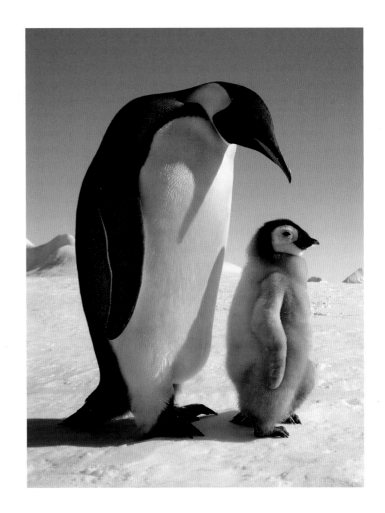

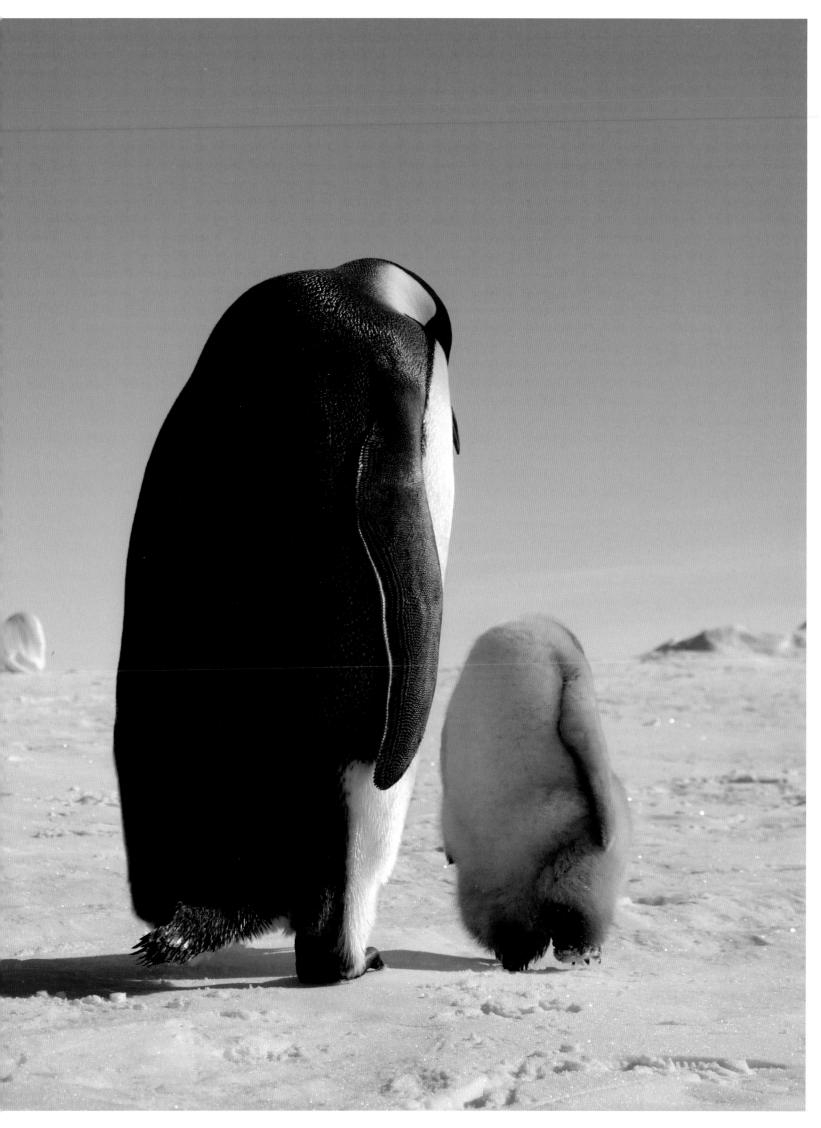

GROWING

As the young chicks grow, they start to form crèches, which sometimes can resemble a scene from *Happy Feet*. By now, the chicks are the most appealing balls of grey fluff. They huddle together like a collection of cuddly toys, or waddle to and fro in search of their next meal, pestering the nearest adult with their beseeching calls.

As they become a little more independent, they start to exercise their wings, flapping them as if attempting to take off – an exercise in futility if ever there was one. I love watching them go on their walkabouts together, bravely exploring further afield like a gaggle of children on their first trip away from their parents.

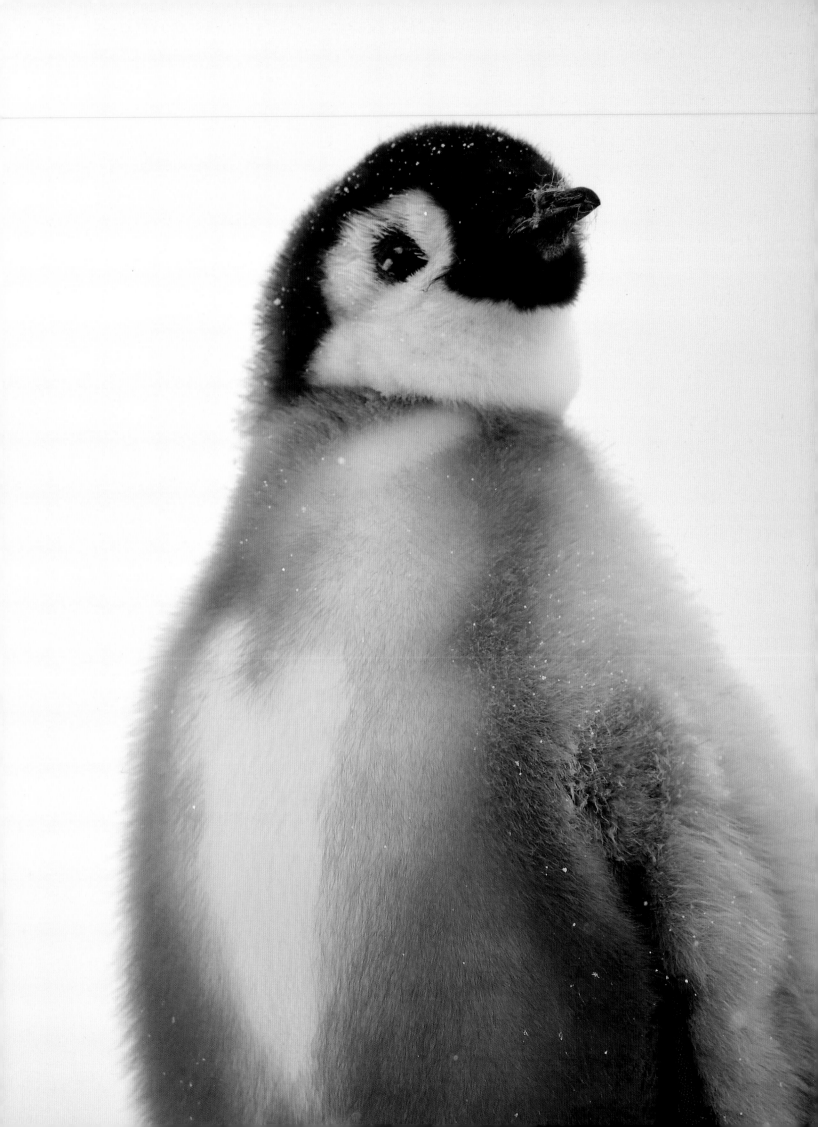

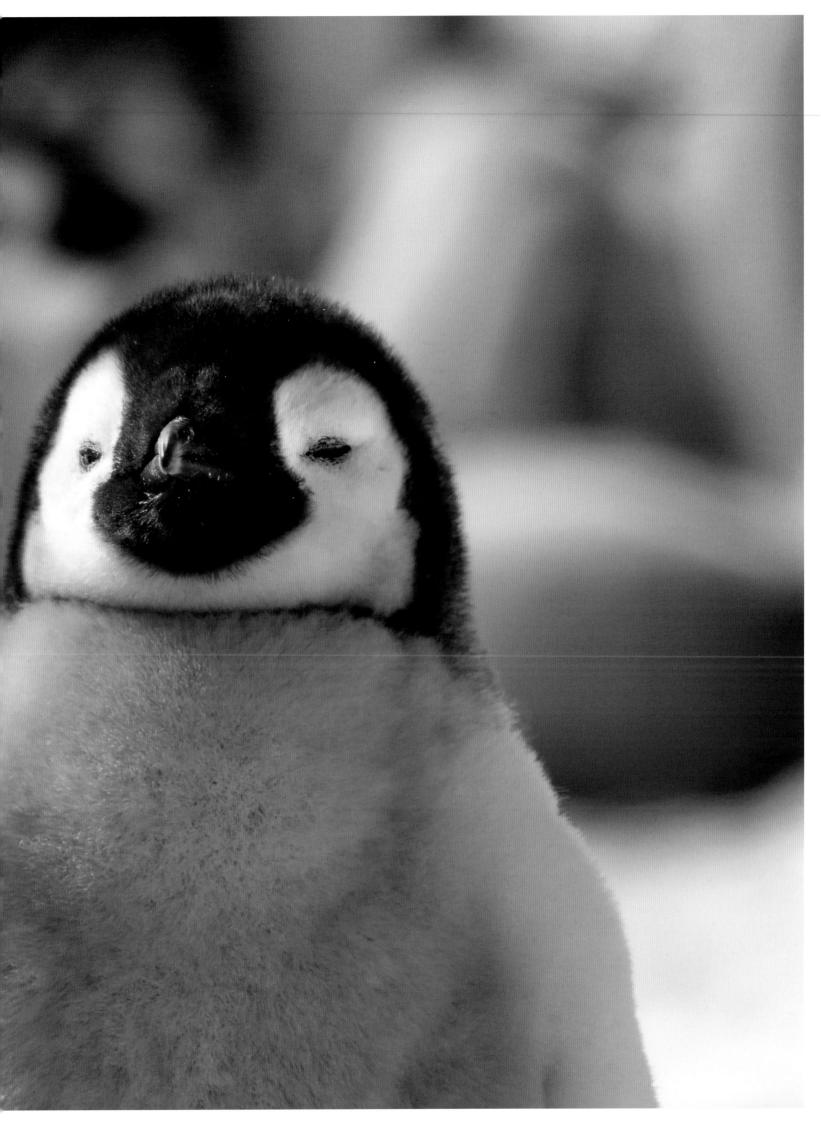

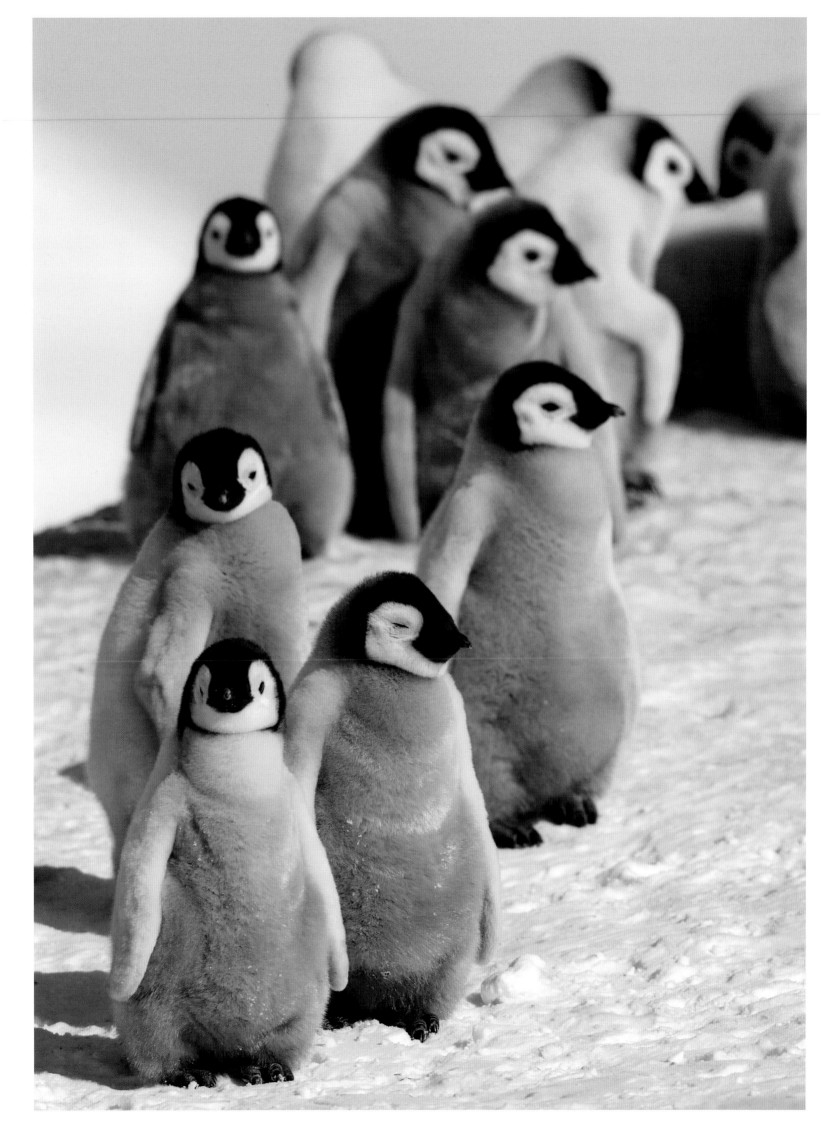

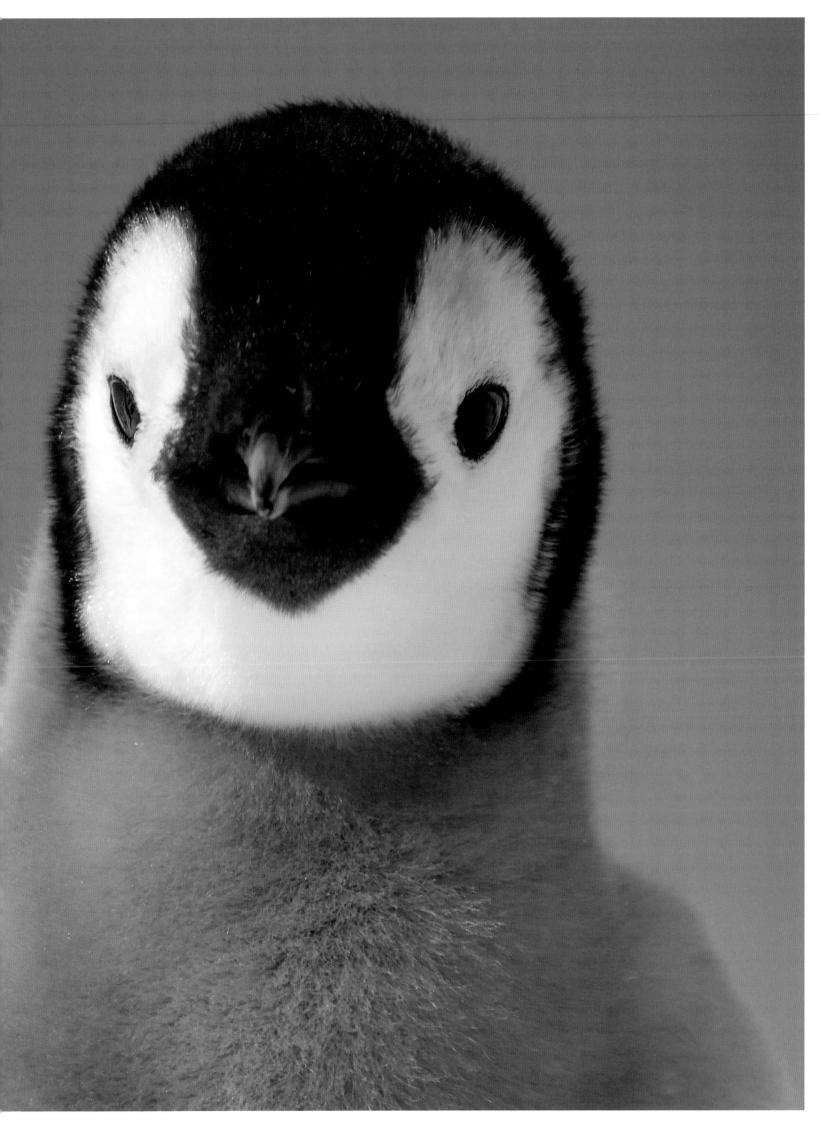

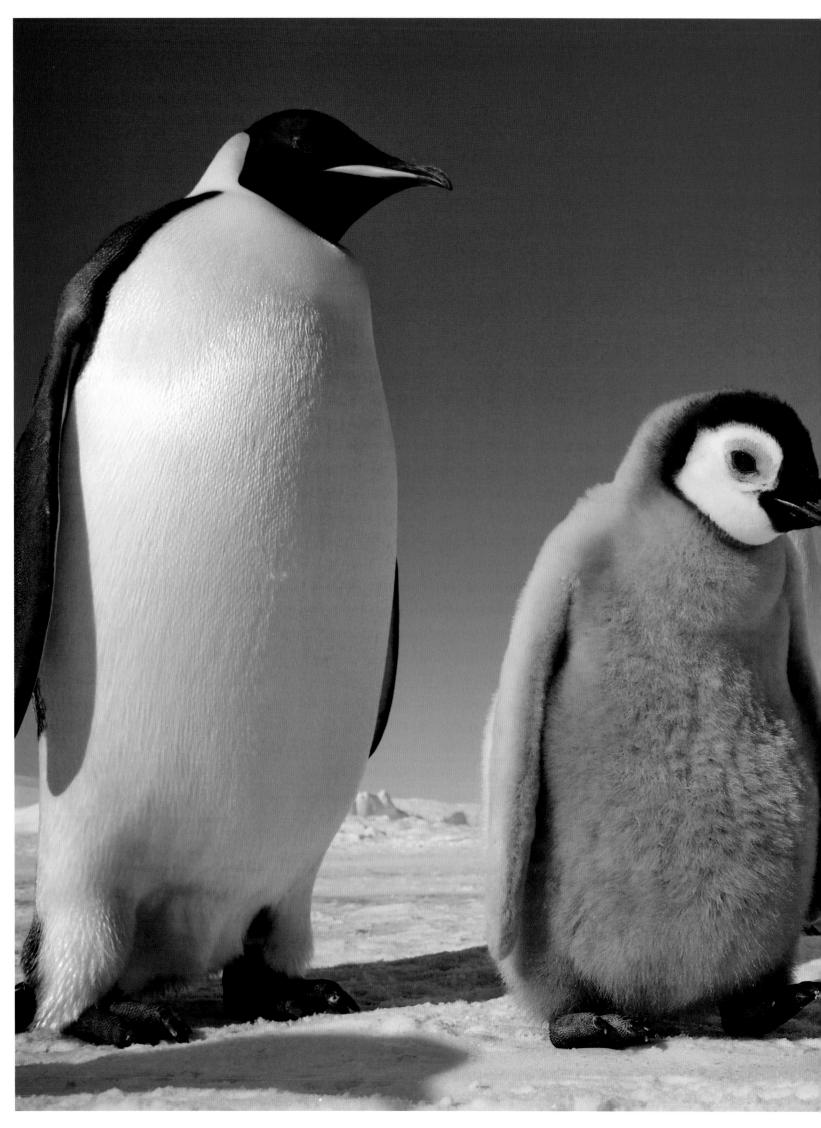

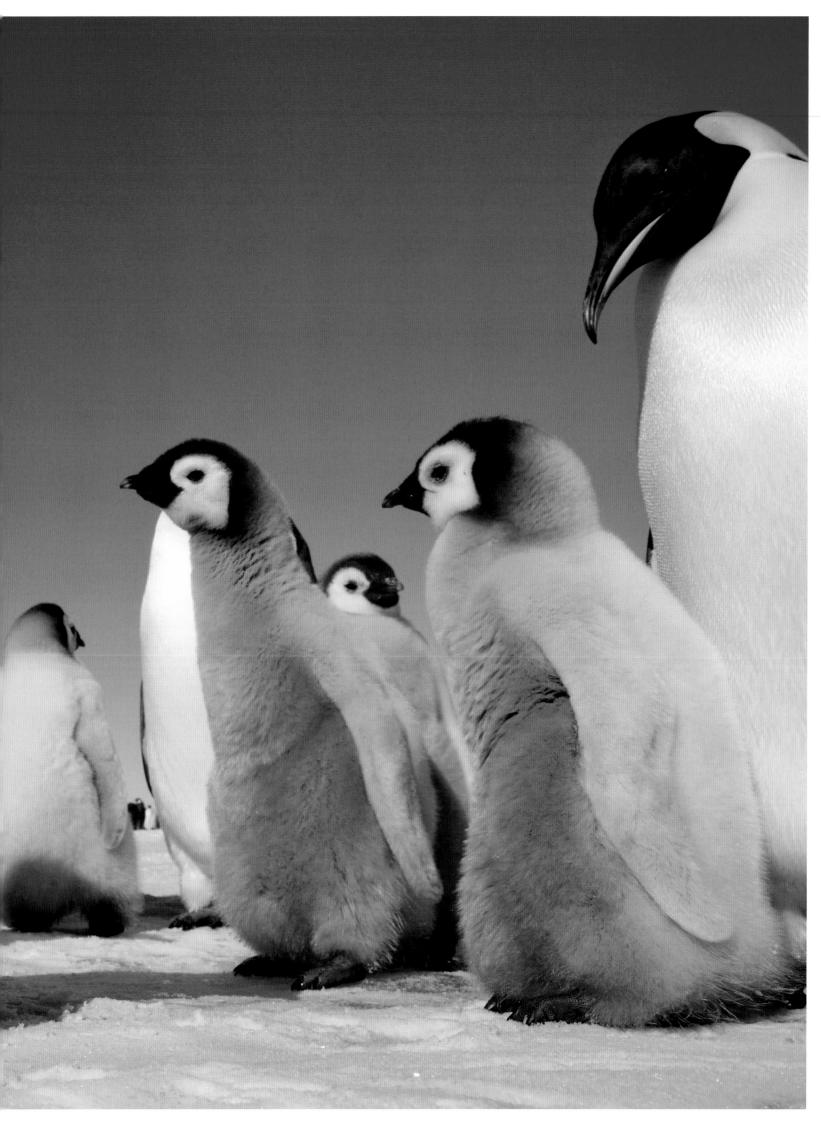

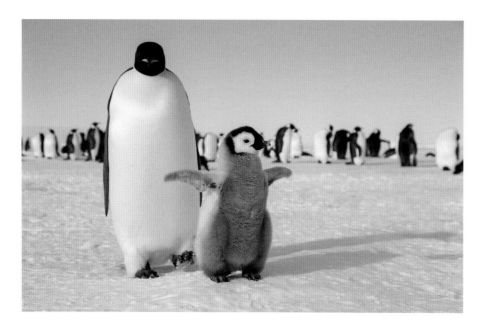

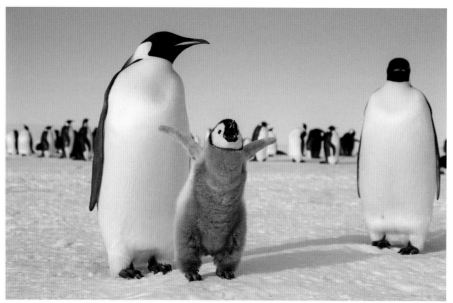

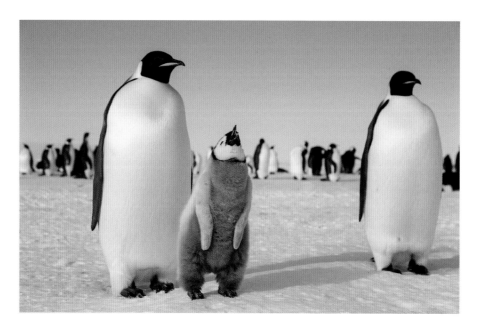

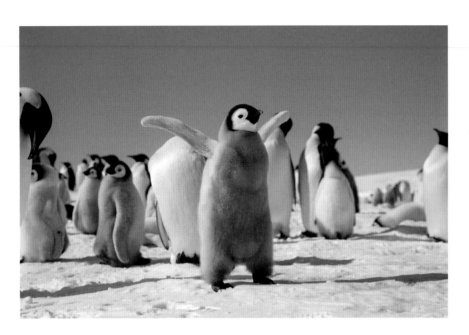

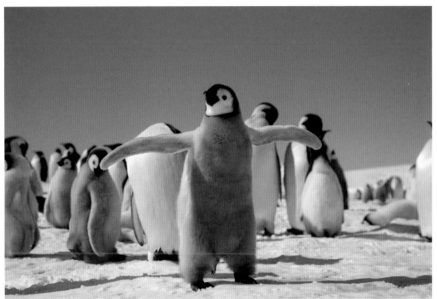

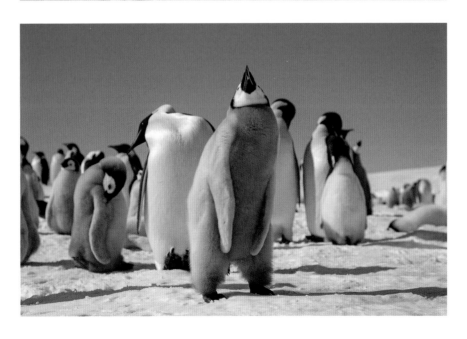

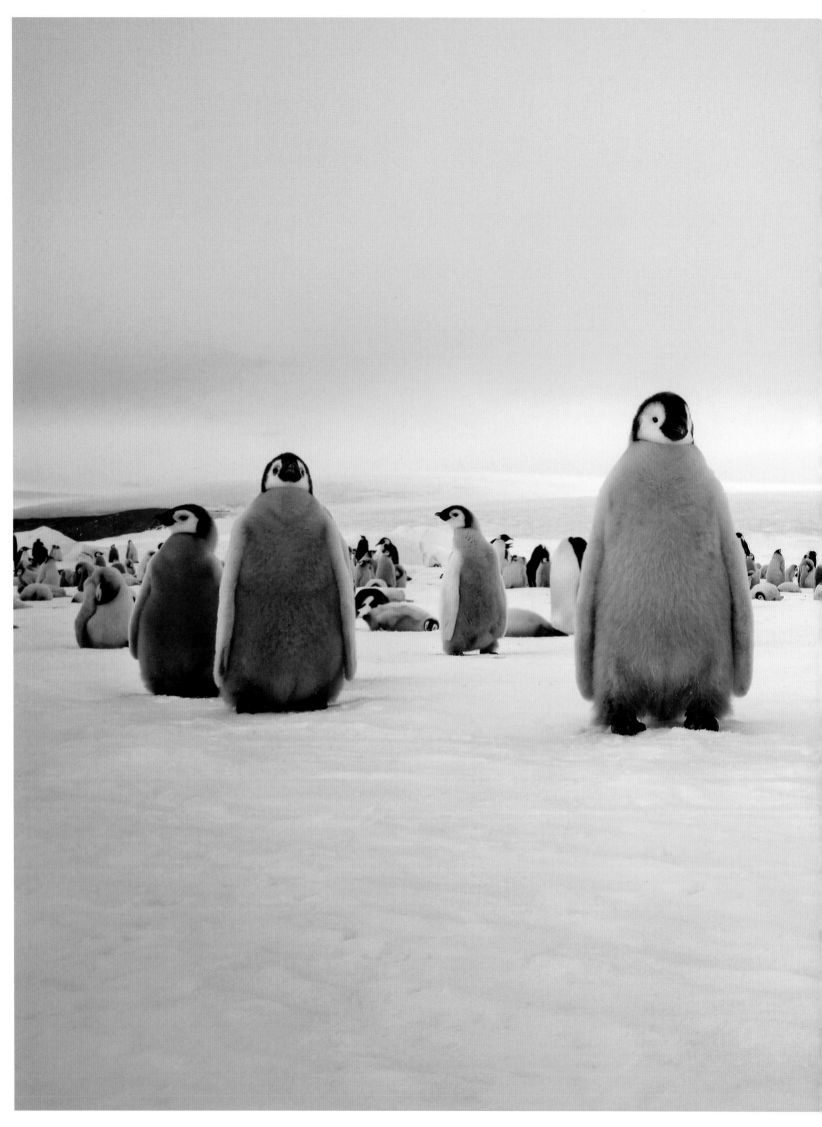

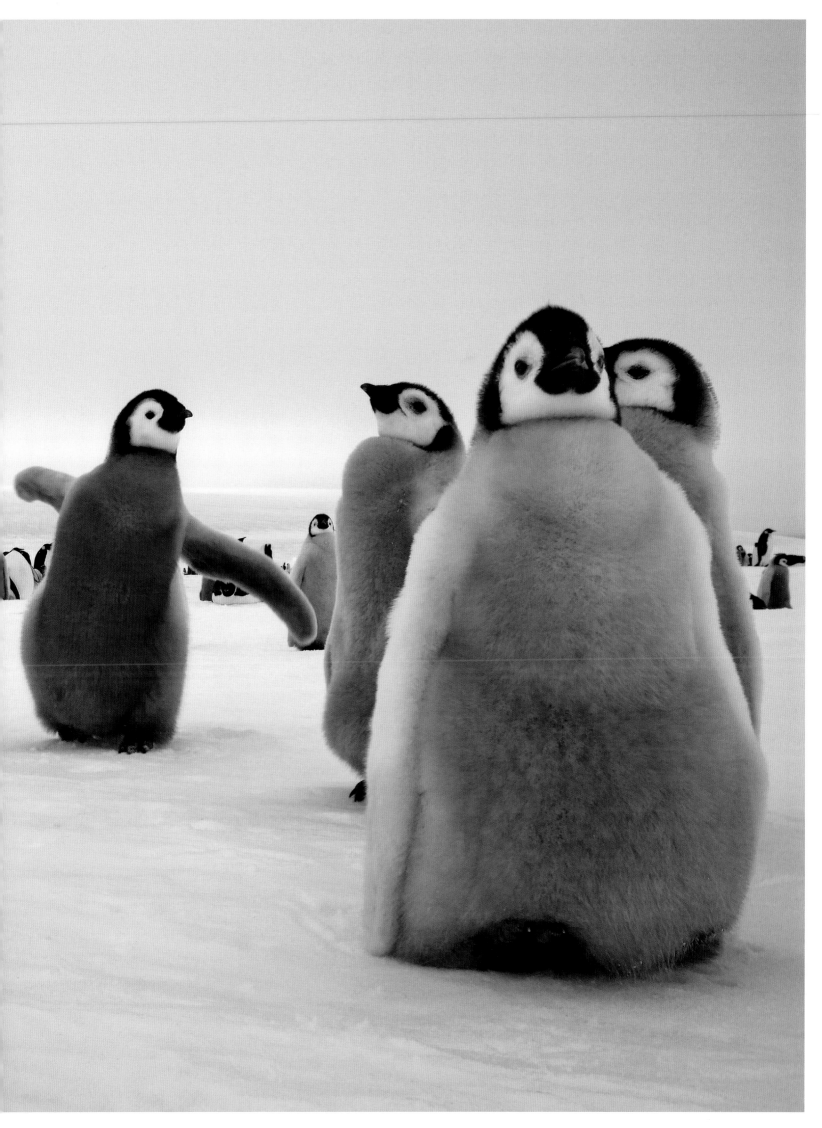

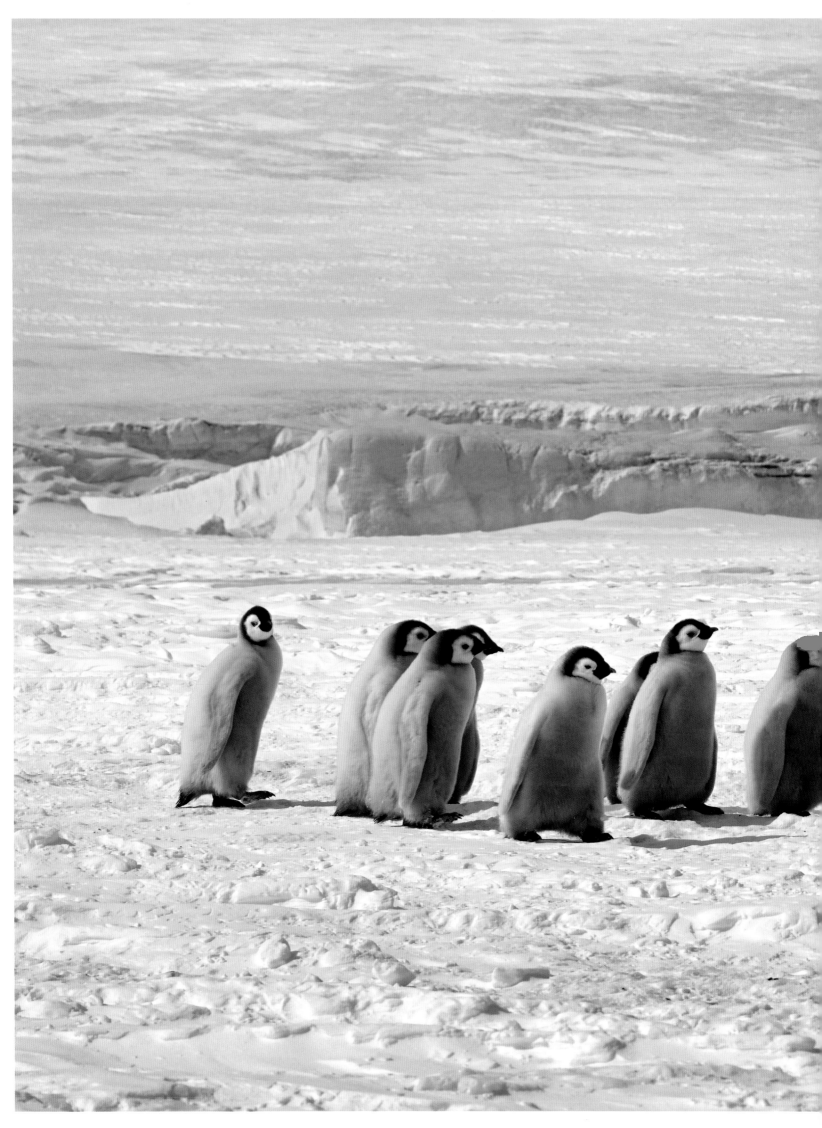

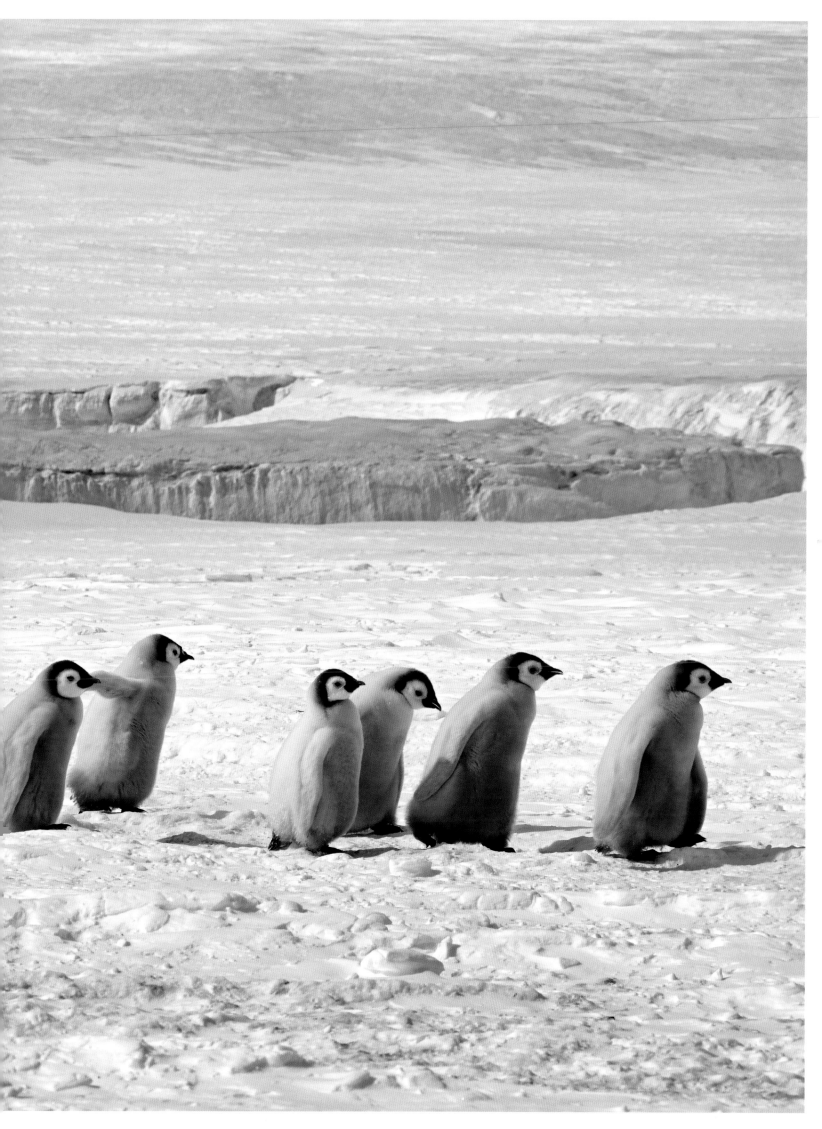

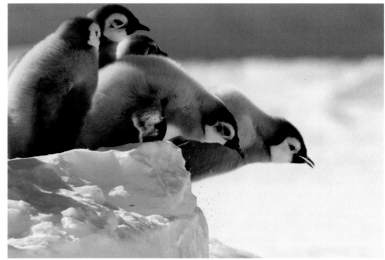

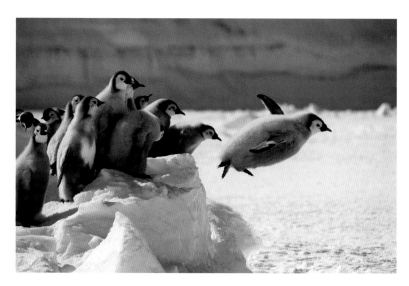
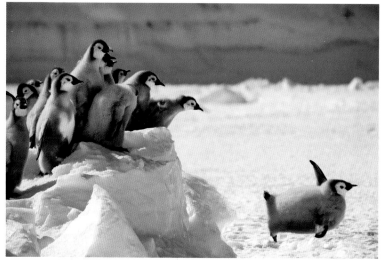

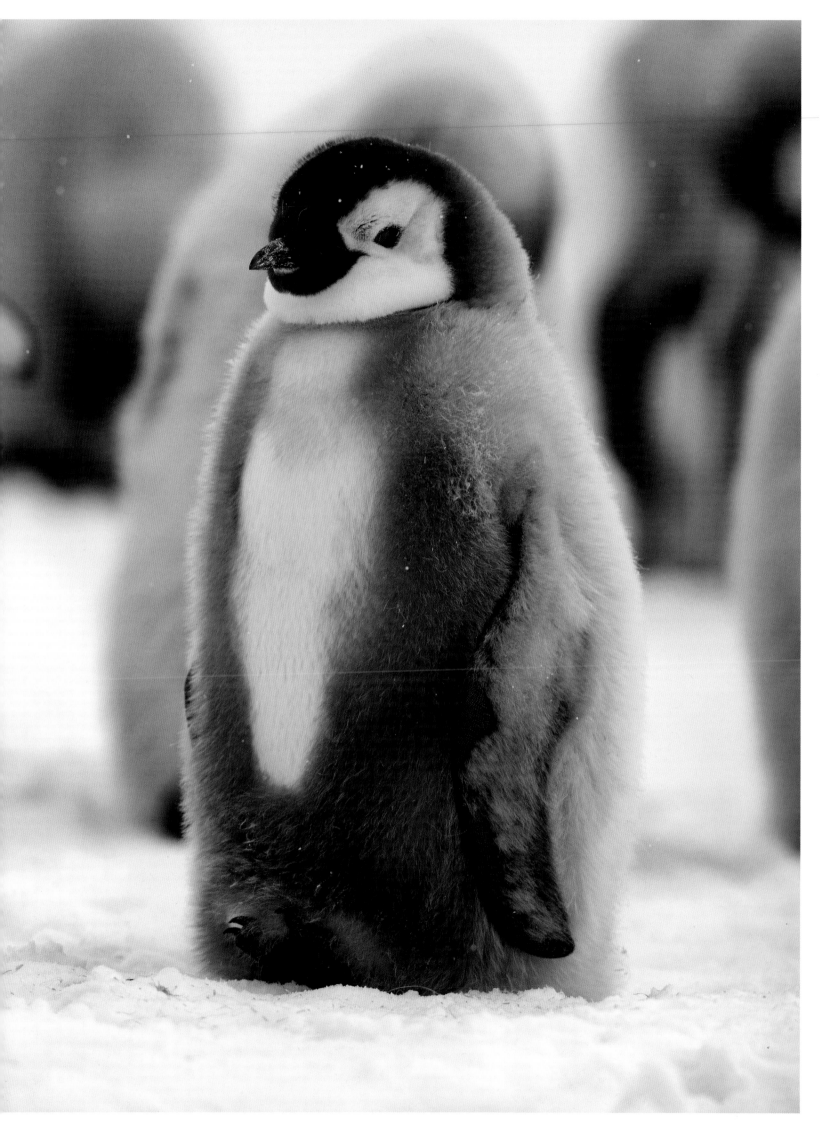

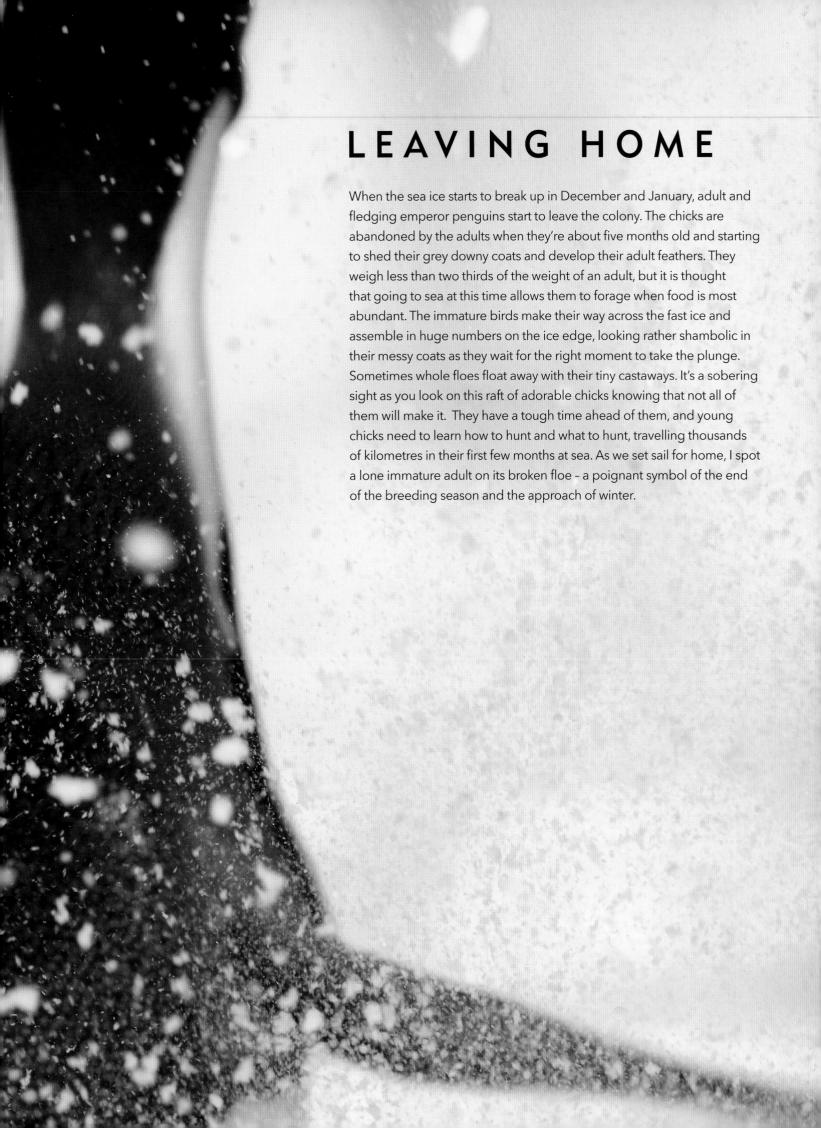

LEAVING HOME

When the sea ice starts to break up in December and January, adult and fledging emperor penguins start to leave the colony. The chicks are abandoned by the adults when they're about five months old and starting to shed their grey downy coats and develop their adult feathers. They weigh less than two thirds of the weight of an adult, but it is thought that going to sea at this time allows them to forage when food is most abundant. The immature birds make their way across the fast ice and assemble in huge numbers on the ice edge, looking rather shambolic in their messy coats as they wait for the right moment to take the plunge. Sometimes whole floes float away with their tiny castaways. It's a sobering sight as you look on this raft of adorable chicks knowing that not all of them will make it. They have a tough time ahead of them, and young chicks need to learn how to hunt and what to hunt, travelling thousands of kilometres in their first few months at sea. As we set sail for home, I spot a lone immature adult on its broken floe - a poignant symbol of the end of the breeding season and the approach of winter.

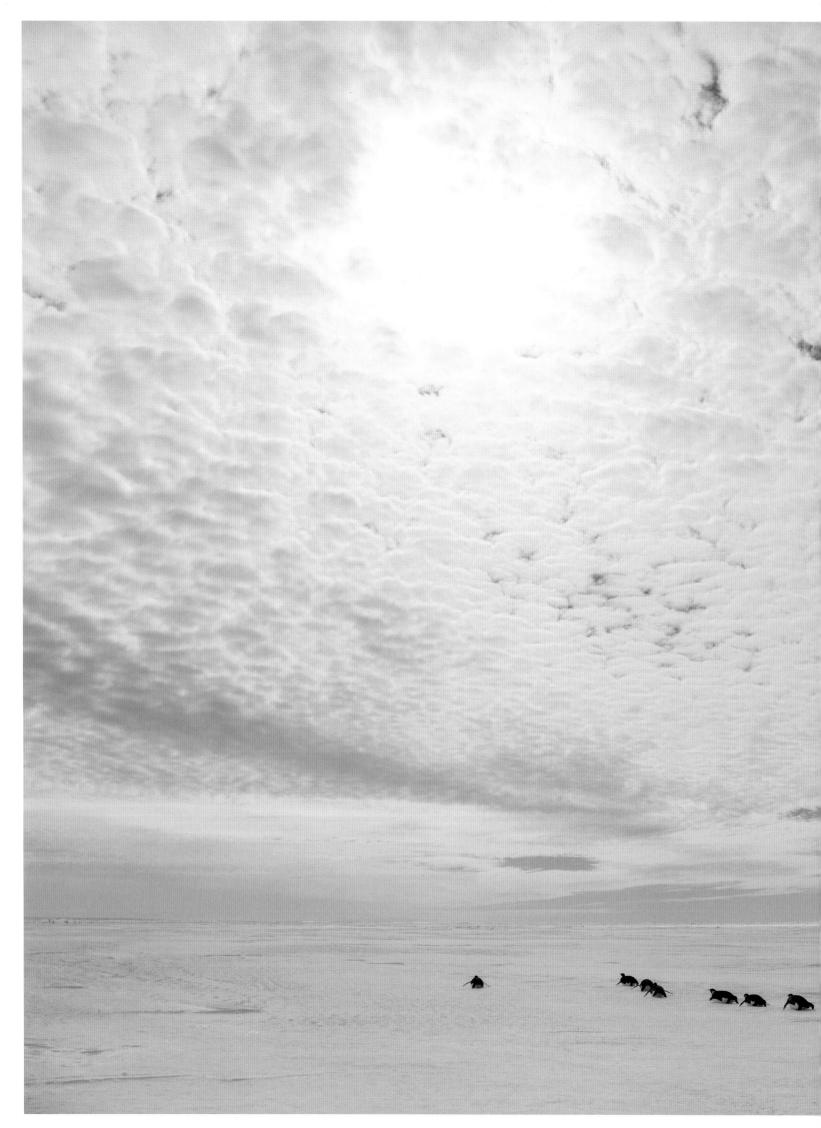

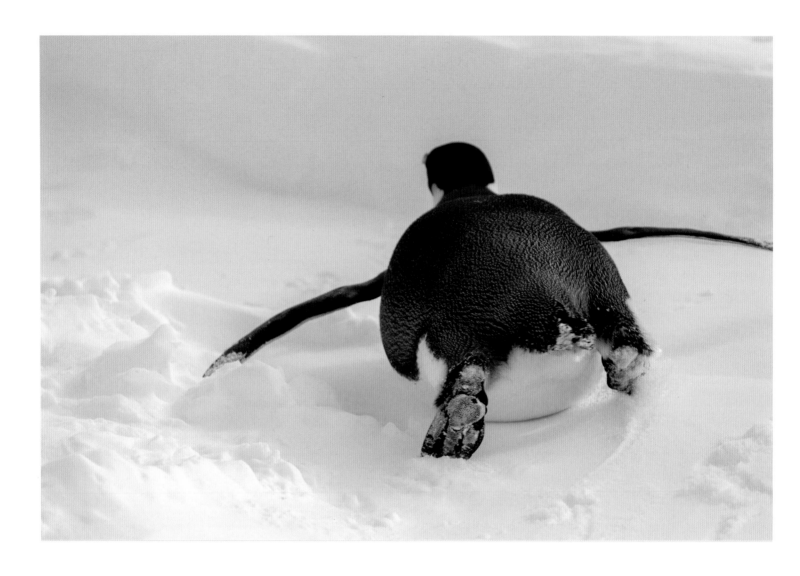

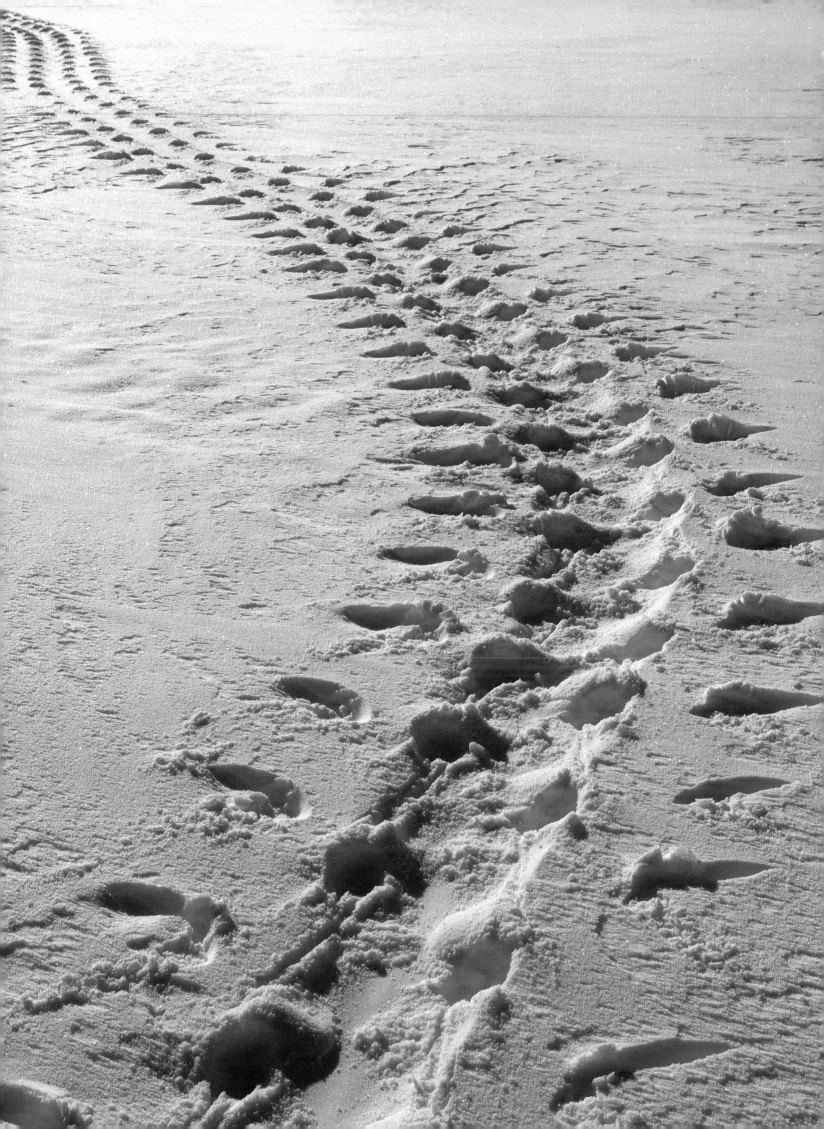

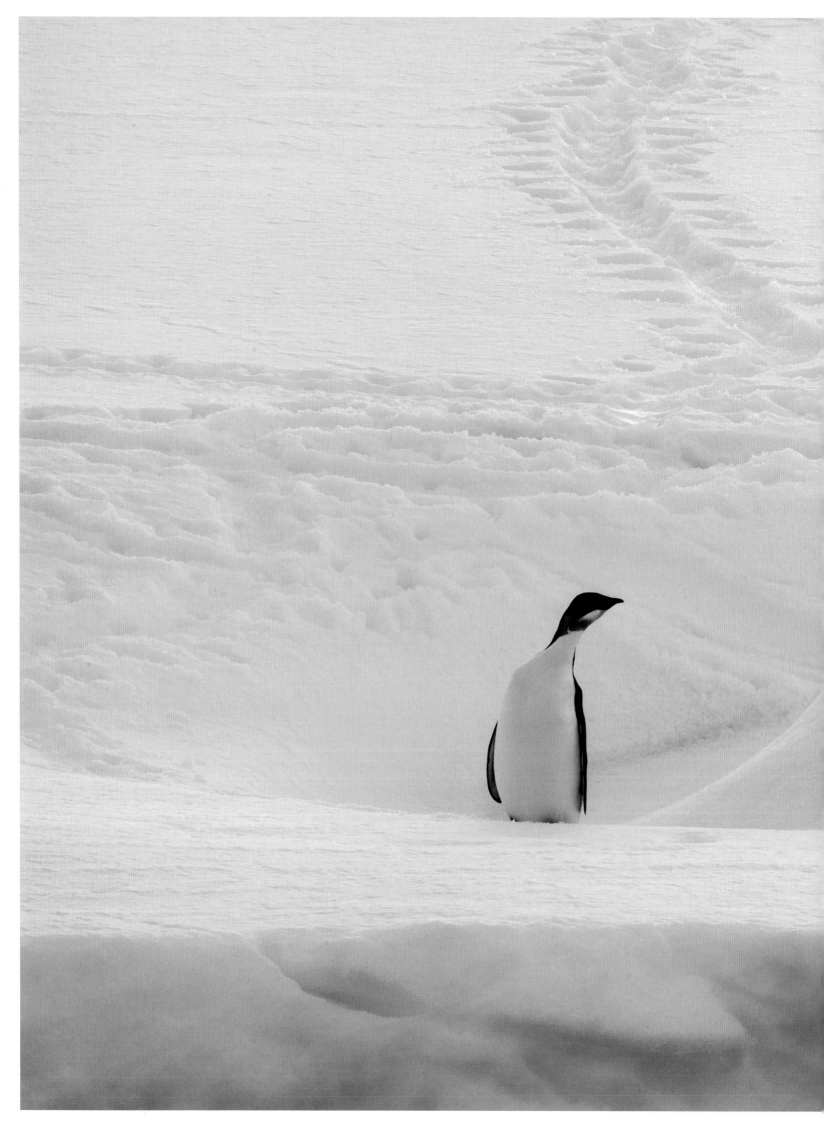

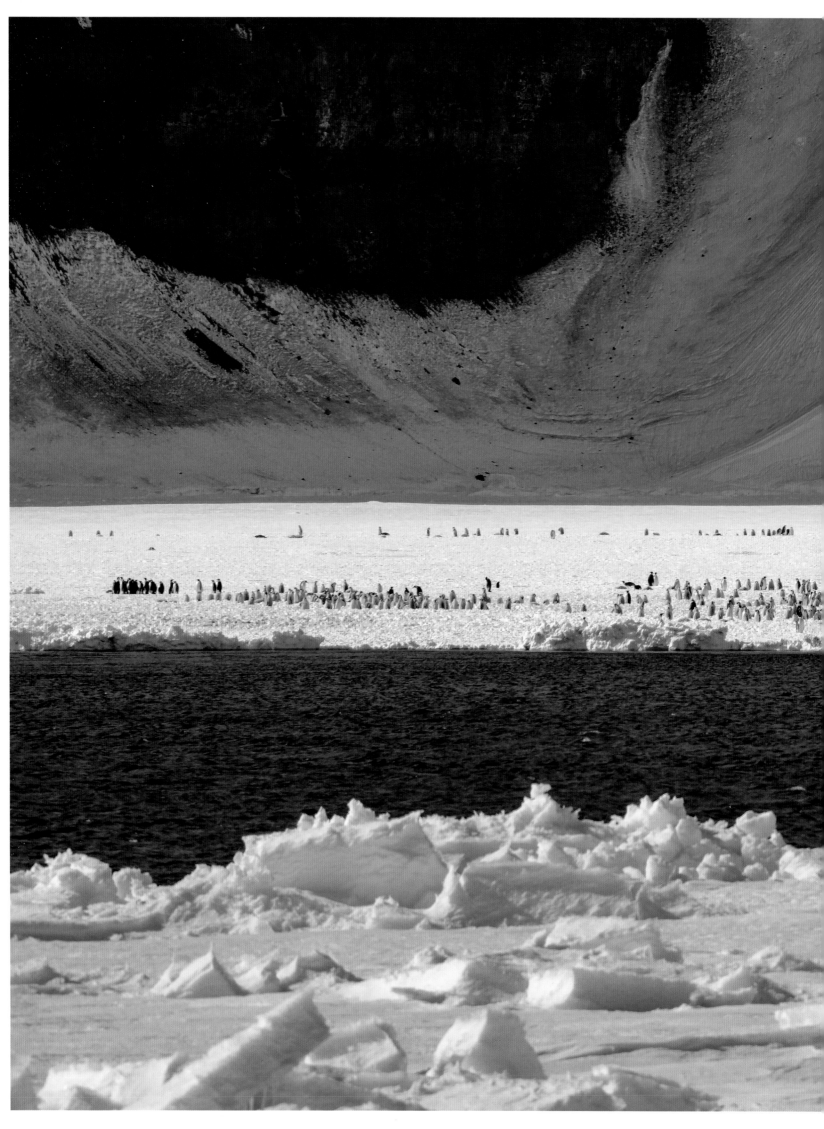

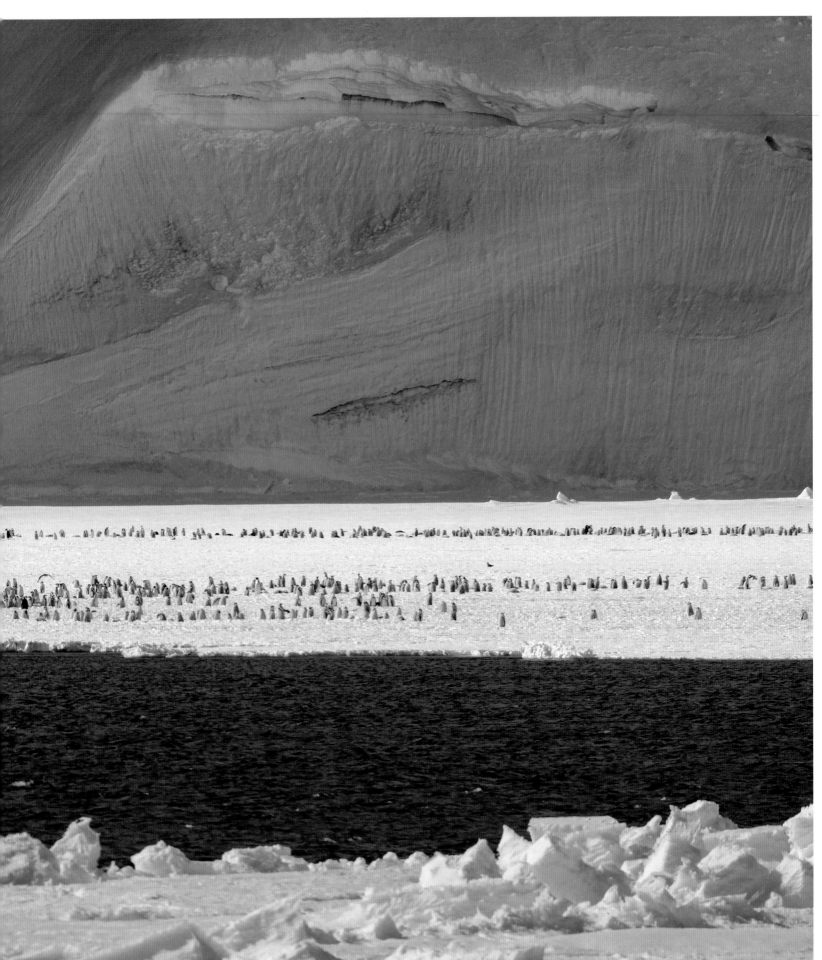

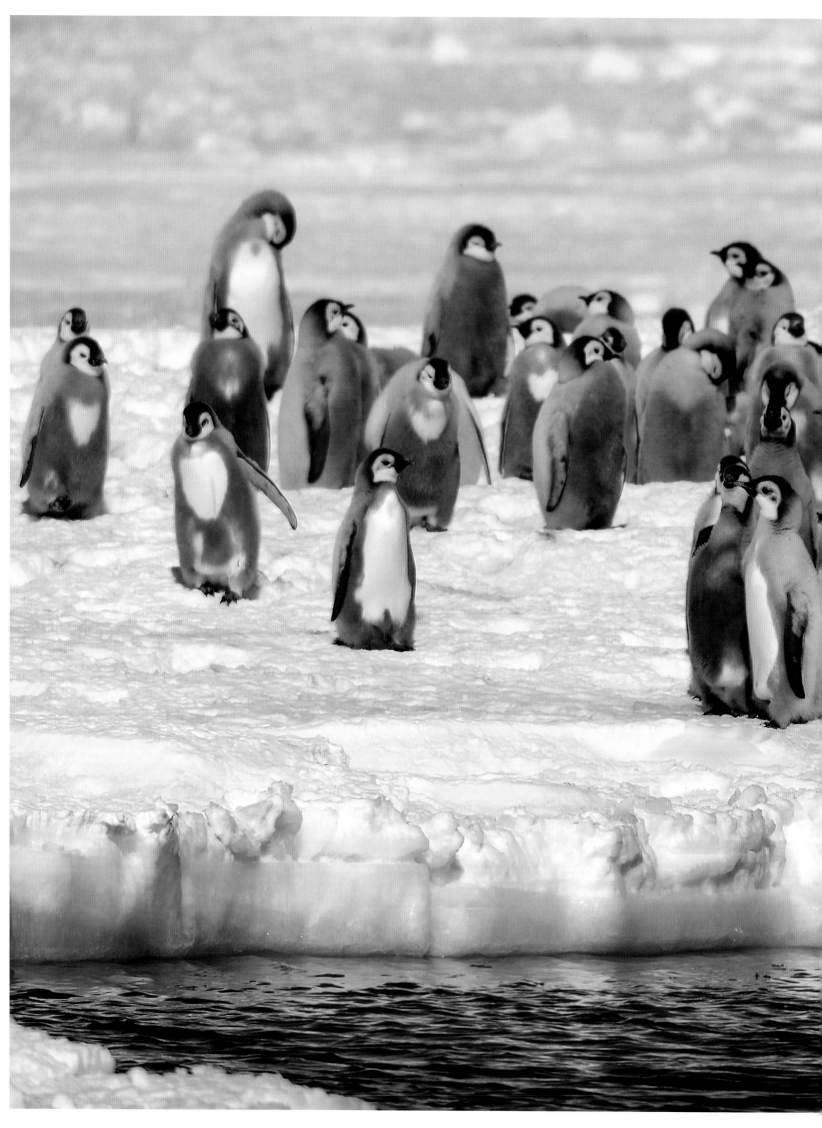

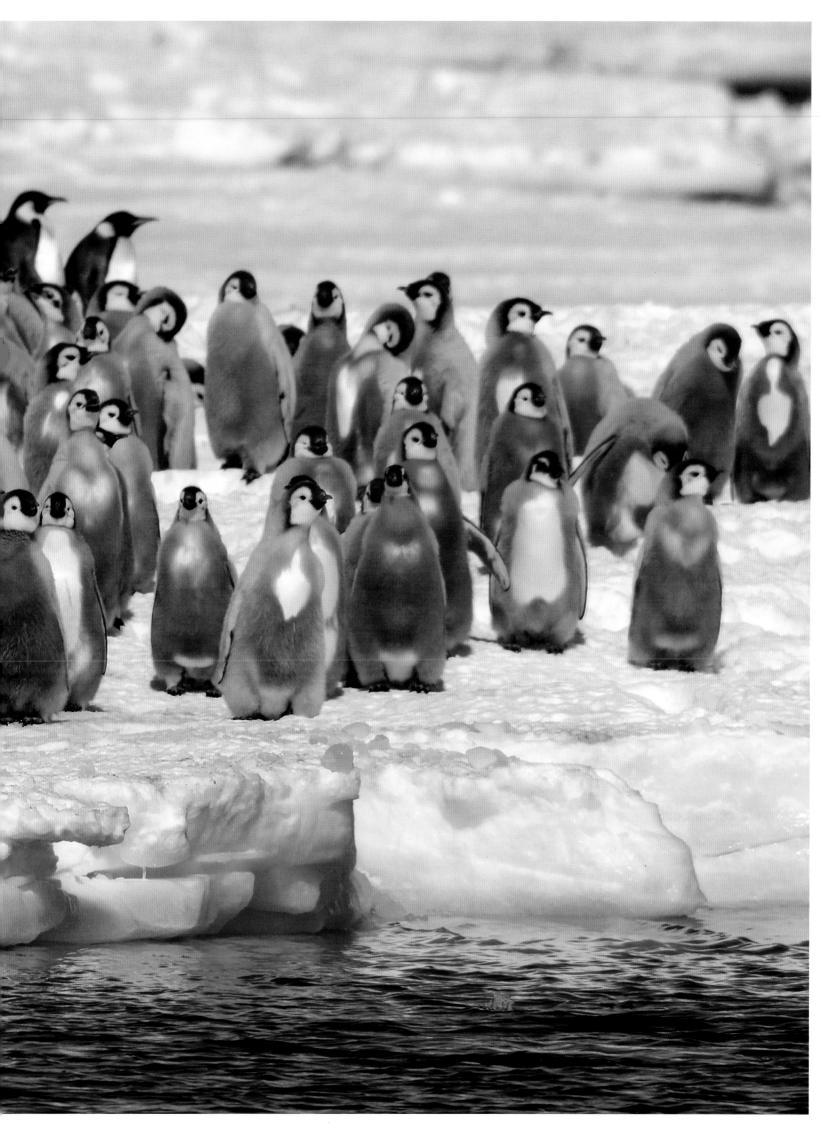

I will never forget the day I took this photograph. It was 22 December 2008, and I was visiting the Cape Washington emperor penguin colony in the Ross Sea.

I was watching some chicks a long way away through my binoculars when suddenly I spotted this one-in-a-million chick with a perfect heart on its chest where it had started to lose its grey downy feathers and moult into its white adult plumage. I was so excited but was scared to take my eye off the chick in case I lost sight of it in the crèche, and so I had to fumble around in my camera bag at my side, trying to assemble my long lens and converter on the camera and put it on my tripod without taking my eye off the chick.

This heart is pure photographic serendipity. I managed to grab just a handful of frames before the chick turned and was lost in the melee of the crèche. Though I've seen thousands and thousands of emperor chicks, I've never seen one with a heart like this since. But I'll keep looking…

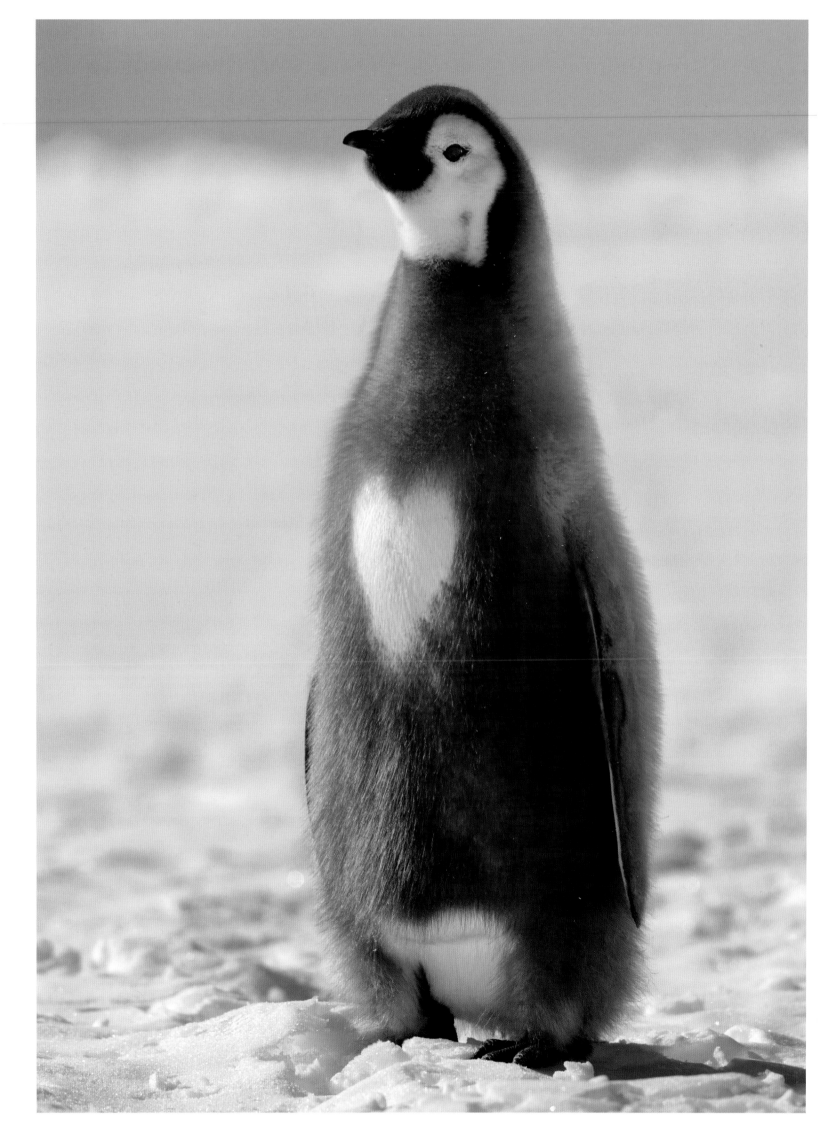

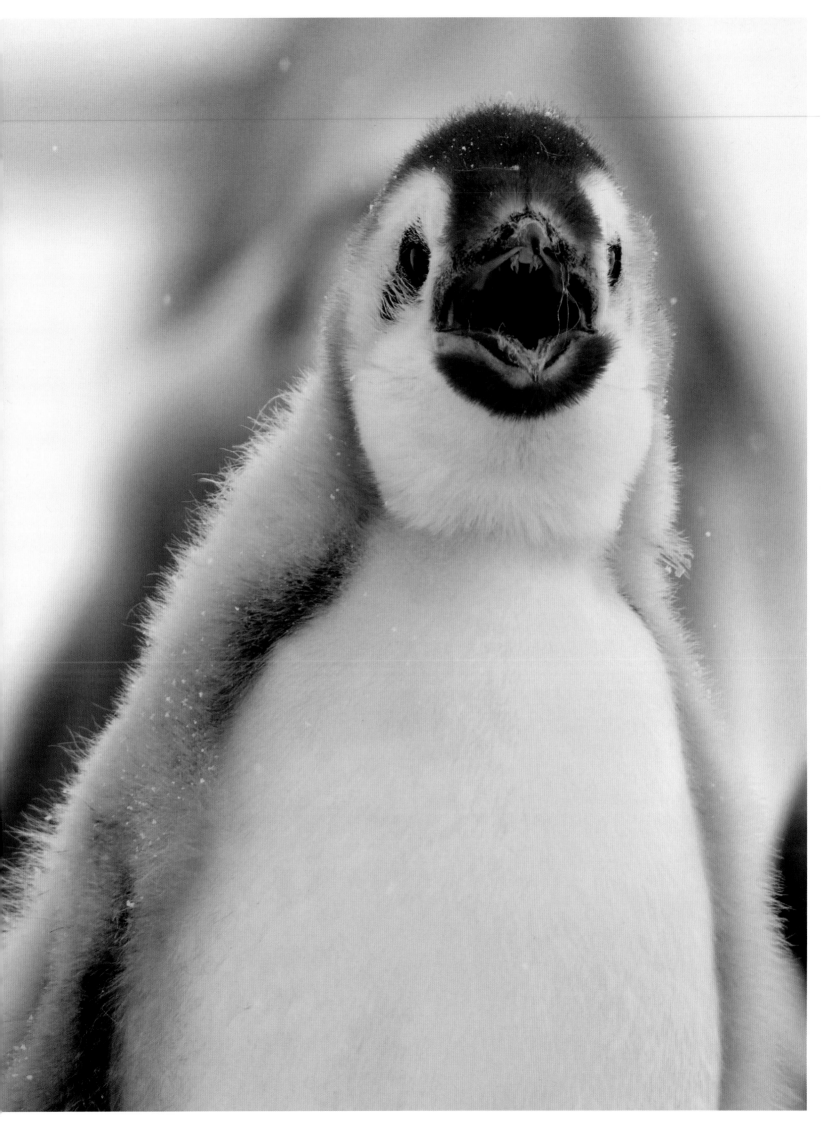

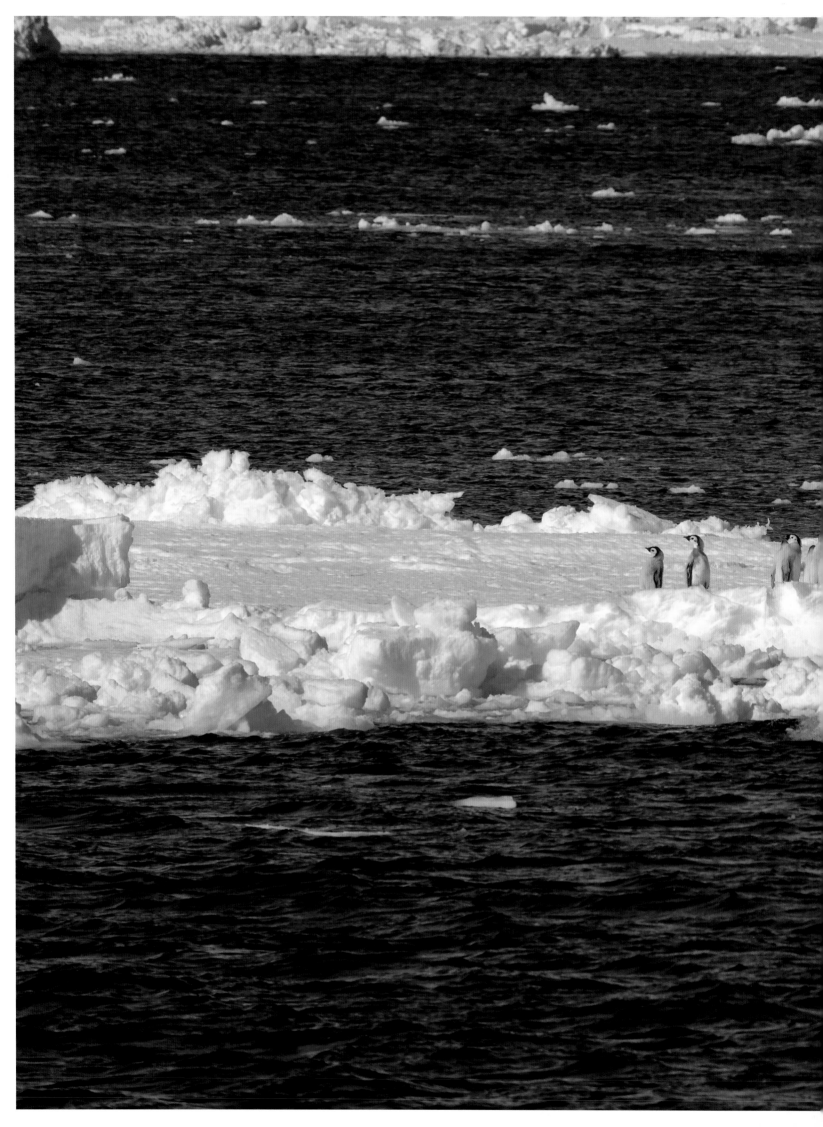

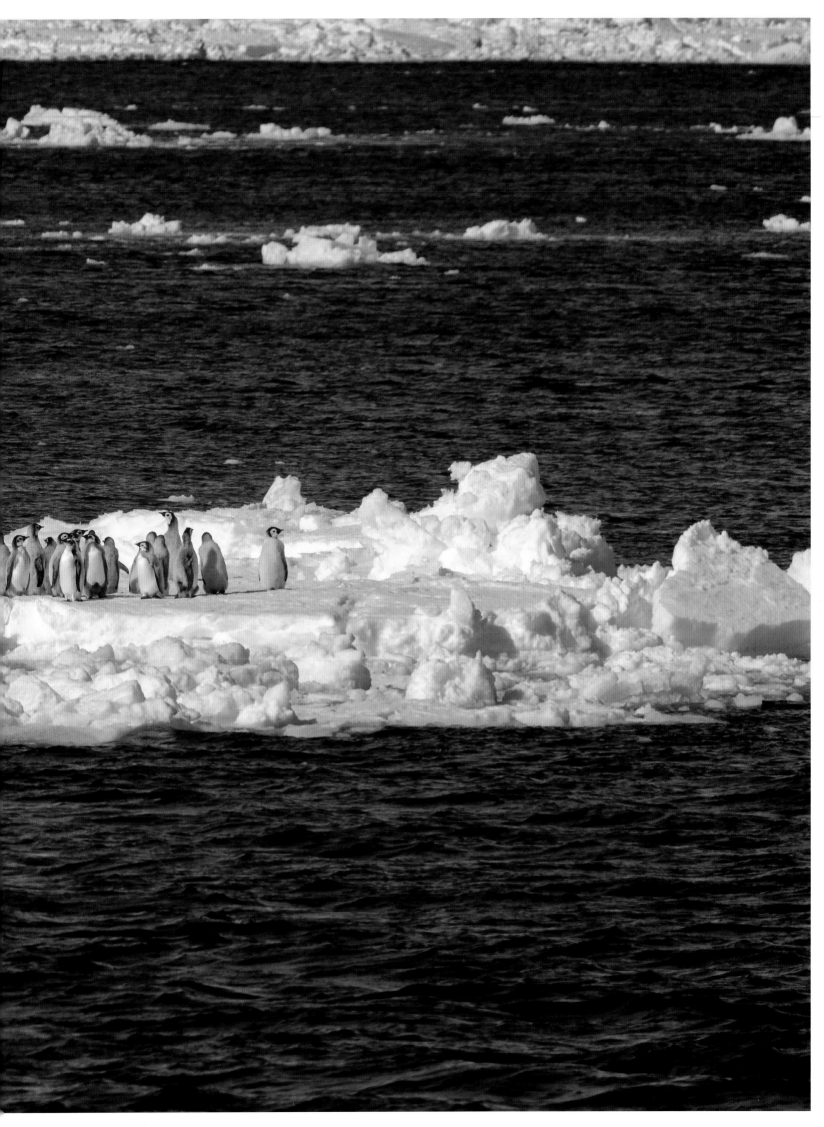

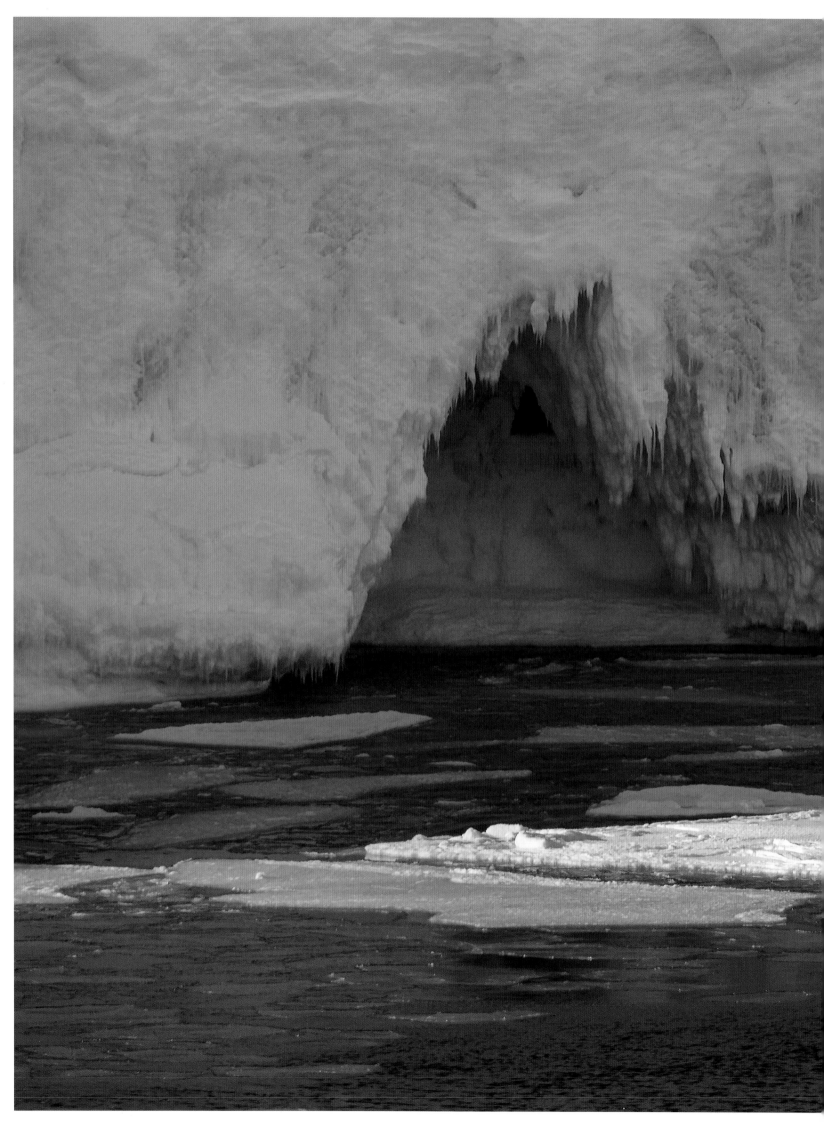

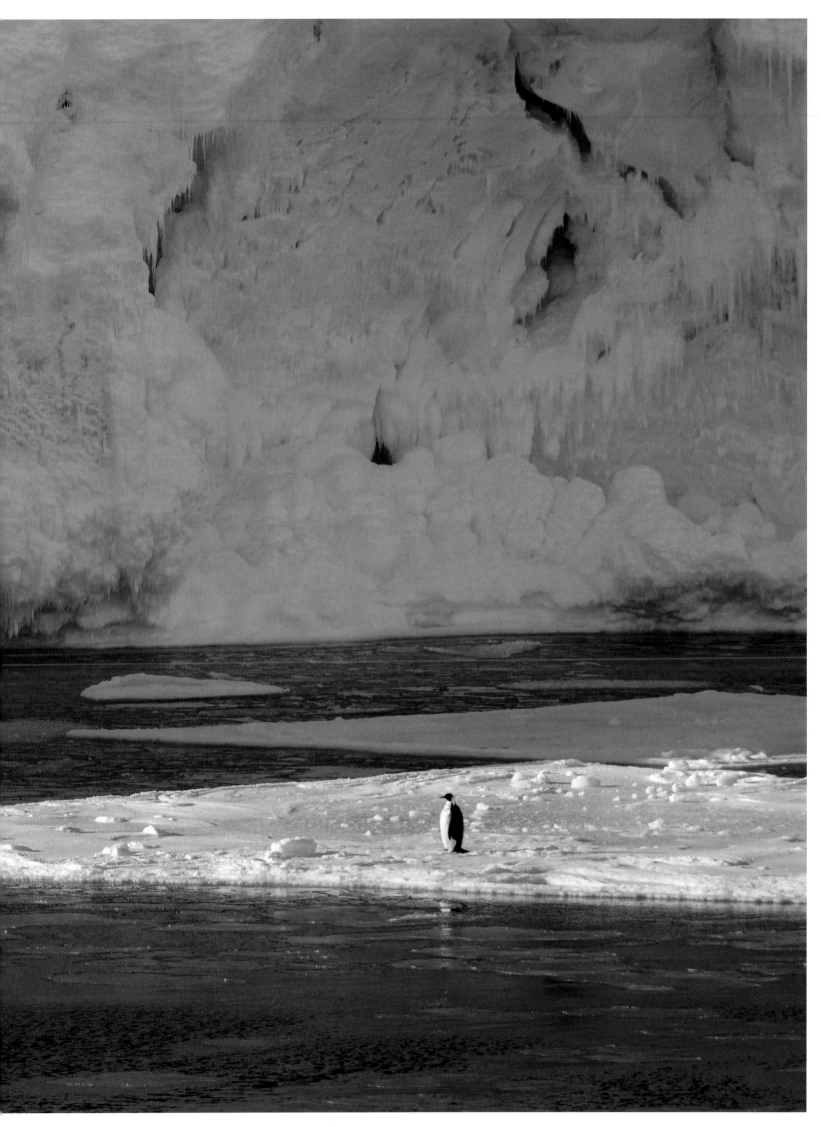

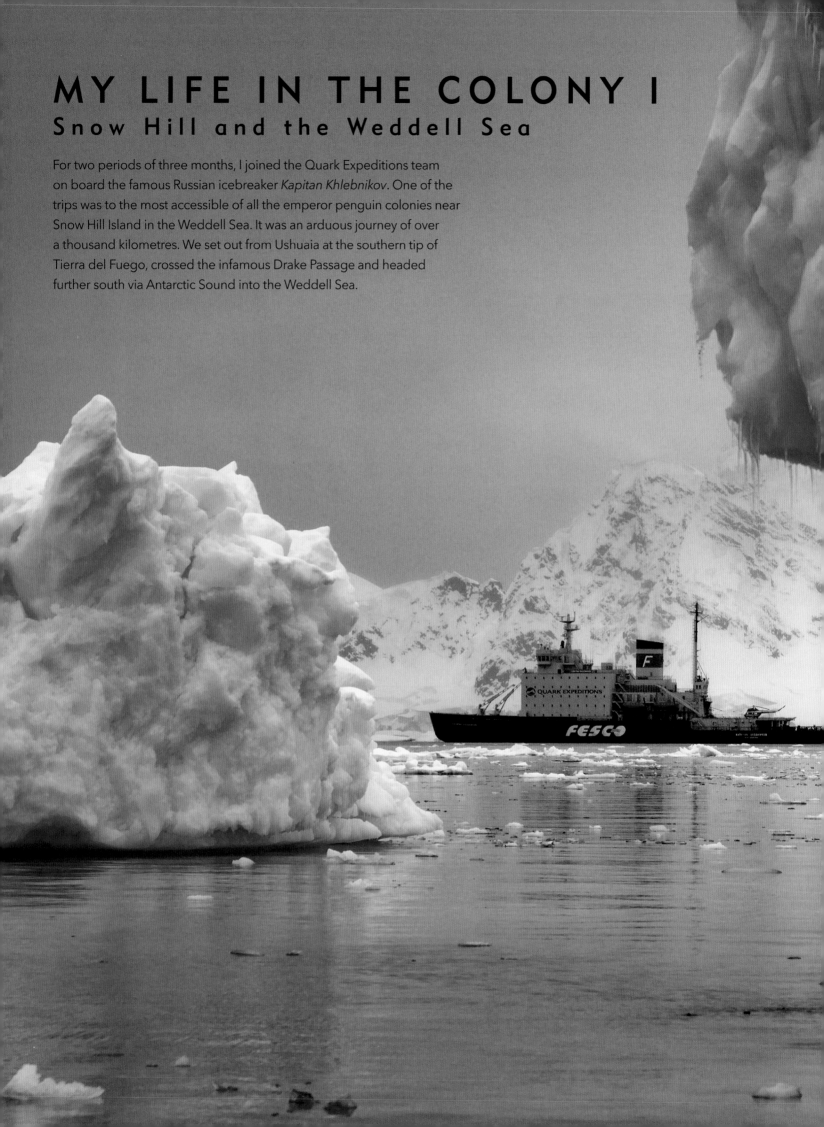

MY LIFE IN THE COLONY I
Snow Hill and the Weddell Sea

For two periods of three months, I joined the Quark Expeditions team on board the famous Russian icebreaker *Kapitan Khlebnikov*. One of the trips was to the most accessible of all the emperor penguin colonies near Snow Hill Island in the Weddell Sea. It was an arduous journey of over a thousand kilometres. We set out from Ushuaia at the southern tip of Tierra del Fuego, crossed the infamous Drake Passage and headed further south via Antarctic Sound into the Weddell Sea.

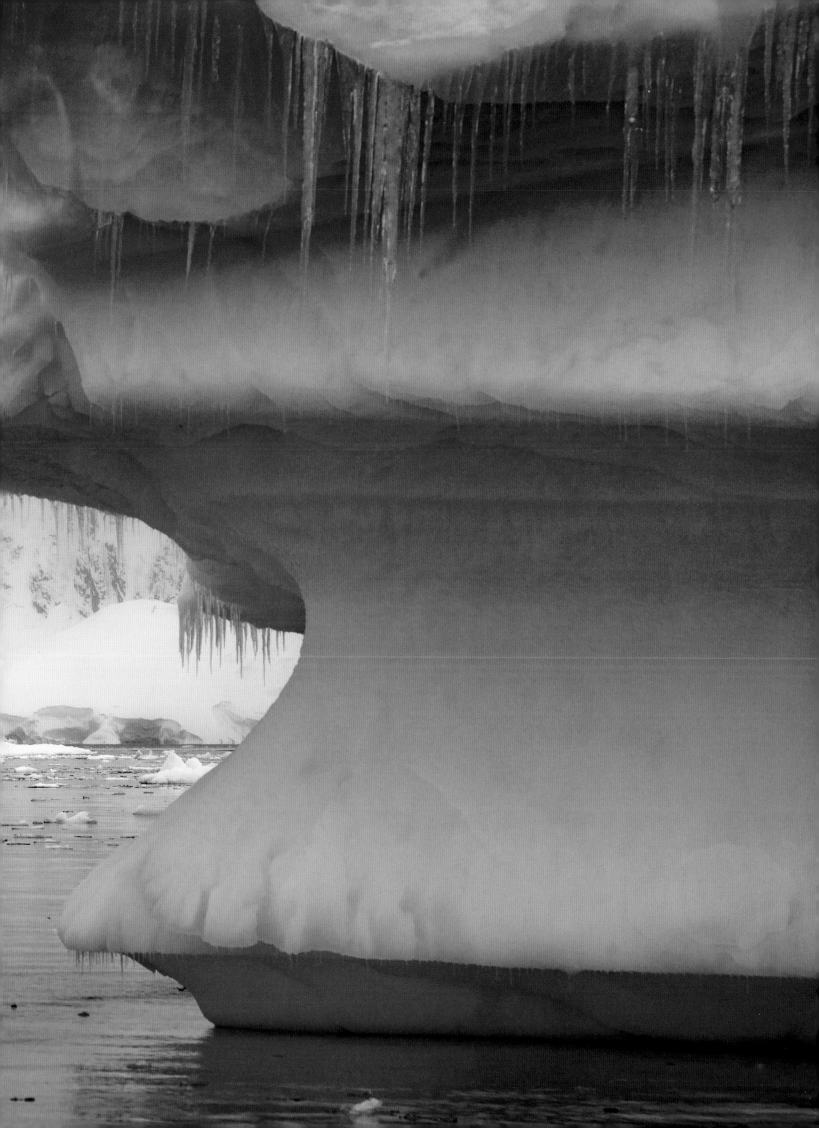

As temperatures plummeted, grease ice
formed like an oily slick on the water's
surface, followed by pancake ice. As we
neared Snow Hill Island, we garaged the
enormous icebreaker in the sea ice.

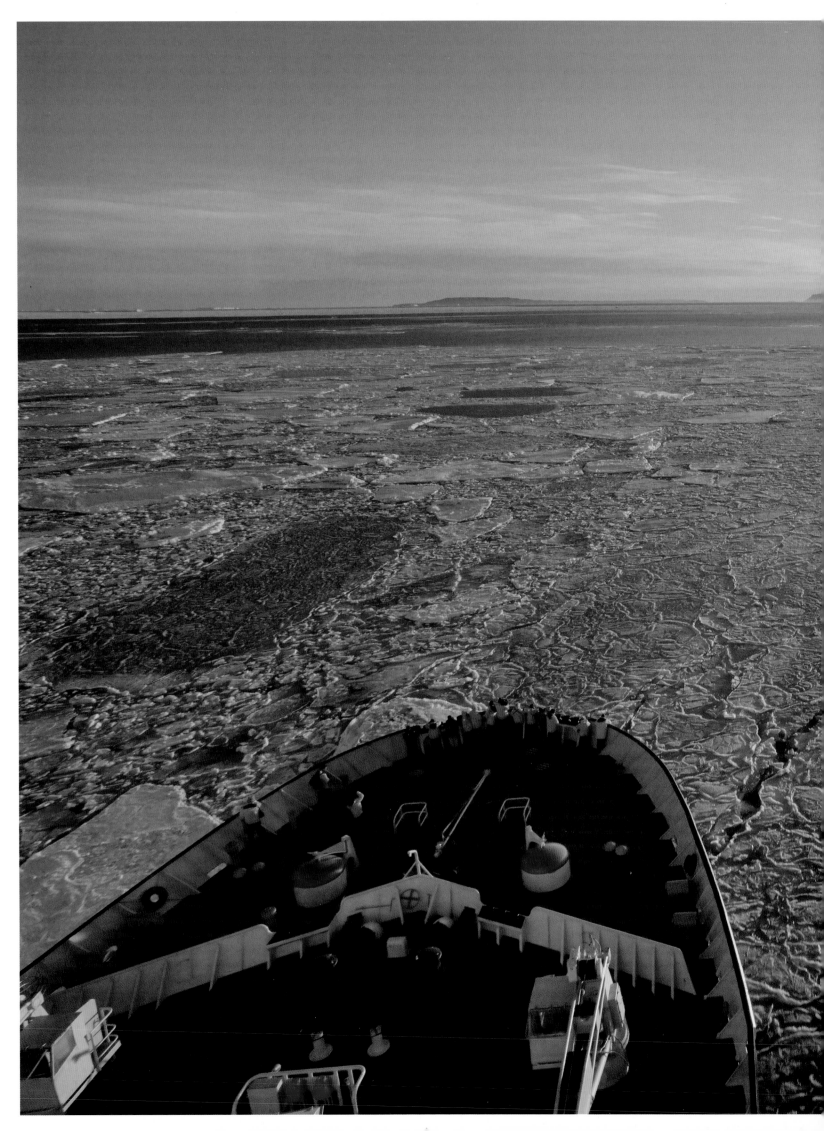

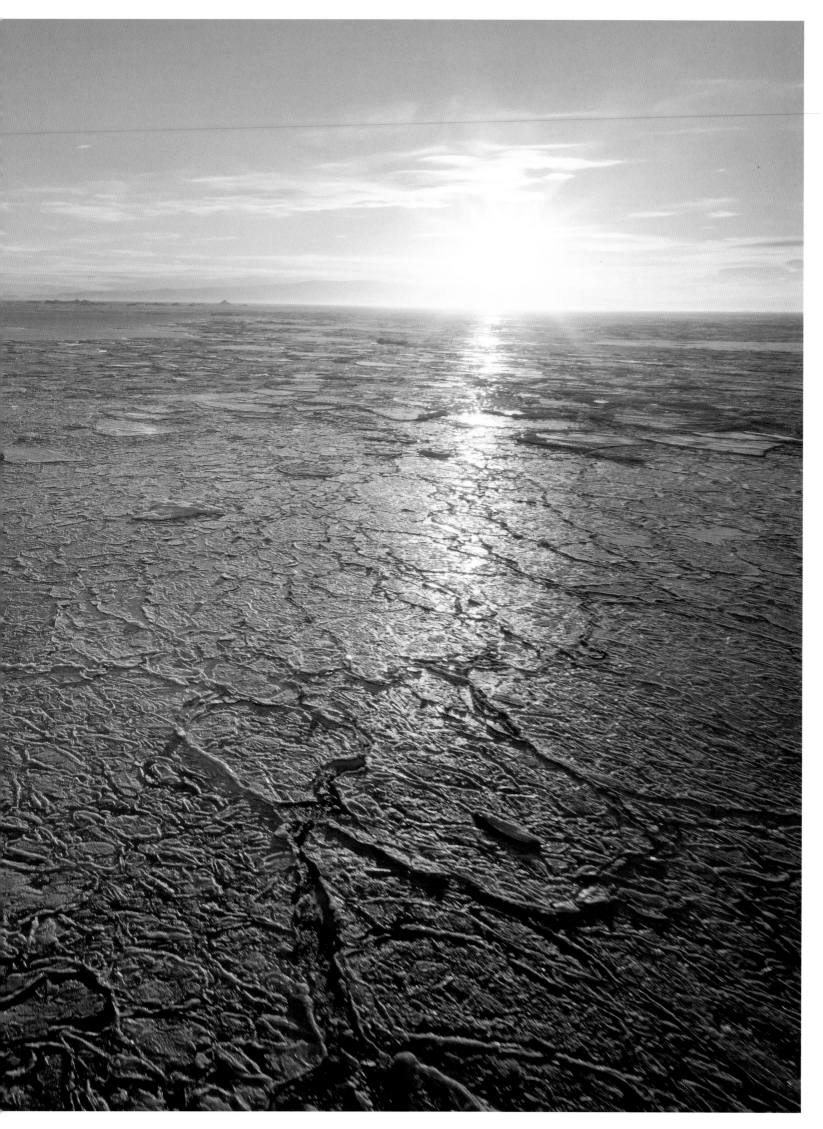

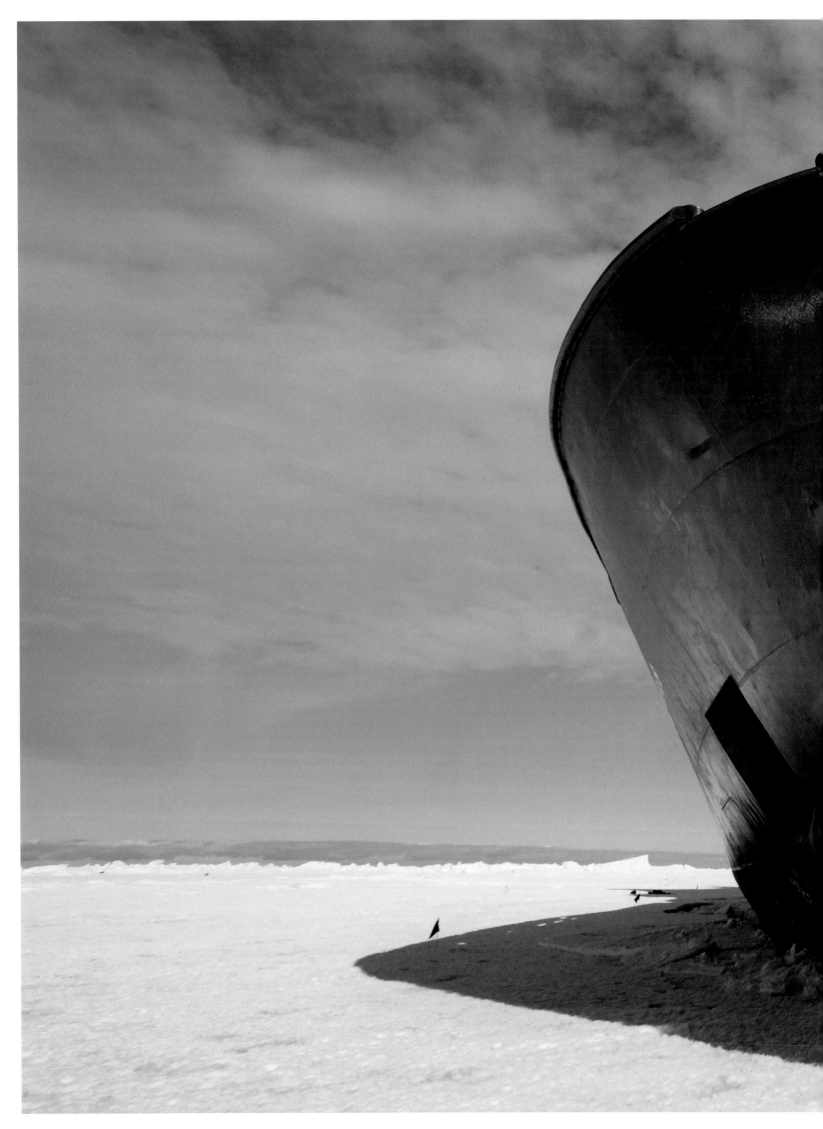

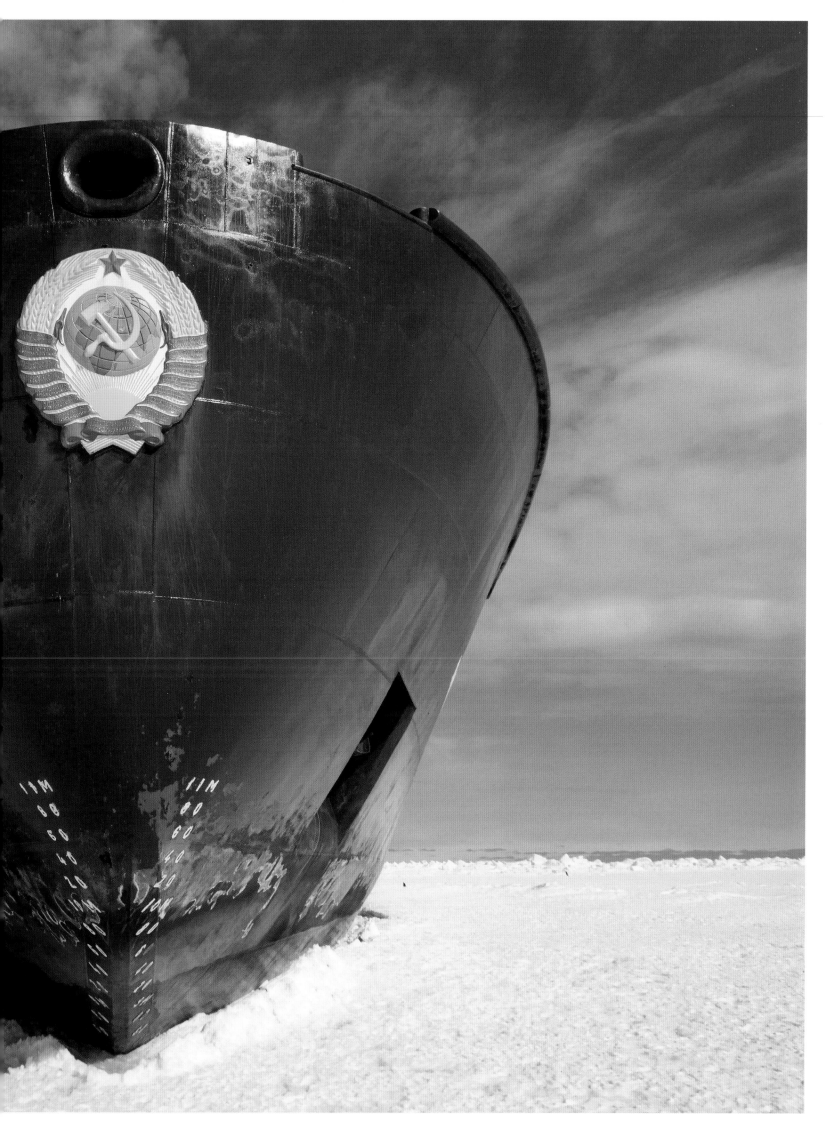

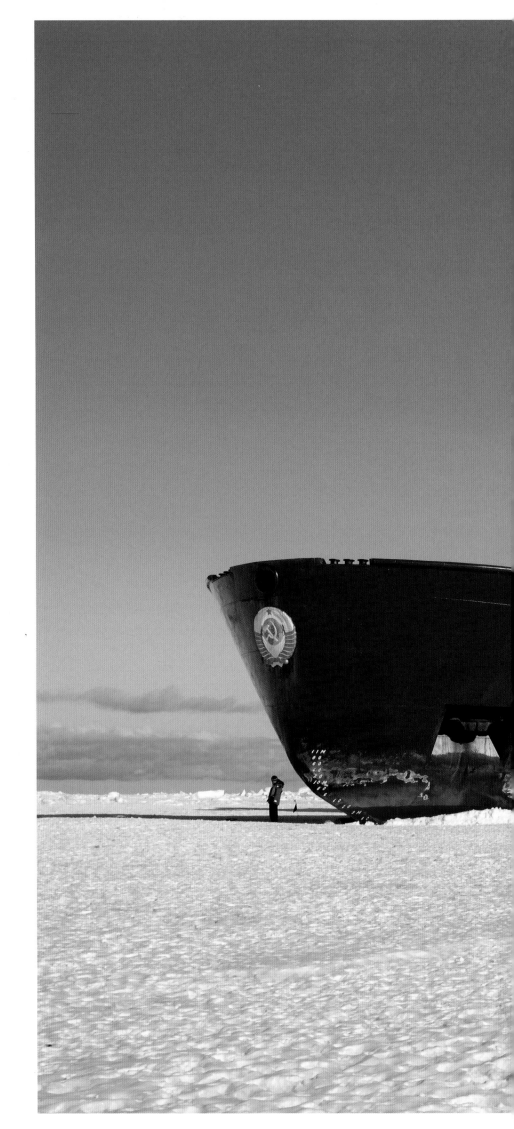

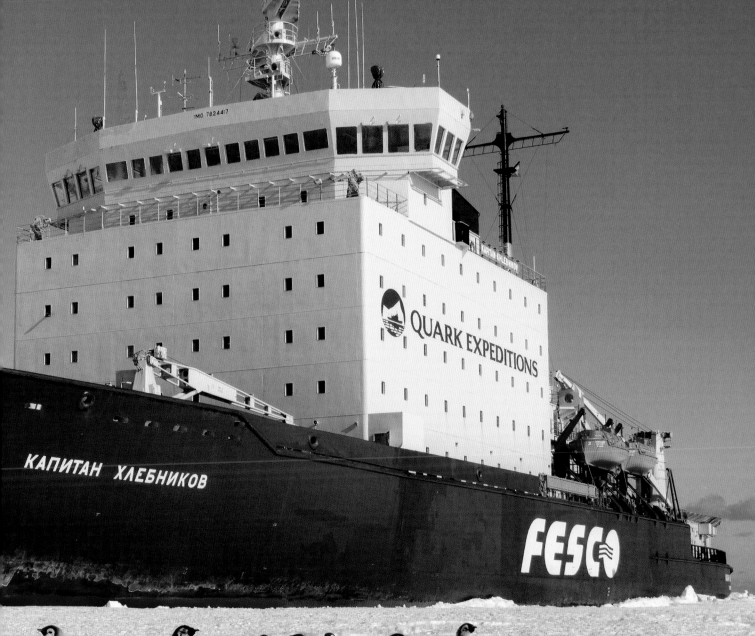

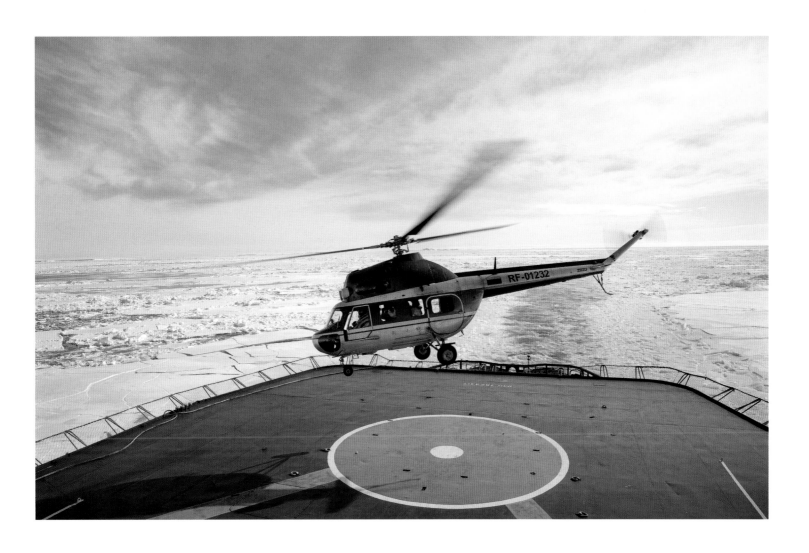

When the weather permitted, the Russian Mi-2 helicopter would take off from the helideck, fly out over miles of ice, past bergs the size of skyscrapers, and set down on the ice at the tented base camp, which the expedition team had erected.

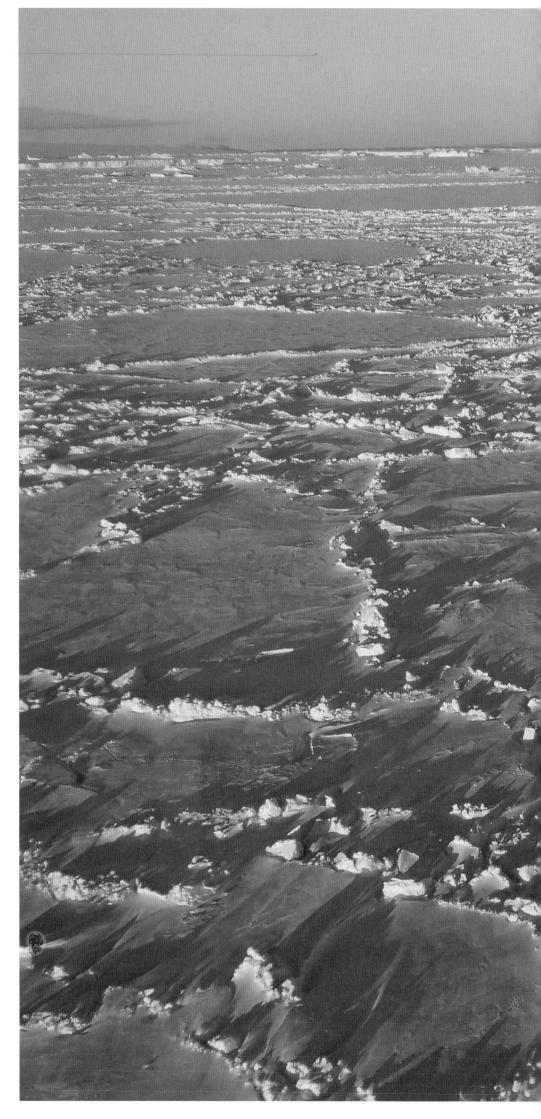

Being on board the *Kapitan Khlebnikov* was a wonderful adventure. I was working with some incredible people, including my dear friend, Irishman Jonathan Shackleton. Jonathan is a cousin of the famous polar explorer Sir Ernest Shackleton, whose ship *Endurance* was beset in the ice of the Weddell Sea on his famous Imperial Trans-Antarctic expedition, before finally being crushed by the pack ice. Due to the unusual climatic conditions, where the wind suddenly dropped for several days, our ship became trapped in the pack ice. As I pointed out to Jonathan, there was another Shackleton beset by ice in the Weddell Sea almost a century after his famous cousin was on board *Endurance*. Happily, we had a far less dramatic ending to our tale. The weather conditions changed, and our icebreaker was able to escape.

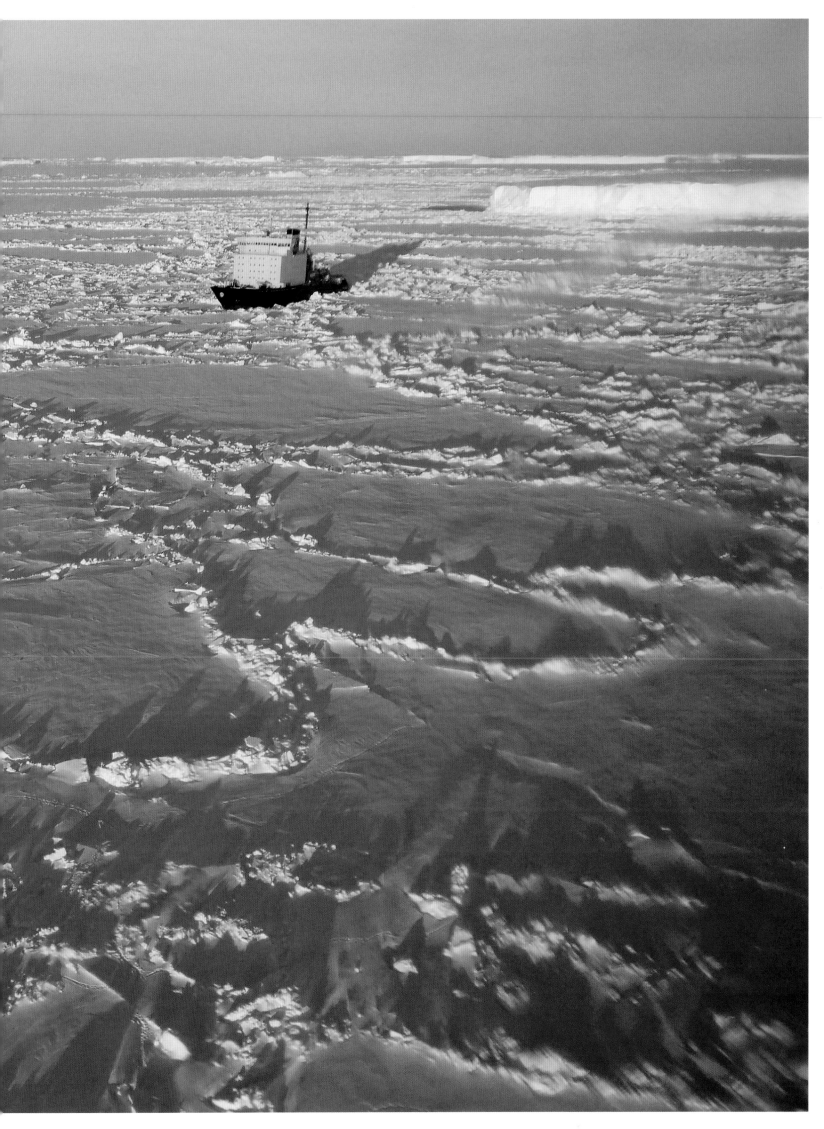

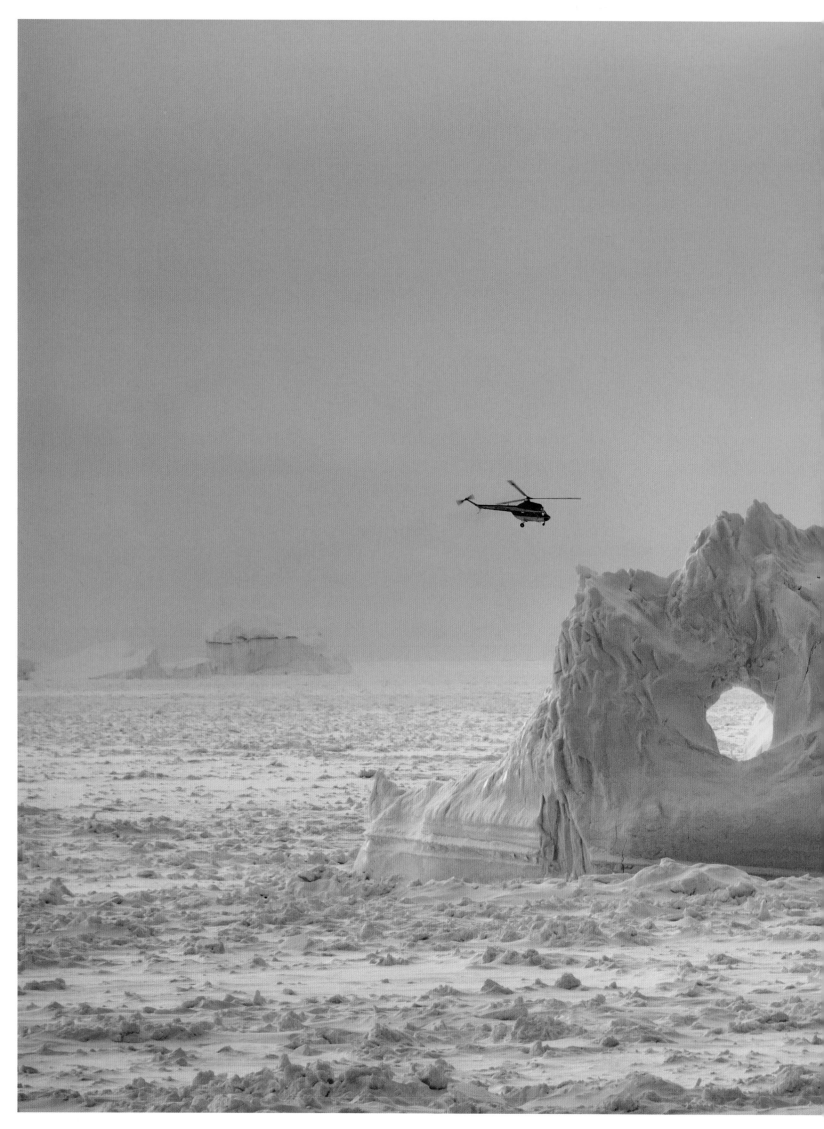

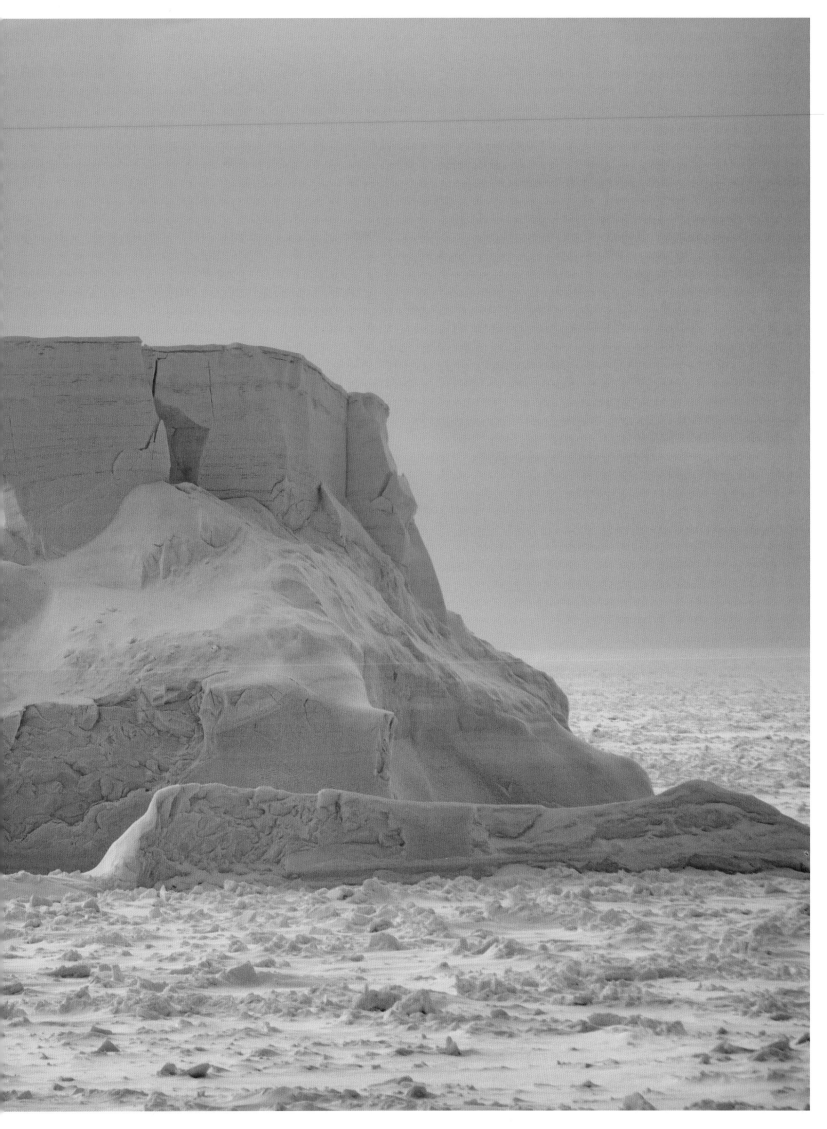

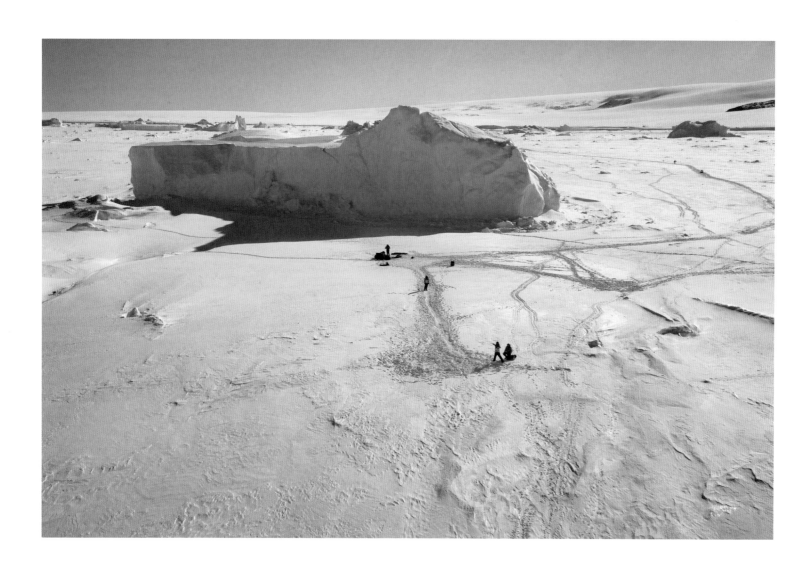

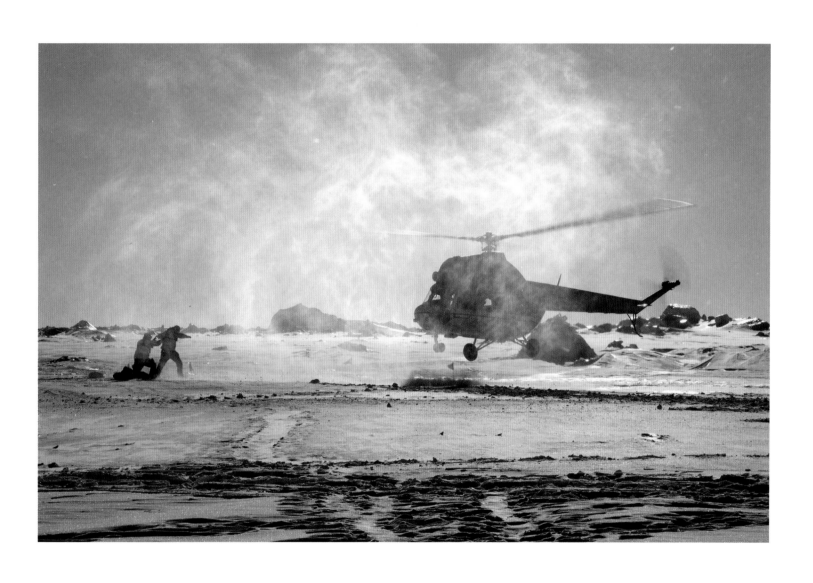

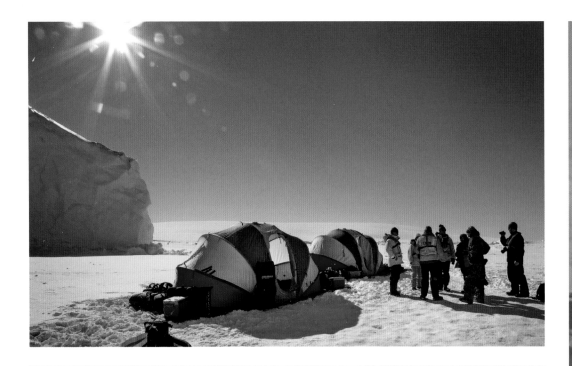

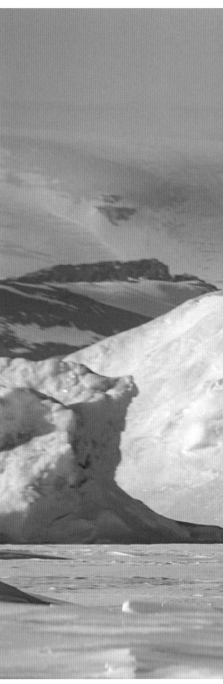

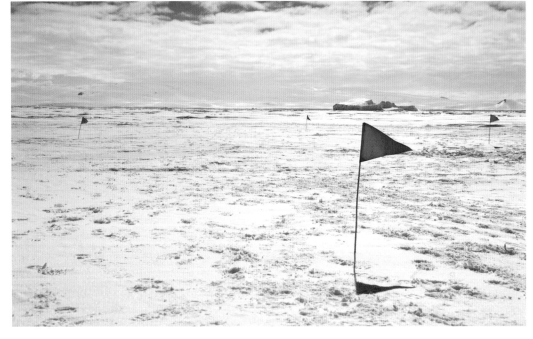

The team marked a way out to the penguin colony across the
ice so as to keep disturbance of the birds to a minimum. After
a challenging walk carrying my heavy camera bag over at least
1.5 kilometres, I was rewarded with one of the most beautiful
sights I'd ever seen. My first emperor penguins.

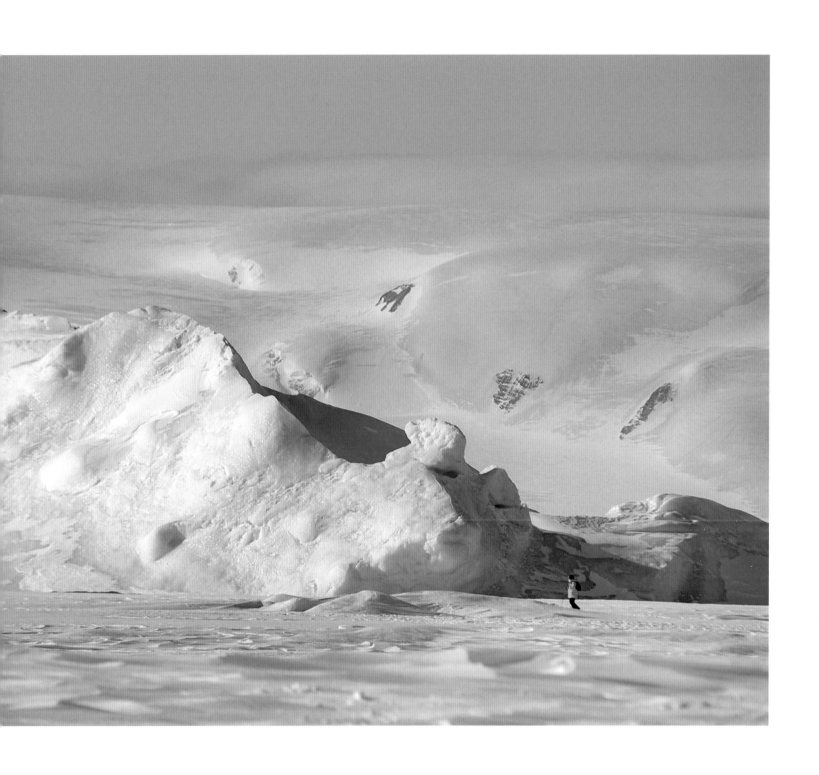

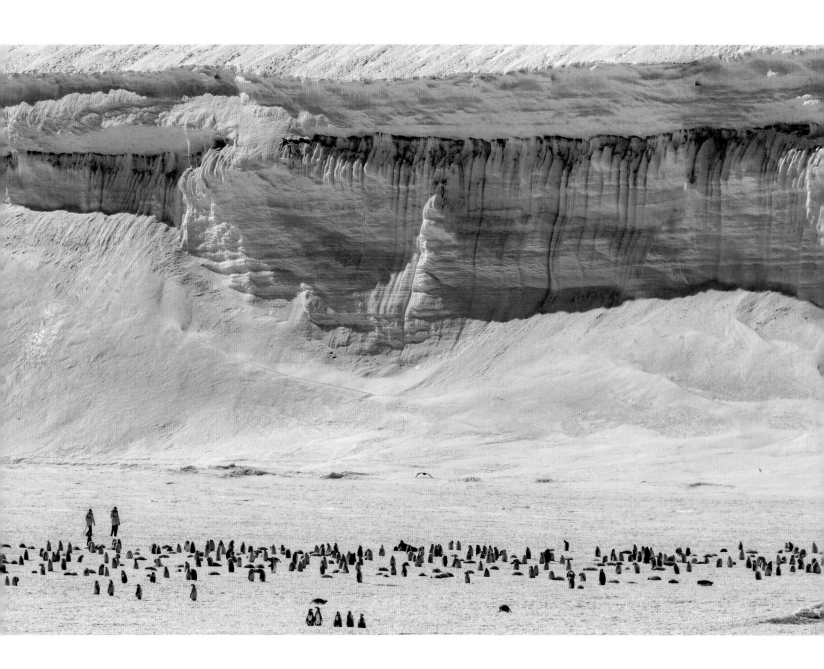

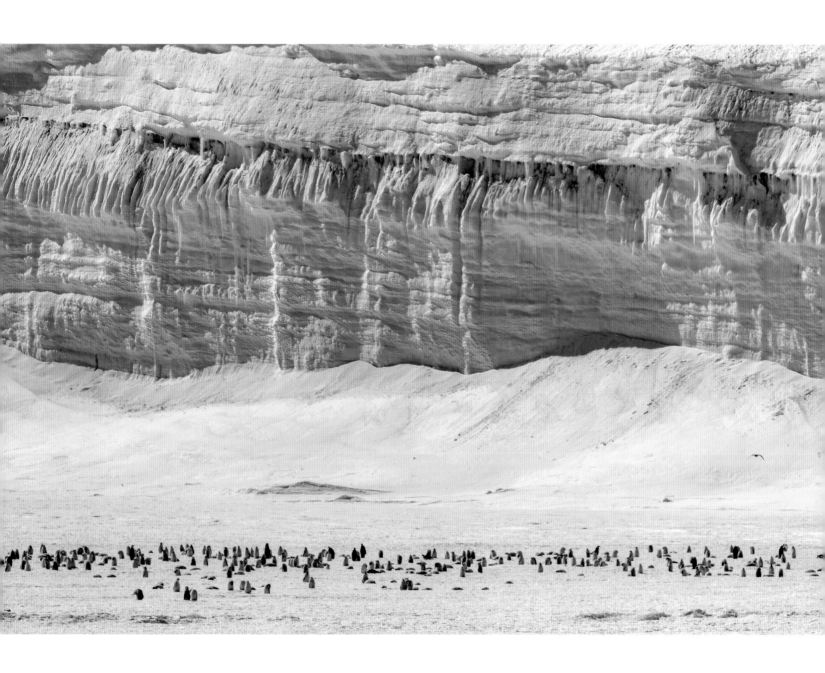

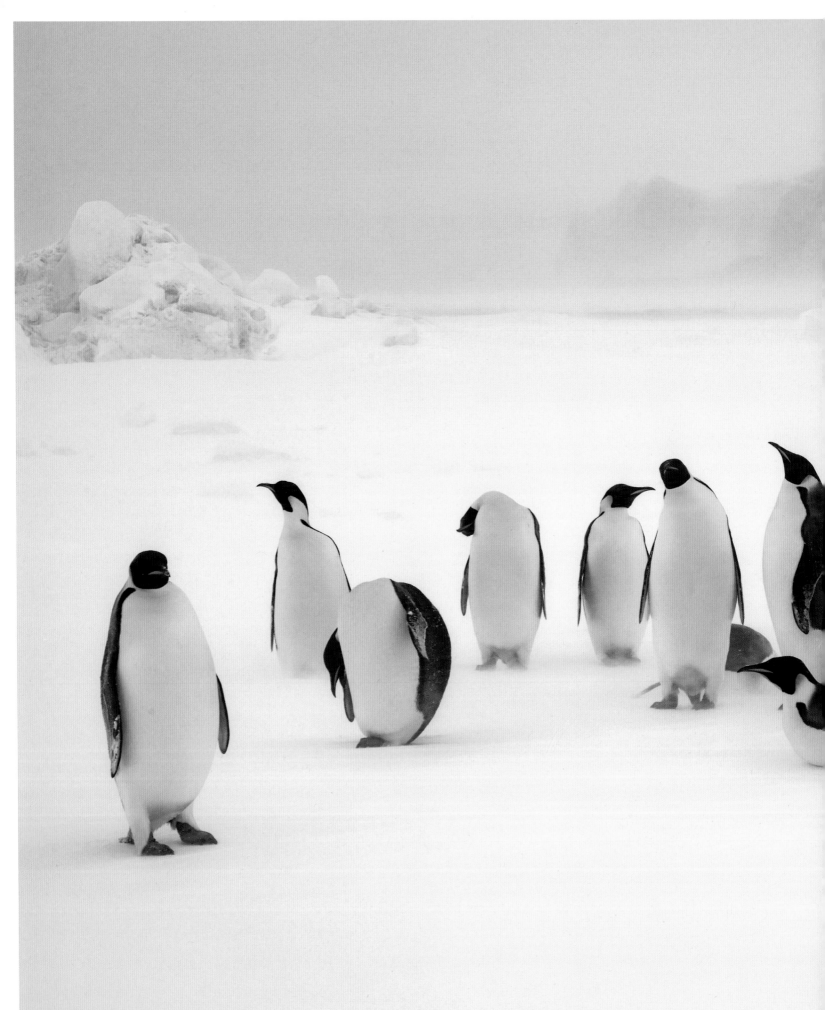

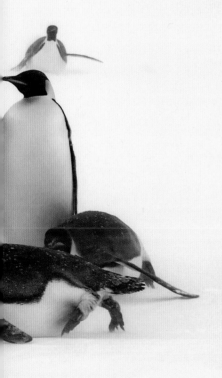

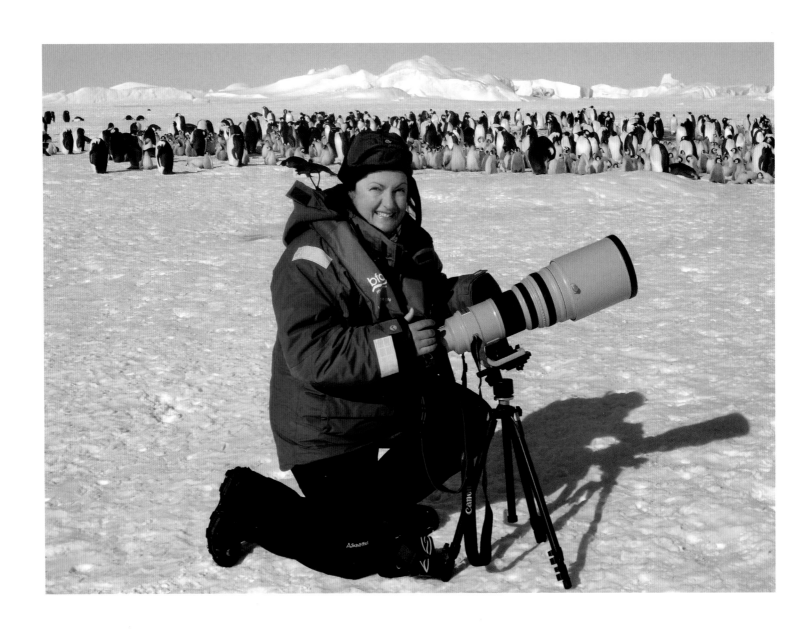

Emperors seemed so much larger than I had
imagined and so perfectly beautiful – a truly
magical experience. I was hooked.

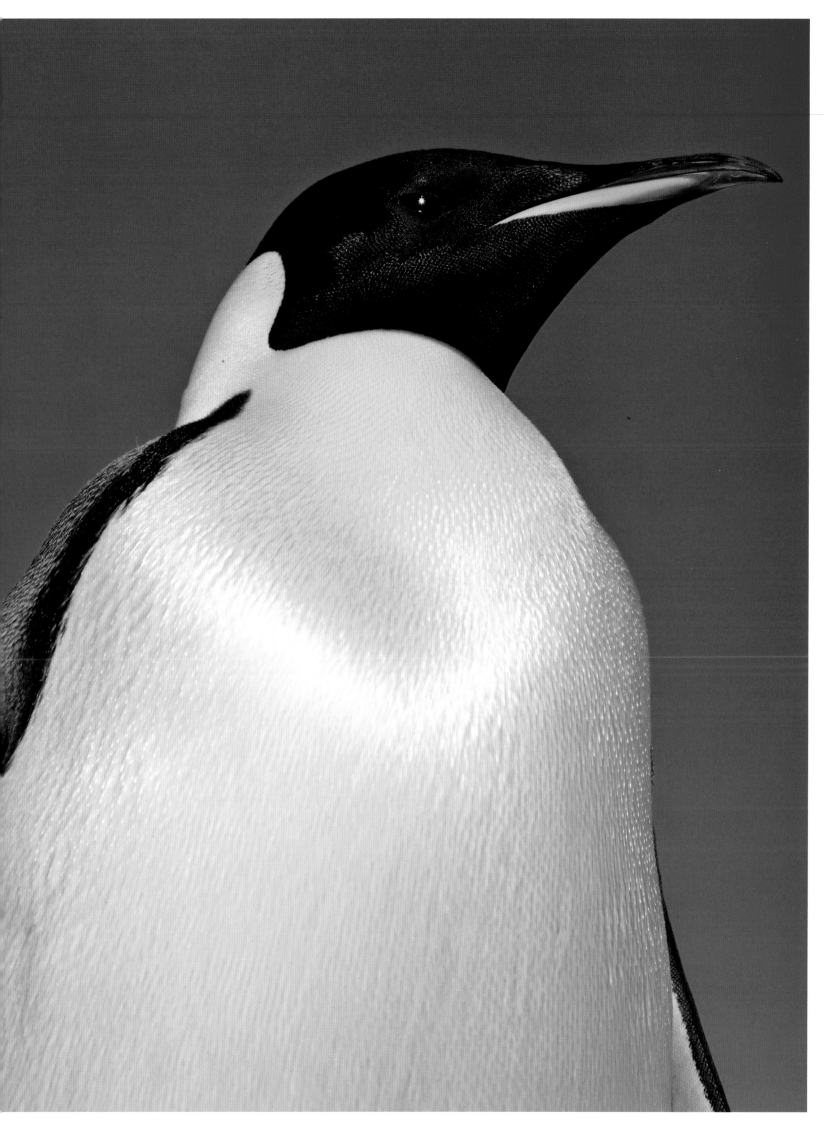

MY LIFE IN THE COLONY II
Gould Bay, Weddell Sea

One of the most demanding, yet most enjoyable, trips I've ever undertaken was in late 2016, when I was selected to be part of the Antarctic Logistics and Expeditions' (ALE) team working at the Gould Bay emperor penguin colony in the Weddell Sea, the most southerly of all the 44 emperor colonies. After an intensive training week in Punta Arenas, Chile, the team flew on an Ilyushin to the ALE base at Union Glacier. I was full of respect for the pilots who were able to land this huge Russian aircraft with apparent ease on the blue-ice runway.

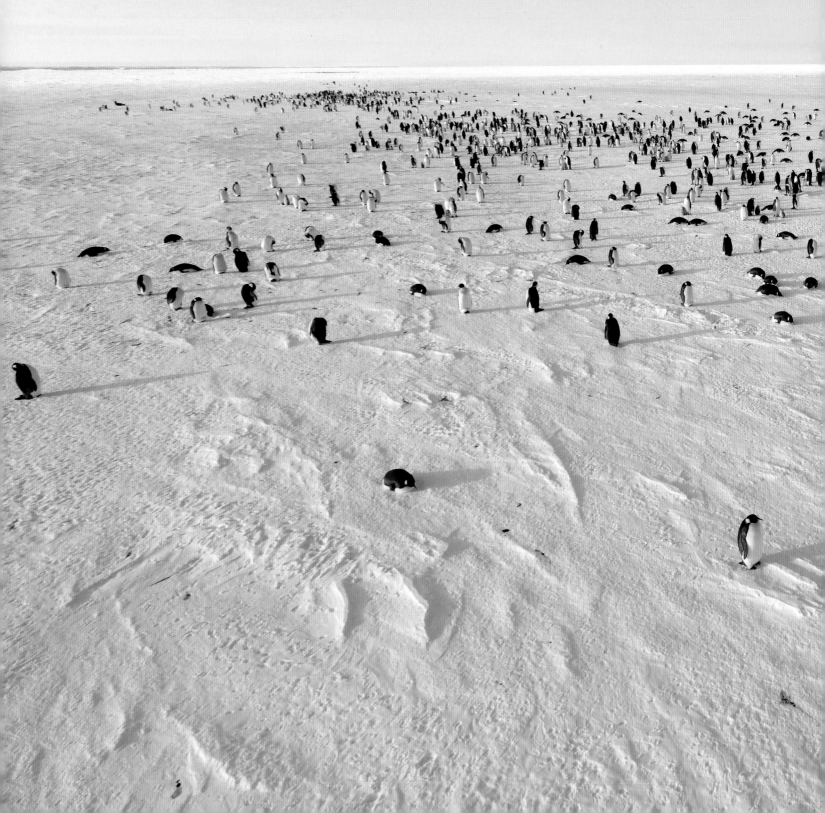

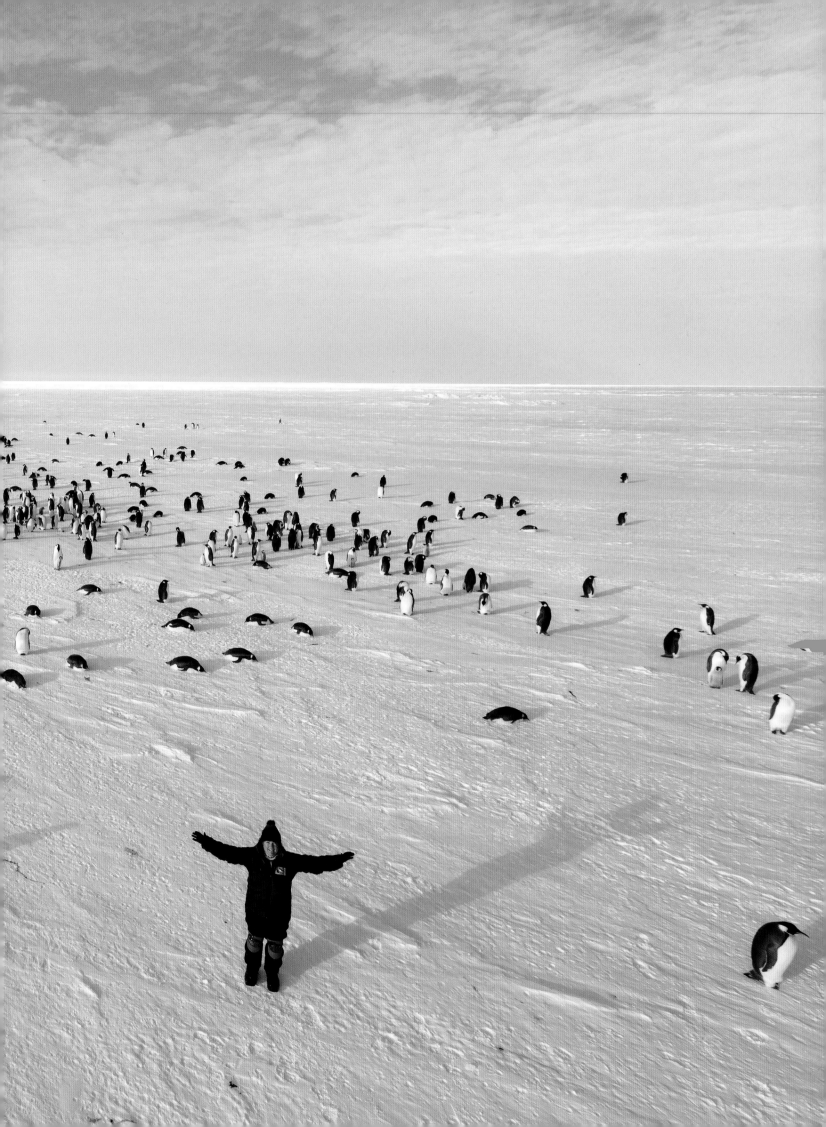

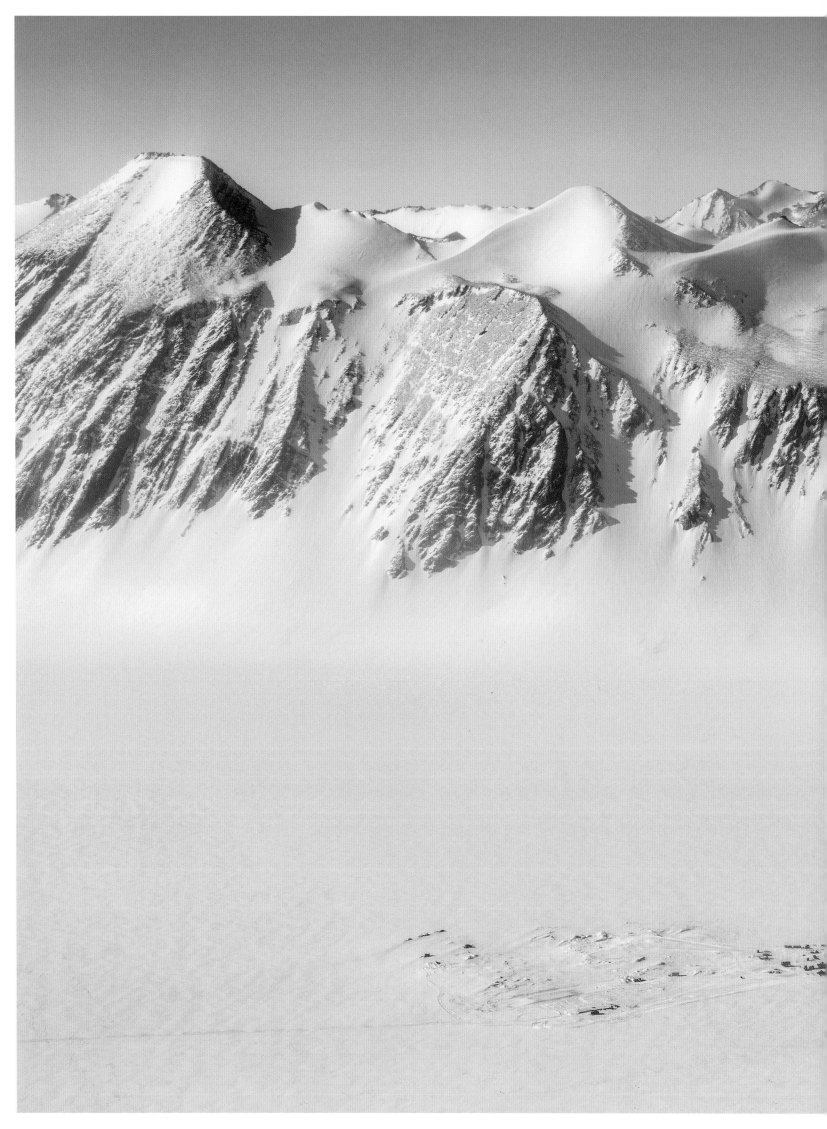

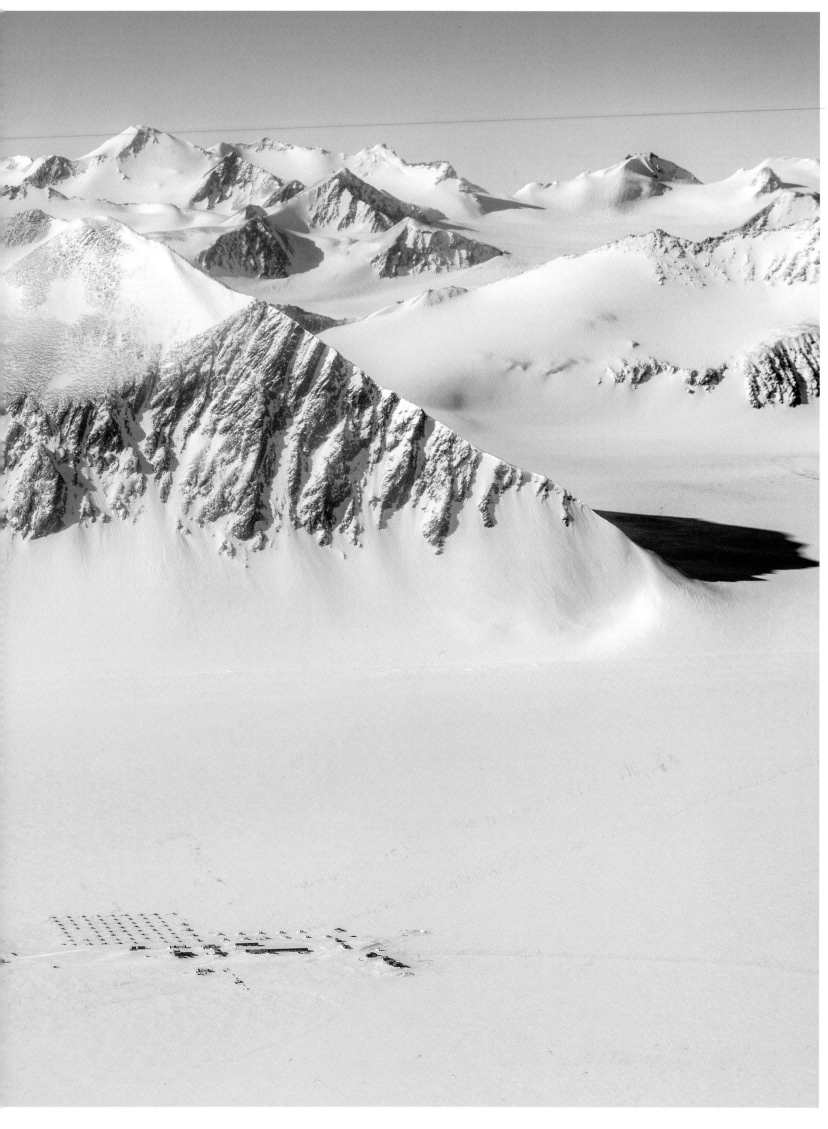

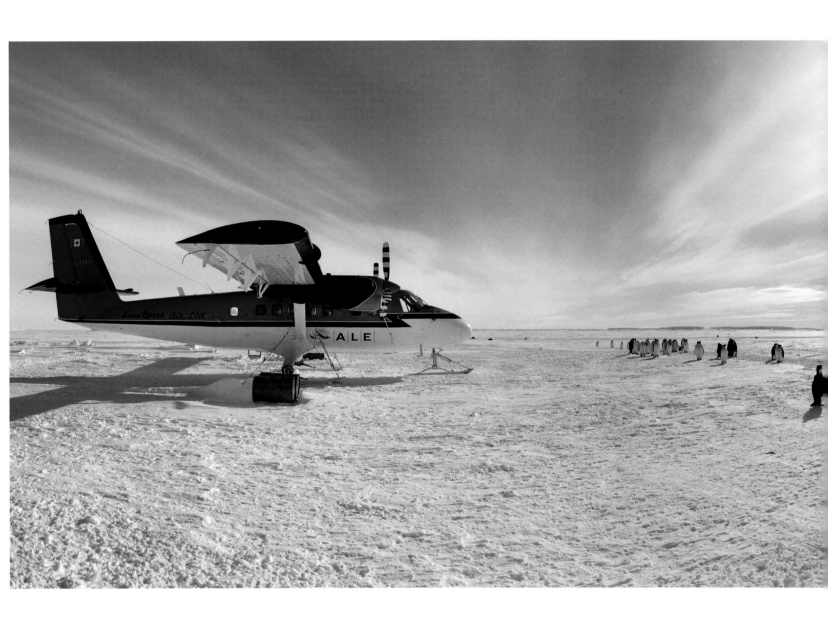

After a night camping at Union
Glacier, I flew in the Twin Otter for
about 700 kilometres to our camp
in Gould Bay, which would be
home for the next month.

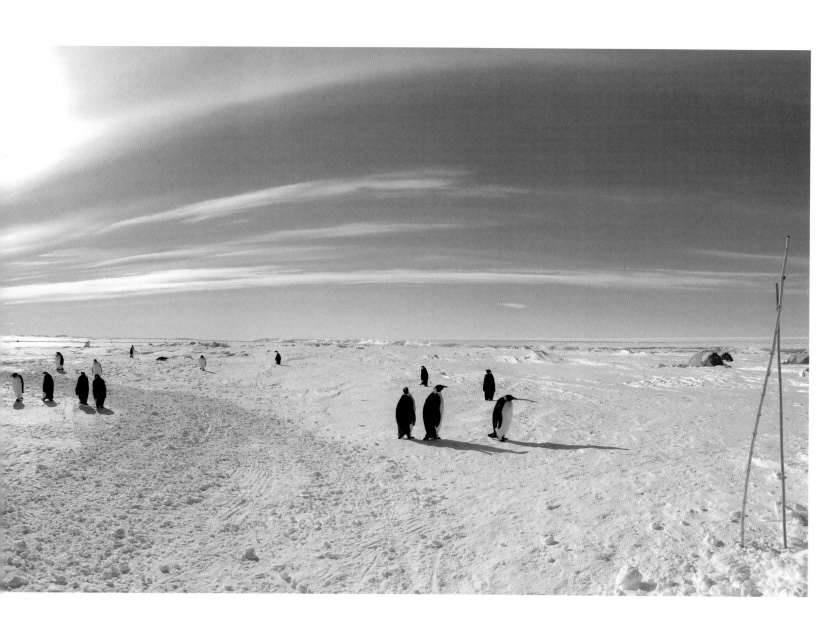

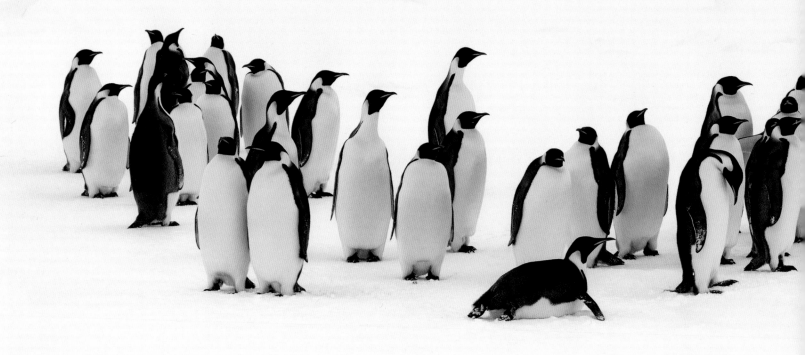

My most recent expedition to photograph emperor penguins provided me with my most memorable accommodation ever. As part of the expedition team, I camped on the sea ice in a one-person tent every night for a month.

I dug a trench just outside my tent door so that, when I crawled out of my tent in the morning, I was able to put my feet straight into my boots – sheer luxury.

It was a cramped space, especially with my camera gear and spare cold-weather clothing, but I absolutely loved living in these sub-zero conditions because of the frequent nightly visitors. Every night I'd crawl into my toasty sleeping bag, listening to my audiobook of Michael Palin reading his wonderful diaries, and would fall asleep – no reflection on Michael, but definitely a reflection on how exhausted I was. In the wee small hours I'd invariably be woken by the sound of penguins calling just outside my tent, and each and every time I'd get out of my sleeping bag to take a look at my noisy campmates. I never got tired of waking up to this view.

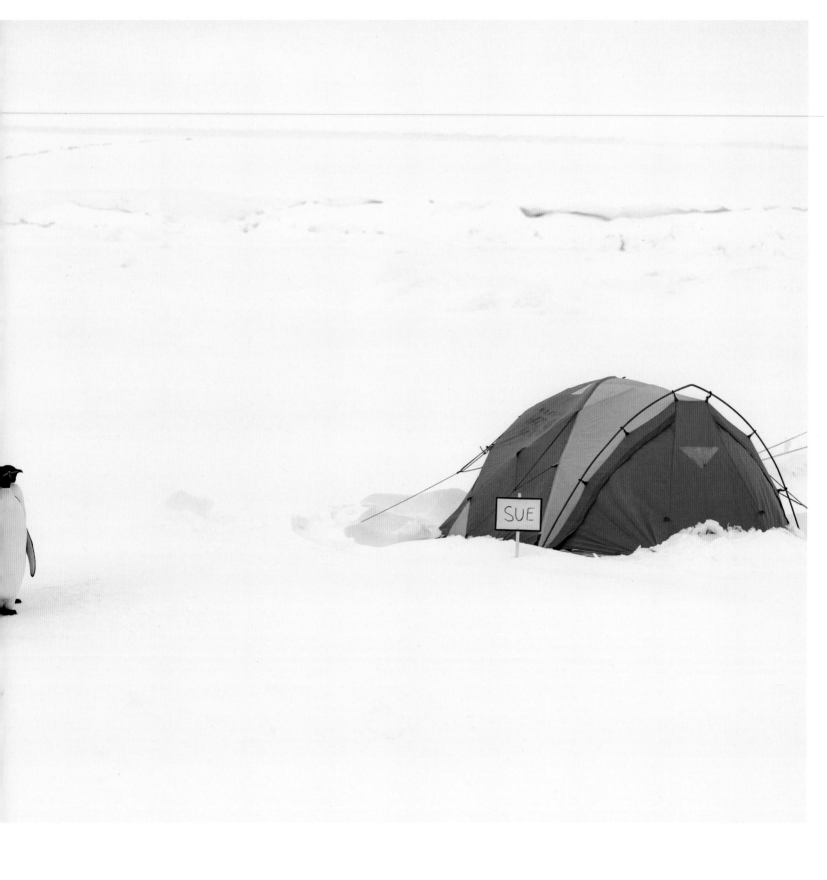

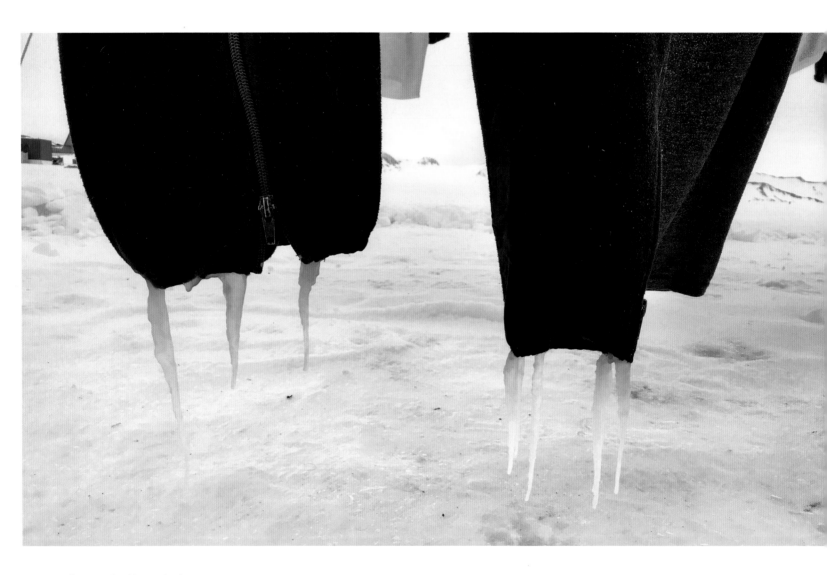

Above: In Gould Bay, I had no access to a shower for several weeks, which was challenging. But I hand-washed my thermal trousers and hung them up to freeze-dry outside.

Right: This is surely the best view from a bed anywhere in the world.

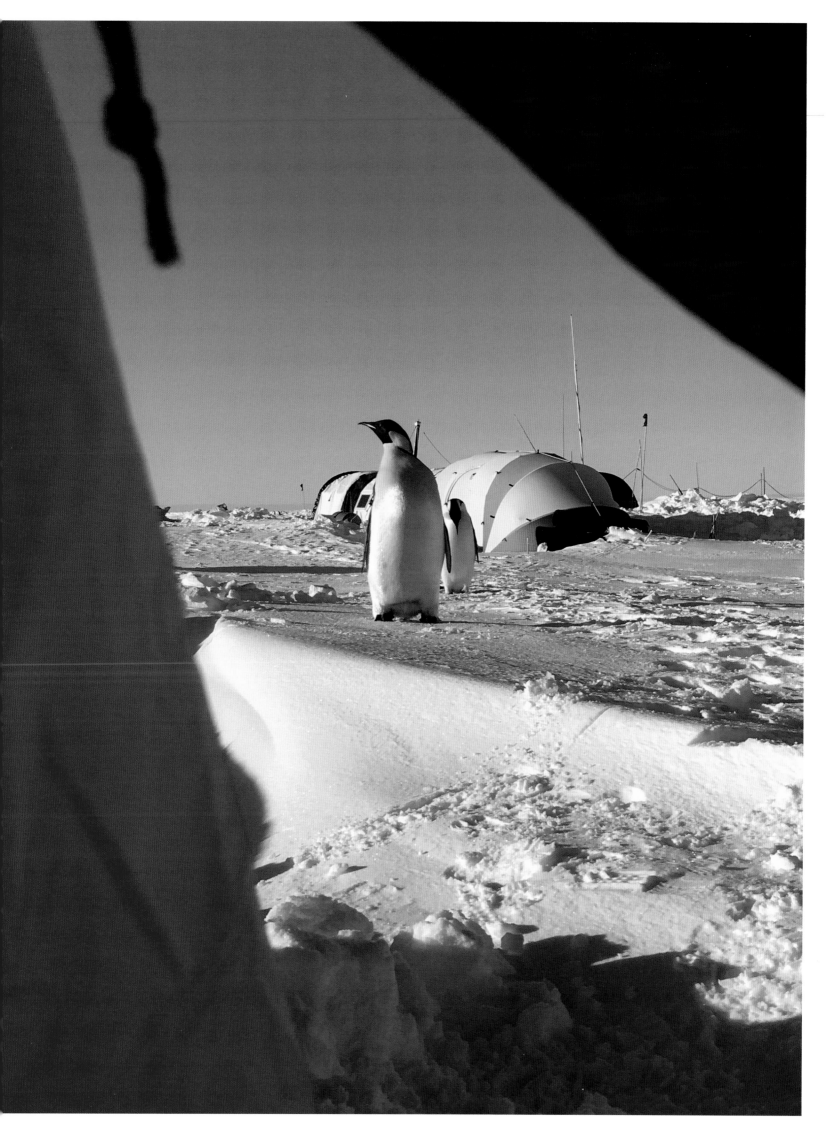

Our camp was positioned about 1.5 kilometres
from the emperor colony, to keep disturbance to an
absolute minimum. I and the other staff marked a route
over the sea ice out to the colony so that people could
walk to see the penguins in safety. It was tiring but
exhilarating, hauling my sledge out to the colony and
spending hours in sub-zero temperatures.

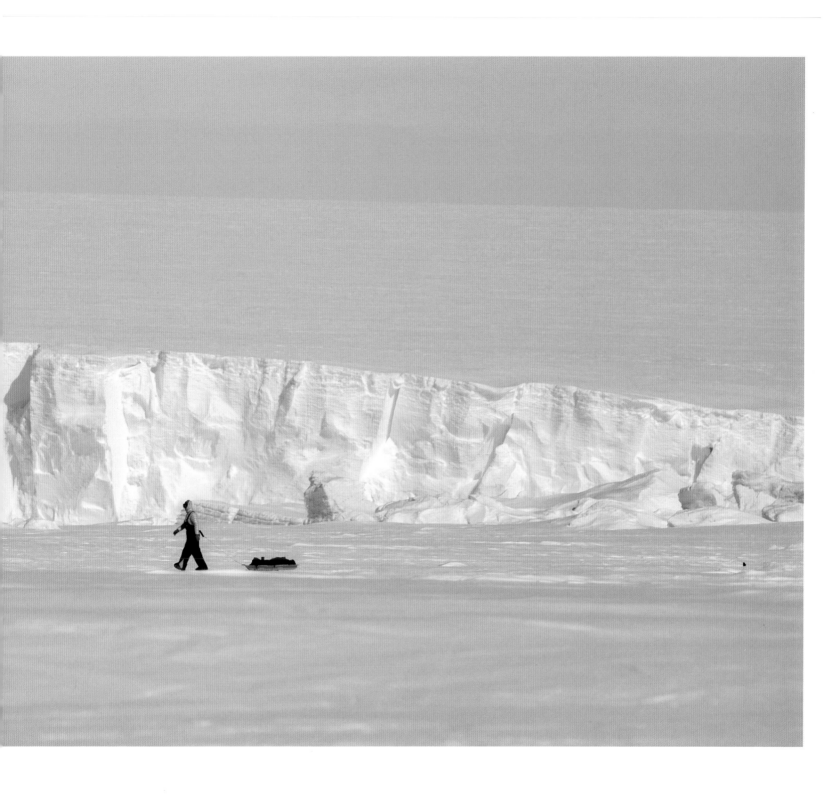

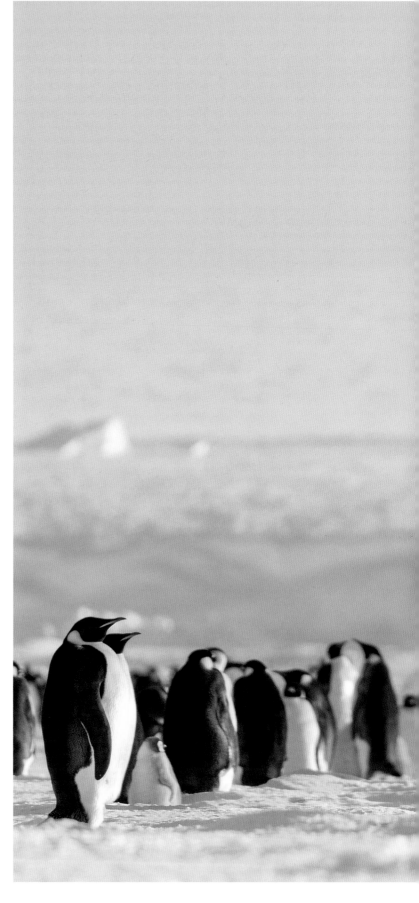

When you're standing around for many hours on the ice, you need to ensure you're wearing lots of layers to stay warm. Unlike skiers, climbers, explorers and others who are more active in these temperatures and so can wear lighter clothing, I needed to wrap up as I was going to be standing still for a long time. I wore two layers of thermal underwear, then a mid-layer, then padded trousers and jacket before donning my top layer. It was also crucial to protect my eyes, even when it was overcast, as long exposure without sun protection can lead to snow blindness.

This was a particularly pleasant day, and so I was able to manage without my big, red down coat which was needed when I was standing around at -25°C and below. Thick soles on my boots, along with heavy felt-liners, ensured my feet stayed warm and dry. But I was always amazed to watch the tiny chicks, some just a few inches high, getting by in these extreme conditions as I tried to keep warm with several layers of expensive insulation.

On the 1.5-kilometre walk back to my tent, pulling my heavy sledge of safety equipment and camera gear, I'd get very warm and have to strip off several layers.

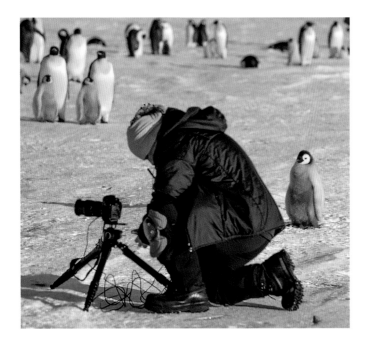

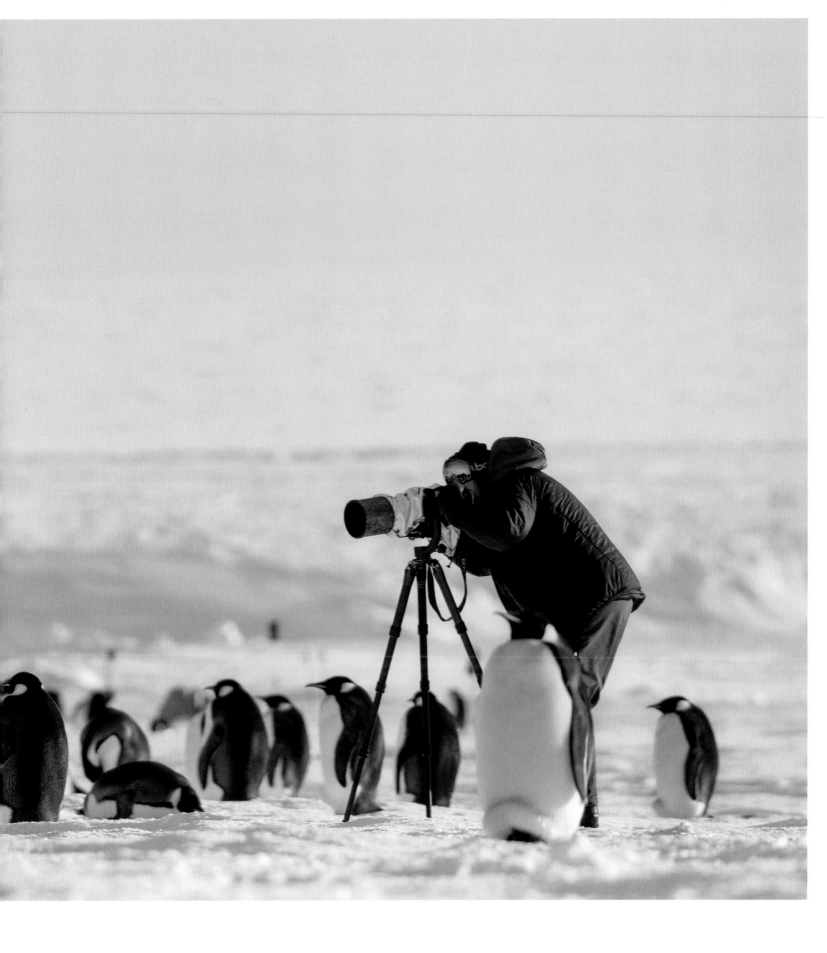

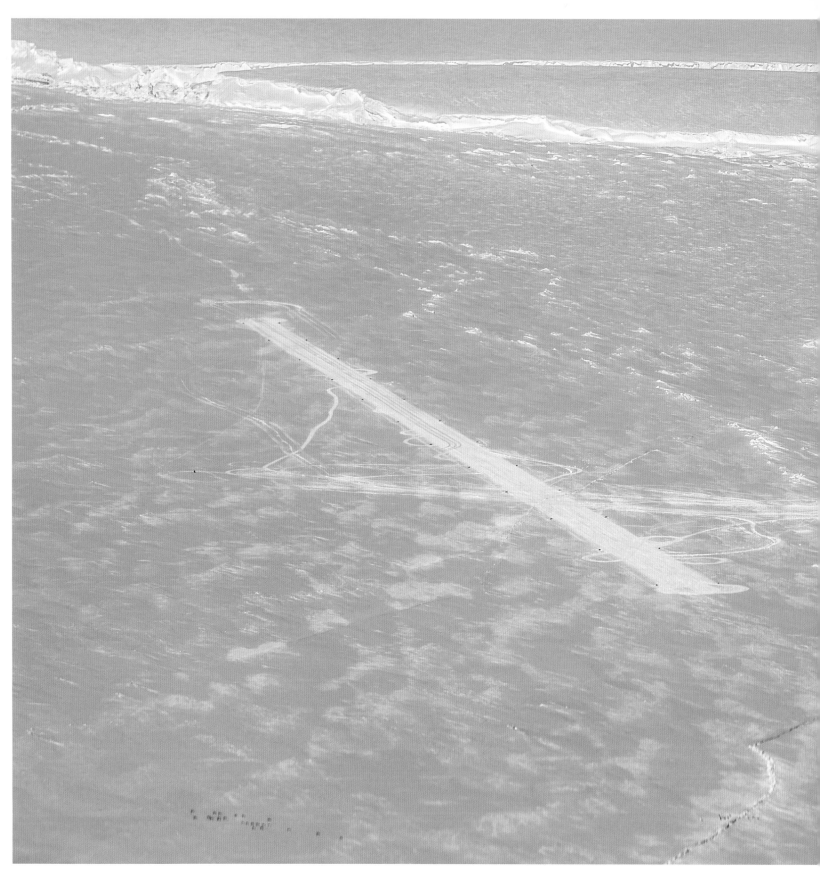

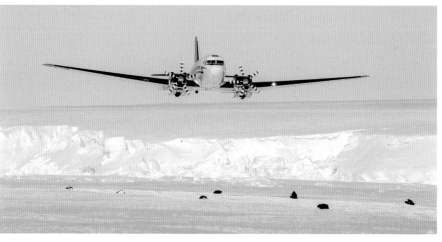

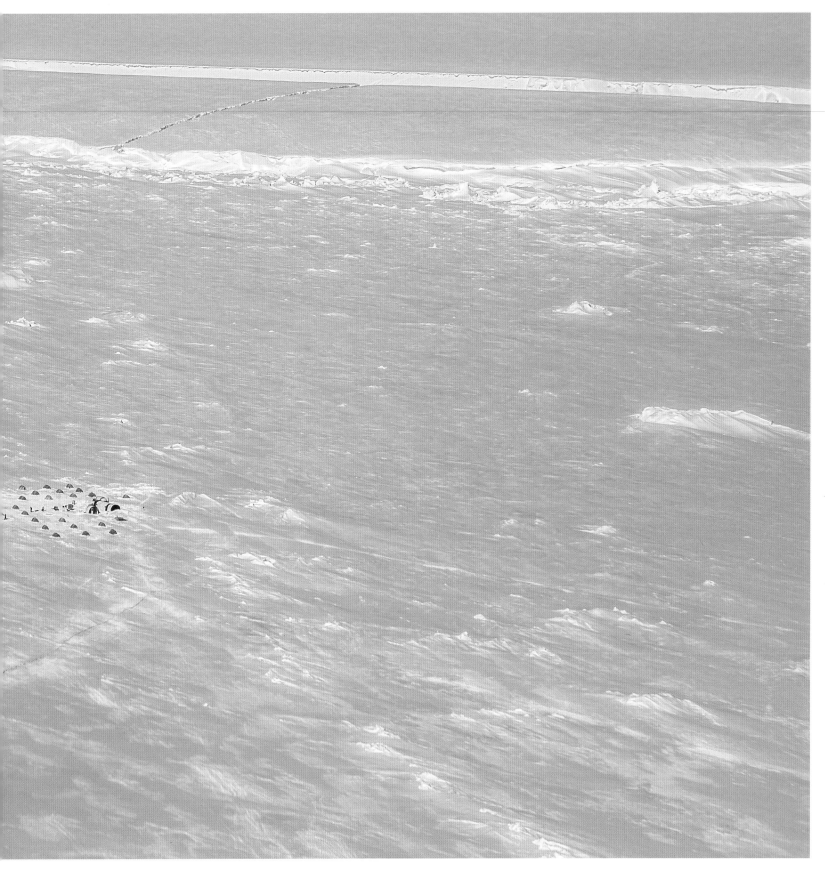

When it was time for the next crew to fly in to the base camp by DC-3, the camp manager, Hannah, groomed the skiway. Then Hannah, Namgya and I walked over and over the route to check it for bumps and cracks to help ensure a safe landing.

Above: On the way home, I was extremely fortunate to fly via the South Pole. It was a particularly pleasant day when, after our four-hour flight from Union Glacier, we arrived at the South Pole to a balmy -27°C. Thanks to the extremely thick ice sheet, you stand at an elevation of around 2,700 metres, so the South Pole is considerably colder than the North Pole, which is in the middle of the Arctic Ocean.

Overleaf: I will never forget the mind-bogglingly beautiful flight over the Transantarctic Mountains as we returned from the Pole to Union Glacier. It was a stunningly clear night, and I was able to see Mount Vinson, the highest mountain in the Antarctic, which Sir Ranulph Fiennes had summited only three days earlier.

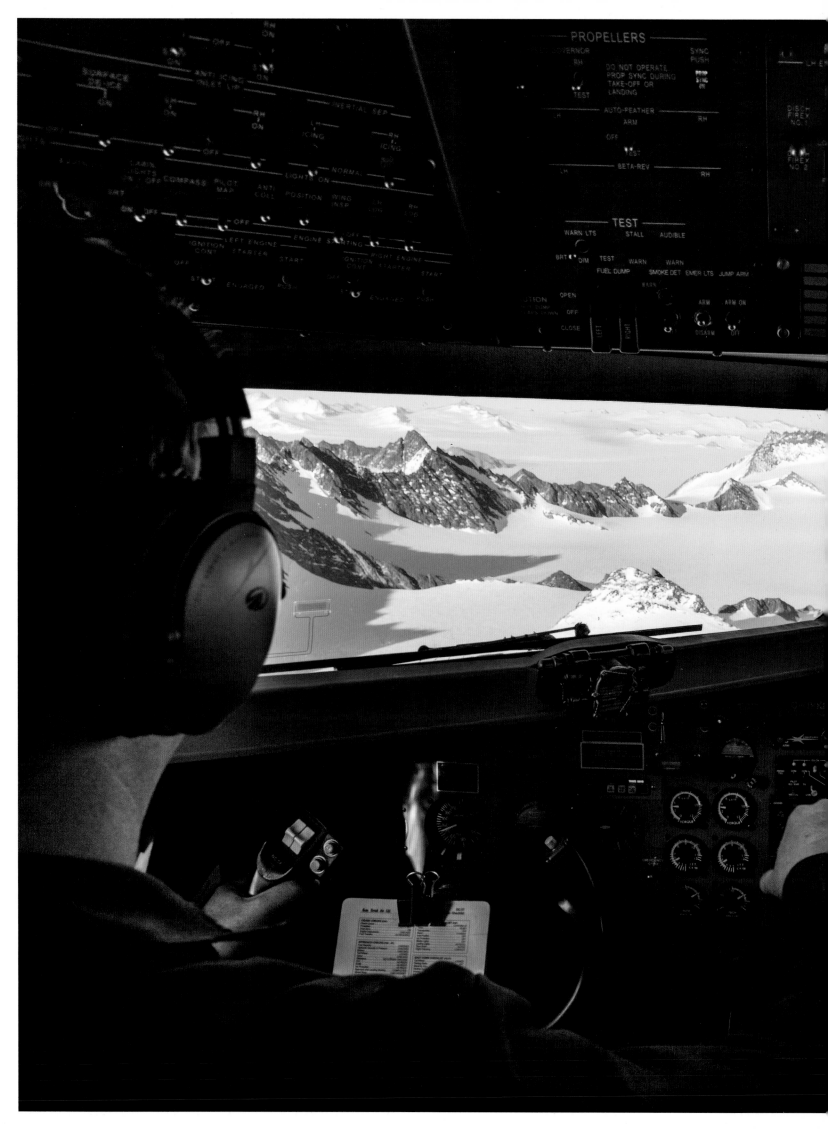

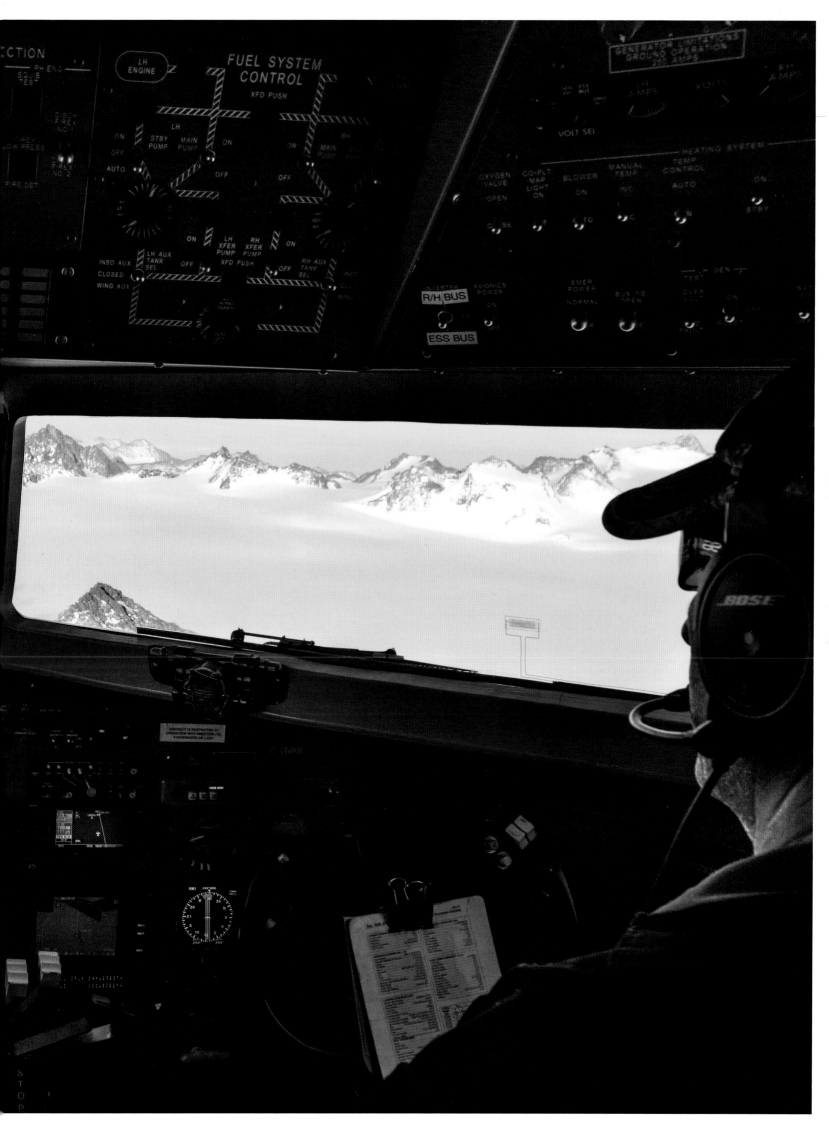

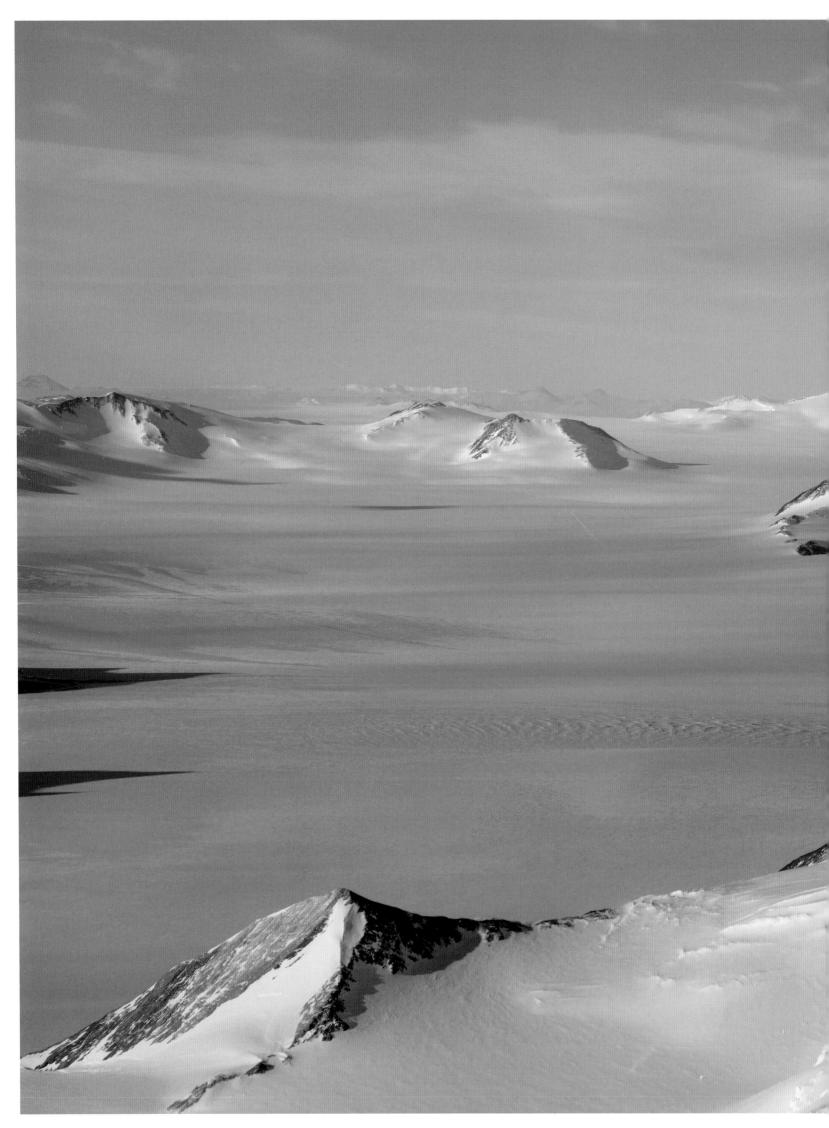

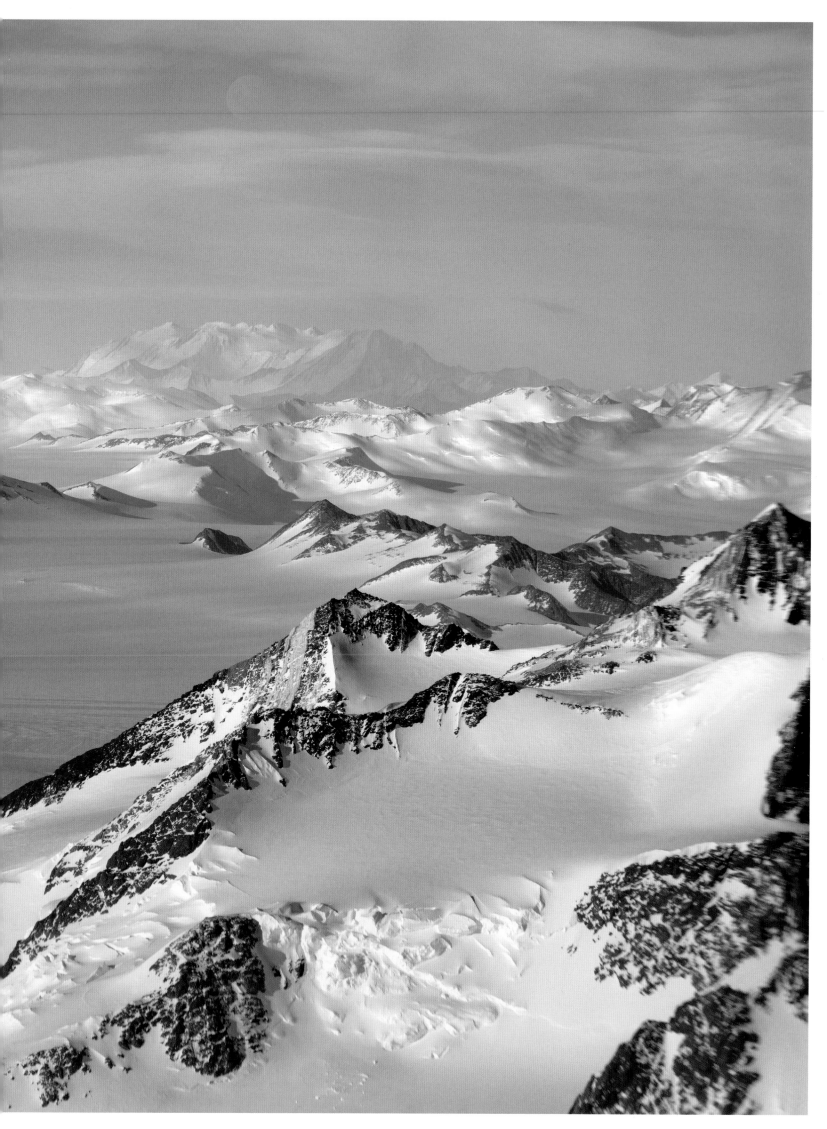

Endpapers
Canon EOS 5D Mark III
Lens: EF16-35mm f/2.8L II USM
1/200 sec; f/11; ISO 200

Front Cover & 105
Canon EOS-1Ds Mark III
Lens: EF100-400mm f/4.5-5.6L IS USM
1/500 sec; f/7.1; ISO 160

Back Cover
Apple iPhone 6s
Lens: front camera 2.65mm f/2.2
1/125 sec; f/2.2; ISO 32

2 & 23
Canon EOS-1Ds Mark III
Lens: EF24-105mm f/4L IS USM
1/400 sec; f/14; ISO 200

4 & 198
Canon EOS 5DS R
Lens: EF24-105mm f/4L IS USM
1/400 sec; f/8; ISO 125

6
Details unknown

8
Details unknown

9
GoPro, HERO5 Black
1/1600 sec; f/2.8; ISO 100

10
Canon EOS 5DS R
Lens: EF24-105mm f/4L IS USM
1/1600 sec; f/9; ISO 320

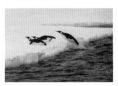

12
Canon EOS-1Ds Mark III
Lens: EF100-400mm f/4.5-5.6L IS USM
1/1000 sec; f/6.3; ISO 160

14
Canon EOS-1Ds Mark III
Lens: EF600mm f/4L IS USM
1/2000 sec; f/8; ISO 320

16
Canon EOS-1Ds Mark III
Lens: EF24-105mm f/4L IS USM
1/800 sec; f/8; ISO 160

18
Canon EOS-1Ds Mark III
Lens: EF24-105mm f/4L IS USM
1/800 sec; f/13; ISO 200

20
Canon EOS-1Ds Mark III
Lens: EF100-400mm f/4.5-5.6L IS II USM
1/3200 sec; f/8; ISO 320

24
Canon EOS-1Ds Mark III
Lens: EF100-400mm f/4.5-5.6L IS USM
1/500 sec; f/11; ISO 160

26
Canon EOS-1Ds Mark III
EF24-105mm f/4L IS USM
1/640 sec; f/8; ISO 160

28
Canon EOS 5DS R
Lens: EF24-105mm f/4L IS USM
1/640 sec; f/10; ISO 100

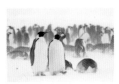

30
Canon EOS-1Ds Mark II
Lens: 600.0 mm
1/500 sec; f/16; ISO 125

32
Canon EOS 5DS R
Lens: EF300mm f/2.8L IS II USM +2x III
1/250 sec; f/7.1; ISO 160

34
Canon EOS-1Ds Mark III
Lens: EF24-105mm f/4L IS USM
1/250 sec; f/22; ISO 200

36
Canon EOS-1Ds Mark II
Lens: 600.0 mm
1/2000 sec; f/8; ISO 160

38
Canon EOS-1Ds Mark II
Lens: 600.0 mm
1/320 sec; f/14; ISO 160

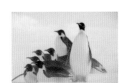

40
Canon EOS 5DS R
Lens: EF100-400mm f/4.5-5.6L IS II USM
1/500 sec; f/9; ISO 160

43
Canon EOS-1Ds Mark II
Lens: 600.0 mm
1/1250 sec; f/8; ISO 160

44
Canon EOS-1Ds Mark II
Lens: 600.0 mm
1/800 sec; f/10; ISO 160

46
Canon EOS 5DS R
Lens: EF100-400mm f/4.5-5.6L IS II USM
1/400 sec; f/9; ISO 160

49
Canon EOS-1Ds Mark III
Lens: EF600mm f/4L IS USM
1/640 sec; f/9; ISO 160

51
Canon EOS 5DS R
Lens: EF300mm f/2.8L IS II USM +2x III
1/320 sec; f/14; ISO 250

52
Canon EOS 5DS R
Lens: EF300mm f/2.8L IS II USM +2x III
1/320 sec; f/14; ISO 250

54
Canon EOS 5D Mark III
Lens: EF100-400mm f/4.5-5.6L IS II USM
1/4000 sec; f/6.3; ISO 320

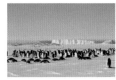

56
Canon EOS 5DS R
Lens: EF100-400mm f/4.5-5.6L IS II USM
1/500 sec; f/5.6; ISO 100

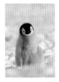

57
Canon EOS-1Ds Mark III
Lens: EF600mm f/4L IS USM
1/320 sec; f/10; ISO 125

58
Canon EOS 5DS R
Lens: EF300mm f/2.8L IS II USM +2x III
1/200 sec; f/9; ISO 160

60
Canon EOS-1Ds Mark III
Lens: EF100-400mm f/4.5-5.6L IS USM
1/160 sec; f/11; ISO 160

62
Canon EOS 5DS R
Lens: EF300mm f/2.8L IS II USM +2x III
1/320 sec; f/10; ISO 125

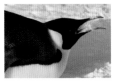

64
Canon EOS 5D Mark III
Lens: EF100-400mm f/4.5-5.6L IS II USM
1/500 sec; f/9; ISO 200

66
Canon EOS 5DS R
Lens: EF300mm f/2.8L IS II USM +2x III
1/320 sec; f/16; ISO 400

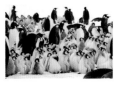

68
Canon EOS-1Ds Mark III
Lens: EF100-400mm f/4.5-5.6L IS USM
1/100 sec; f/16; ISO 160

71
Canon EOS-1Ds Mark II
Lens: 600.0 mm
1/640 sec; f/9; ISO 160

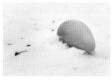

72
Canon EOS-1Ds Mark II
Lens: 600.0 mm
1/640 sec; f/9; ISO 160

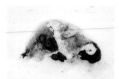

73
Canon EOS-1Ds Mark II
Lens: 600.0 mm
1/640 sec; f/9; ISO 160

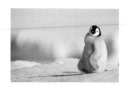

74
Canon EOS-1Ds Mark II
Lens: 600.0 mm
1/640 sec; f/9; ISO 160

76
Canon EOS 5DS R
Lens: EF300mm f/2.8L IS II USM +2x III
1/250 sec; f/8; ISO 160

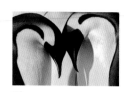

78
Canon EOS 5DS R
Lens: EF300mm f/2.8L IS II USM +2x III
1/400 sec; f/8; ISO 125

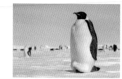

80
Canon EOS 5D Mark III
Lens: EF24-105mm f/4L IS USM
1/500 sec; f/7.1; ISO 125

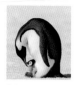

83
Canon EOS-1Ds Mark III
Lens: EF600mm f/4L IS USM
1/1000 sec; f/7.1; ISO 100

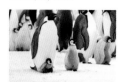

84
Canon EOS-1Ds Mark III
Lens: EF100-400mm f/4.5-5.6L IS USM
1/160 sec; f/13; ISO 160

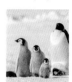

87
Canon EOS-1Ds Mark III
EF100-400mm f/4.5-5.6L IS USM
1/160 sec; f/13; ISO 160

88
Canon EOS 5DS R
Lens: EF300mm f/2.8L IS II USM +2x III
1/640 sec; f/6.3; ISO 125

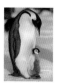

88
Canon EOS 5DS R
Lens: EF300mm f/2.8L IS II USM +2x III
1/640 sec; f/6.3; ISO 125

89
Canon EOS 5DS R
Lens: EF300mm f/2.8L IS II USM +2x III
1/640 sec; f/6.3; ISO 125

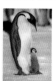

89
Canon EOS 5DS R
EF300mm f/2.8L IS II USM +2x III
1/640 sec; f/6.3; ISO 125

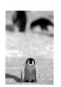

91
Canon EOS 5DS R
Lens: EF300mm f/2.8L IS II USM +2x III
1/800 sec; f/6.3; ISO 100

92
Canon EOS 5DS R
Lens: EF300mm f/2.8L IS II USM +2x III
1/250 sec; f/6.3; ISO 125

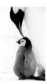

95
Canon EOS 5DS R
Lens: EF300mm f/2.8L IS II USM +2x III
1/400 sec; f/7.1; ISO 100

97
Canon EOS 5DS R
EF300mm f/2.8L IS II USM +2x III
1/500 sec; f/7.1; ISO 125

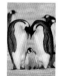

98
Canon EOS-1Ds Mark II
Lens: 600.0 mm
1/800 sec; f/9; ISO 160

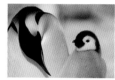

101
Canon EOS 5DS R
EF300mm f/2.8L IS II USM +2x III
1/640 sec; f/6.3; ISO 125

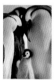

103
Canon EOS-1Ds Mark III
Lens: EF600mm f/4L IS USM
1/640 sec; f/8; ISO 125

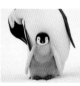

105 & Cover
Canon EOS-1Ds Mark III
Lens: EF100-400mm f/4.5-5.6L IS USM
1/500 sec; f/7.1; ISO 160

107
Canon EOS-1Ds Mark III
Lens: EF600mm f/4L IS USM
1/320 sec; f/9; ISO 100

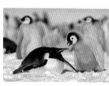

109
Canon EOS-1Ds Mark II
Lens: 600.0 mm
1/800 sec; f/8; ISO 160

110
Canon EOS 5DS R
Lens: EF24-105mm f/4L IS USM
1/2500 sec; f/7.1; ISO 200

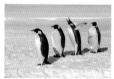

112
Canon EOS 5DS R
EF24-105mm f/4L IS USM
1/2500 sec; f/6.3; ISO 320

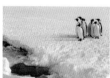

112
Canon EOS 5DS R
EF24-105mm f/4L IS USM
1/2500 sec; f/6.3; ISO 200

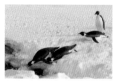

112
Canon EOS 5DS R
EF24-105mm f/4L IS USM
1/2500 sec; f/6.3; ISO 200

113
Canon EOS 5D Mark III
Lens: EF100-400mm f/4.5-5.6L IS II USM
1/3200 sec; f/6.3; ISO 320

113
Canon EOS 5D Mark III
Lens: EF100-400mm f/4.5-5.6L IS II USM
1/3200 sec; f/6.3; ISO 320

113
Canon EOS 5D Mark III
Lens: EF100-400mm f/4.5-5.6L IS II USM
1/2500 sec; f/6.3; ISO 320

114
Canon EOS-1Ds Mark III
Lens: EF600mm f/4L IS USM
1/160 sec; f/13; ISO 125

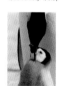

114
Canon EOS-1Ds Mark III
Lens: EF600mm f/4L IS USM
1/160 sec; f/11; ISO 125

114
Canon EOS-1Ds Mark III
Lens: EF600mm f/4L IS USM
1/160 sec; f/11; ISO 125

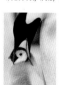

115
Canon EOS 5DS R
EF300mm f/2.8L IS II USM +2x III
1/320 sec; f/6.3; ISO 125

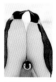

117
Canon EOS-1Ds Mark III
EF100-400mm f/4.5-5.6L IS USM
1/200 sec; f/14; ISO 160

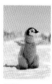

118
Canon EOS-1Ds Mark III
EF100-400mm f/4.5-5.6L IS USM
1/320 sec; f/9; ISO 100

119
Canon EOS-1Ds Mark III
Lens: EF600mm f/4L IS USM +1.4x
1/250 sec; f/14; ISO 100

119
Canon EOS-1Ds Mark III
Lens: EF600mm f/4L IS USM +1.4x
1/125 sec; f/14; ISO 100

119
Canon EOS-1Ds Mark III
Lens: EF600mm f/4L IS USM +1.4x
1/125 sec; f/14; ISO 100

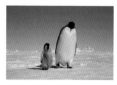

120
Canon EOS-1Ds Mark III
Lens: EF24-105mm f/4L IS USM
1/320 sec; f/10; ISO 125

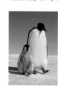

122
Canon EOS-1Ds Mark III
Lens: EF24-105mm f/4L IS USM
1/320 sec; f/10; ISO 125

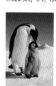

122
Canon EOS-1Ds Mark III
Lens: EF24-105mm f/4L IS USM
1/320 sec; f/10; ISO 125

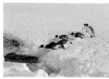

123
Canon EOS-1Ds Mark III
Lens: EF24-105mm f/4L IS USM
1/320 sec; f/10; ISO 125

123
Canon EOS-1Ds Mark III
Lens: EF24-105mm f/4L IS USM
1/320 sec; f/10; ISO 125

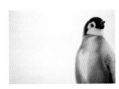

124
Canon EOS-1Ds Mark III
Lens: EF24-105mm f/4L IS USM
1/320 sec; f/9; ISO 125

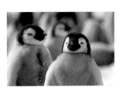

126
Canon EOS-1Ds Mark III
Lens: EF600mm f/4L IS USM
1/2500 sec; f/5.0; ISO 200

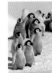

128
Canon EOS-1Ds Mark III
EF600mm f/4L IS USM
1/200 sec; f/16; ISO 125

131
Canon EOS-1Ds Mark III
Lens: EF600mm f/4L IS USM +1.4x
1/640 sec; f/9; ISO 125

132
Canon EOS-1Ds Mark III
Lens: EF600mm f/4L IS USM +1.4x
1/640 sec; f/9; ISO 125

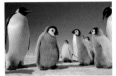

134
Canon EOS-1Ds Mark II
Lens: 24.0-105.0 mm
1/320 sec; f/13; ISO 200

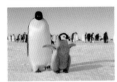

136
Canon EOS 5D Mark III
Lens: EF24-105mm f/4L IS USM
1/200 sec; f/7.1; ISO 100

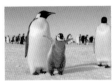

136
Canon EOS 5D Mark III
Lens: EF24-105mm f/4L IS USM
1/200 sec; f/7.1; ISO 100

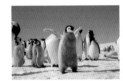

136
Canon EOS 5D Mark III
Lens: EF24-105mm f/4L IS USM
1/200 sec; f/7.1; ISO 100

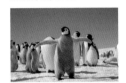

137
Canon EOS-1Ds Mark III
Lens: EF24-105mm f/4L IS USM
1/400 sec; f/6.3; ISO 125

137
Canon EOS-1Ds Mark III
Lens: EF24-105mm f/4L IS USM
1/400 sec; f/6.3; ISO 125

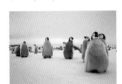

137
Canon EOS-1Ds Mark III
Lens: EF24-105mm f/4L IS USM
1/400 sec; f/6.3; ISO 125

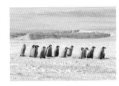

138
Canon EOS-1Ds Mark III
Lens: EF17-35mm f/2.8L USM
1/200 sec; f/18; ISO 200

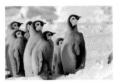

140
Canon EOS-1Ds Mark III
Lens: EF100-400mm f/4.5-5.6L IS USM
1/320 sec; f/11; ISO 100

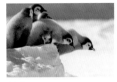

142
Canon EOS-1Ds Mark III
Lens: EF600mm f/4L IS USM
1/320 sec; f/14; ISO 125

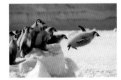

142
Canon EOS-1Ds Mark III
Lens: EF600mm f/4L IS USM
1/500 sec; f/10; ISO 125

143
Canon EOS-1Ds Mark III
Lens: EF600mm f/4L IS USM
1/500 sec; f/10; ISO 125

143
Canon EOS-1Ds Mark III
Lens: EF600mm f/4L IS USM
1/500 sec; f/10; ISO 125

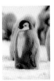

145
Canon EOS-1Ds Mark III
Lens: EF600mm f/4L IS USM
1/1250 sec; f/7.1; ISO 200

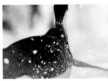

146
Canon EOS-1Ds Mark II
Lens: 600.0 mm
1/800 sec; f/9; ISO 160

148
Canon EOS 5DS R
Lens: EF24-105mm f/4L IS USM
1/1600 sec; f/8; ISO 400

150
Canon EOS 5DS R
Lens: EF100-400mm f/4.5-5.6L IS II USM
1/500 sec; f/8; ISO 100

151
Canon EOS-1Ds Mark III
Lens: EF24-105mm f/4L IS USM
1/250 sec; f/13; ISO 125

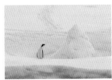

152
Canon EOS-1Ds Mark II
Lens: 400.0 mm
1/400 sec; f/18; ISO 400

154
Canon EOS-1Ds Mark II
Lens: 600.0 mm
1/800 sec; f/10; ISO 125

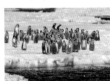

156
Canon EOS-1Ds Mark III
Lens: EF600mm f/4L IS USM +1.4x
1/1600 sec; f/8; ISO 160

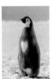

159
Canon EOS-1Ds Mark III
Lens: EF600mm f/4L IS USM
1/800 sec; f/8; ISO 125

160
Canon EOS-1Ds Mark III
Lens: EF600mm f/4L IS USM
1/1250 sec; f/7.1; ISO 200

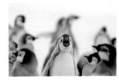

162
Canon EOS-1Ds Mark II
Lens: 600.0 mm
1/640 sec; f/11; ISO 160

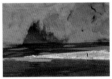

164
Canon EOS-1Ds Mark III
Lens: EF600mm f/4L IS USM
1/400 sec; f/9; ISO 125

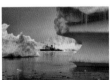

166
Canon EOS-1Ds Mark II
Lens: 24.0-105.0 mm
1/500 sec; f/9; ISO 125

168
Canon EOS-1Ds Mark II
Lens: 24.0-105.0 mm
1/500 sec; f/7.1; ISO 500

170
Canon EOS-1Ds Mark III
Lens: EF100-400mm f/4.5-5.6L IS USM
1/160 sec; f/9; ISO 160

172
Canon EOS-1Ds Mark II
Lens: 17.0-35.0 mm
1/50 sec; f/18; ISO 320

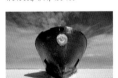

174
Canon EOS-1Ds Mark III
Lens: EF14mm f/2.8L USM
1/640 sec; f/10; ISO 160

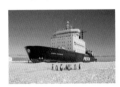

176
Canon EOS-1Ds Mark III
Lens: EF17-35mm f/2.8L USM
1/200 sec; f/14; ISO 160

178
Panasonic DMC-FX100
1/800 sec; f/3.8; ISO 80

179
Canon EOS-1Ds Mark III
Lens: EF24-105mm f/4L IS USM
1/160 sec; f/9; ISO 160

180
Canon EOS-1Ds Mark III
Lens: EF24-105mm f/4L IS USM
1/160 sec; f/9; ISO 160

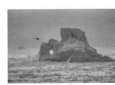

182
Canon EOS-1Ds Mark II
Lens: 100.0-400.0 mm
1/250 sec; f/7.1; ISO 200

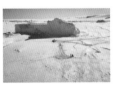

184
Canon EOS-1Ds Mark III
Lens: EF24-105mm f/4L IS USM
1/500 sec; f/9; ISO 160

 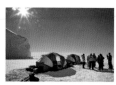

185
Canon EOS-1Ds Mark III
Lens: EF24-105mm f/4L IS USM
1/80 sec; f/22; ISO 250

186
Canon EOS-1Ds Mark III
Lens: EF24-105mm f/4L IS USM
1/80 sec; f/22; ISO 160

186
Canon EOS-1Ds Mark III
Lens: EF24-105mm f/4L IS USM
1/640 sec; f/9; ISO 160

187
Canon EOS-1Ds Mark III
Lens: EF100-400mm f/4.5-5.6L IS USM
1/320 sec; f/11; ISO 100

188
Canon EOS-1Ds Mark III
Lens: EF600mm f/4L IS USM +1.4x
1/500 sec; f/16; ISO 160

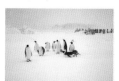 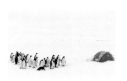 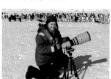

190
Canon EOS-1Ds Mark II
Lens: 24.0-105.0 mm
1/400 sec; f/11; ISO 160

192
Panasonic DMC-FX100
1/250 sec; f/13; ISO 80

193
Canon EOS-1Ds Mark II
Lens: 24.0-105.0 mm
1/400 sec; f/7.1; ISO 125

194
Canon EOS 5D Mark III
Lens: EF16-35mm f/2.8L II USM
1/250 sec; f/11; ISO 160

196
Canon EOS 5D Mark III
Lens: EF16-35mm f/2.8L II USM
1/640 sec; f/8; ISO 100

198
Canon EOS 5DS R
Lens: EF24-105mm f/4L IS USM
1/400 sec; f/8; ISO 125

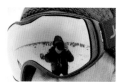 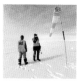 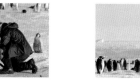

200
Apple iPhone 6s
1/5000 sec; f/2.2; ISO 25

202
Canon EOS 5DS R
Lens: EF100-400mm f/4.5-5.6L IS II USM
1/800 sec; f/6.3; ISO 100

204
Apple iPhone 6s
1/1600 sec; f/2.2; ISO 25

205
Apple iPhone 6s
1/2653 sec; f/2.2; ISO 25

206
Canon EOS 5D Mark III
Lens: EF100-400mm f/4.5-5.6L IS II USM
1/4000 sec; f/7.1; ISO 320

 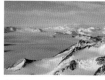

208
Canon EOS 5DS R
Lens: EF24-105mm f/4L IS USM
1/160 sec; f/13; ISO 320

210
Canon EOS 5DS R
Lens: EF100-400mm f/4.5-5.6L IS II USM
1/1000 sec; f/6.3; ISO 100

211
Canon EOS 7D Mark II
Lens: EF100-400mm f/4.5-5.6L IS II USM
1/640 sec; f/6.3; ISO 320

212
Canon EOS 5D Mark III
Lens: EF24-105mm f/4L IS USM
1/800 sec; f/8; ISO 250

212
Canon EOS 5D Mark III
Lens: EF16-35mm f/2.8L II USM
1/500 sec; f/13; ISO 200

212
Canon EOS 5DS R
Lens: EF100-400mm f/4.5-5.6L IS II USM
1/800 sec; f/8; ISO 100

214
Canon EOS 5DS R
Lens: EF24-105mm f/4L IS USM
1/1000 sec; f/5.0; ISO 100

215
Canon EOS 5D Mark III
Lens: EF16-35mm f/2.8L II USM
1/250 sec; f/10; ISO 100

216
Canon EOS 5DS R
Lens: EF24-105mm f/4L IS USM
1/400 sec; f/10; ISO 160

218
Canon EOS 5DS R
Lens: EF24-105mm f/4L IS USM
1/800 sec; f/10; ISO 160

Acknowledgements

First and foremost, thank you to the national treasure that is Michael Palin for his most generous foreword or, as he would say, 'words of slavish devotion'. Having admired Michael and his talent for words, wit and wisdom for decades, I found myself in the enviable position of travelling to the Antarctic with him and a small group of mutual friends for what was a remarkable voyage. I am extremely grateful for his kindness in agreeing to write a foreword for the book, and experience a lovely warm glow whenever I see our names together on the cover.

Talking of national treasures, in my first book, *Cold Places*, I thanked Sir David Attenborough, whose enthusiasm and love for the natural world has inspired me and countless others for decades. That bears repeating. Watching him on *Life in the Freezer* made me want to see these extraordinary polar creatures for myself. To have worked with David on *The Blue Planet*, *Planet Earth* and other documentaries really was a dream come true.

Those of you who have travelled to the Antarctic know what an incredible, life-changing experience it is. It has been my huge privilege to return there many times over the past 20 years. And it was, appropriately enough, where I met one of the people for whom I have the utmost admiration and respect, Sir Ranulph Fiennes. So my deepest gratitude to him for his warm words.

I'm so grateful to Quark Expeditions, who gave me the opportunity to see emperor penguins for the first time. I was selected to be part of the expedition team on board the famous Russian icebreaker *Kapitan Khlebnikov* in 2008 and 2009, and I spent many happy days working at the Snow Hill Island emperor penguin colony. Huge thanks to Karl Kannstadter for giving me the opportunity to return there in 2018. Antarctica's extraordinary wilderness is made all the more special when one can experience it with kindred spirits, so thanks to my friends on the Snow Hill Expedition team: Brandon Harvey, Cheli Larsen, Nigel Millius, David McEown, Rick Price, Jonathan Shackleton and Kara Weller for memories that will last a lifetime.

A heartfelt thanks to David Rootes for giving me the opportunity to be part of the amazing team at Antarctic Logistics and Expeditions (ALE) at the Gould Bay camp in 2016. It was a joy and privilege to work alongside such a ridiculously talented, yet modest and lovely, team including Camp Manager Hannah McKeand, Carolyn Bailey, Nick Lewis, Yoshi Miyasaki-Back, Zac Poulton, Iain Rudkin and Namgya Sherpa, and the Kenn Borek Air team of Jim Haffey, Dillan Josland, Alex Bishop and John Garzon. The flight returning to Union Glacier from the South Pole was one of the most amazing things I've ever experienced – thanks Jim and Dillan!

Emperor – The Perfect Penguin would not have been possible without the design talent, creativity, friendship and support of Simon Bishop, who pulled out the stops to help me realise the vision for this book. Simon's cheerful company and great ideas were an inspiration throughout. Likewise, Stephen Johnson of Copyright Image Ltd for his advice and talent in prepping my images, and Roz Kidman Cox for her help with the editing.

I am indebted to James Smith and his team at ACC Publishing for having faith in this project and giving me the opportunity to have such a huge input with the production, and particularly to Rebecca Brash at ACC for her enthusiasm for the project from the outset. Thank you also to Sarah Smye, Hannah Gooch and Andrew Whittaker.

Thank you to the following wonderful people for their support and encouragement in various ways – Jody Allen, Paul Allen, Pam Beddard, Ian Condie, my parents Howard and Anne, Richard, Sara and George Flood, Michael Bright, Meabh Flynn, Rupert Friend, Peter Gabriel, Rachael Garner, Jim and Irene Graham, Amy Gray, Olivia Harrison, Cindy Miller Hopkins, Eric and Tania Idle, Aimee Mullins, Linda and Dennis Myers, Kate Nathoo, Judith Owen, Jane Pigott, Chris and Anne Reyes, Alexa Rice, Tom Schonhoff, Harry Shearer, Burkhard Stemann, Greg and Ava Vorwaller and the great team at Steppes Travel, especially Justin Wateridge, Nick Laing and Jarrod Kyte.

Particular mention to the Chinstraps (Olivia, Michael, Jools, Christabel, Tom, Rita, Dennis, Carolyn and Jonathan) and the N'Iceholes (Olivia, Dhani, Mereki, Rupert, Aimee, Chris, Melinda, Dave, Julia and Maria) for the two most extraordinary and inspiring voyages I've experienced.

Finally, last but most certainly not least, I want to thank my husband Chris Graham, whose kindness, unswerving love and loyalty, and wonderful ability to make me laugh every day makes life a joy.

Sue Flood